This book is dedicated to Vicken, my inspiration and my strength.

Publisher's Acknowledgements
We would like to thank the following authors and publishers for their kind permission to reprint articles: **Art Gallery of New South Wales**; **Contemporary Sculpture Centre**, Tokyo; **Irish Museum of Modern Art**, Dublin; **Malmö Konsthall**; **Declan McGonagle**, Dublin; **Serpentine Gallery**, London; **Tate Gallery Liverpool**, and **Winnipeg Art Gallery**. We are grateful to the following for lending reproductions: **Chinati Foundation**, Marfa, Texas; **Paula Cooper Gallery**, New York; **Richard Deacon**, London; **Anthony d'Offay Gallery**, London; **Feature**, New York; **Illuminations Television**, London; **Lisson Gallery**, London; **Louisiana Museum**, Humlebaek, Denmark; **Pace Wildenstein Gallery**, New York; **Karsten Schubert Gallery**, London; **Bill Woodrow**, London; and **Donald Young Gallery**, Seattle. Photographers: **Luis Bustamante, Boris Cvjetanovic, Chris Davies, Todd Eberle, John Kellett, Mary Kristen, John McWilliams, Daro Montag, Andrew Moore, Sue Ormerod, Antonio Pinto, David Scott, John Searle, Mariusz Szachowski, Jan Uvelius, David Ward, Boyd Webb, Stephen White, Alan Winn** and **Edward Woodman**. Special thanks are due to the White Cube Gallery, London, and to Claire Doherty and Clare Manchester for their assistance in the preparation of materials.

Artist's Acknowledgements
Thanks to my assistants, Steven Pippin, Ian Nutting, Tom Yuill, Niall O'Hare, Robert Turvey, Tim Maslen, Jonathan Lakin-Hall, Peter Moss, Carl Von Weiler and my archivist, Pauline Woodrow.

I would also like to thank Iwona Blazwick, commissioning editor, Gilda Williams, Clare Stent and Stuart Smith of Phaidon Press.

All works are in private collections unless otherwise stated.

Phaidon Press Limited
18 Regent's Wharf
All Saints Street
London N1 9PA

First published 1995
© Phaidon Press Limited 1995
All works of Antony Gormley are © Antony Gormley.

ISBN 0 7148 3383 5

A CIP catalogue record of this book is available from the British Library.

Printed in Hong Kong

cover, **Learning to Think**
1991
Lead, fibreglass, air
5 body cases, 173 × 106 × 31 cm
each

page 4, **Sense** (detail)
1991
Concrete
74.5 × 62.5 × 60 cm

page 6, **Antony Gormley**
1990
photo Isabelle Blondiau

page 30, **Lost Subject,** in progress
1994

page 96, **European Field**
1994
Terracotta, approx. 35,000 figures
Variable size, each figure 8-26 cm
Installation, Muzej Surremene
Umjetnosh, Zagreb

page 106, **Bodyprint in the Snow**
1979

page 144, **Body,** in progress
1991

page 160, **Studio wall**
1993

John Hutchinson E. H. Gombrich Lela B. Njatin

Antony Gormley

In Memory
Of
Rebecca Pomper

Contents

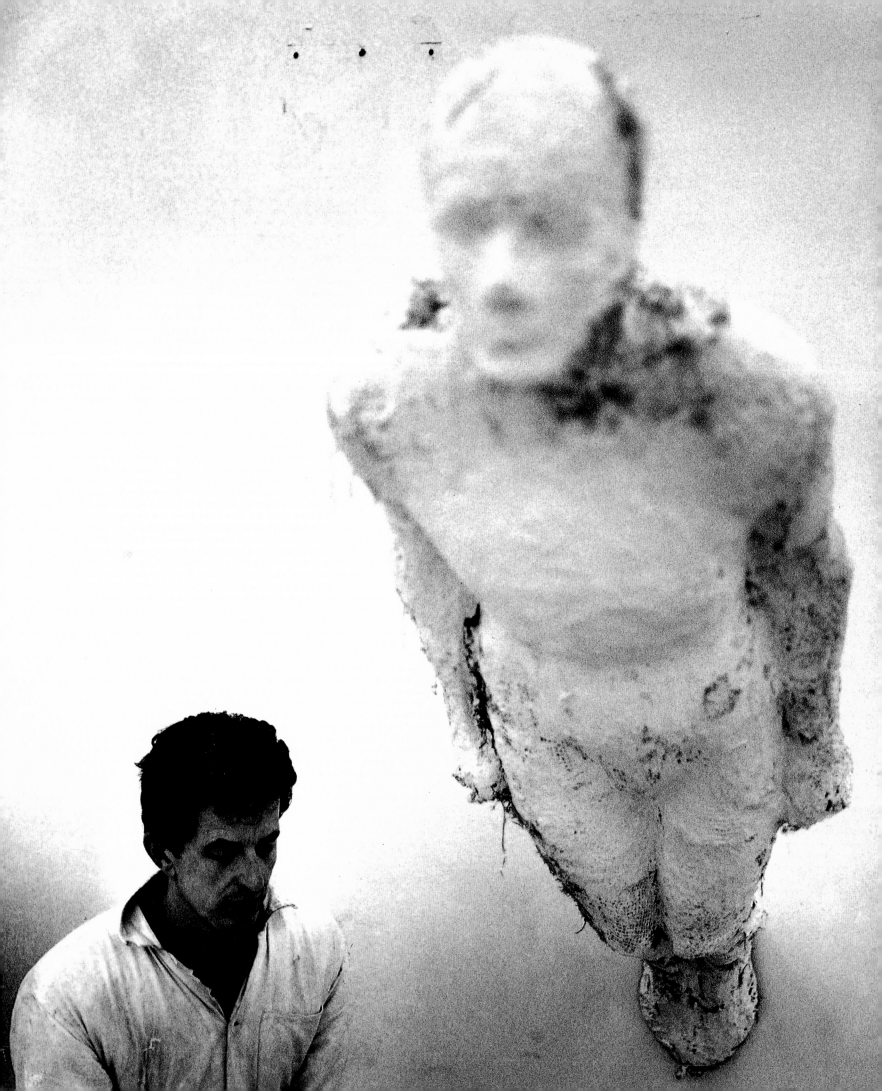

Contents

E. H. Gombrich in conversation with **Antony Gormley**

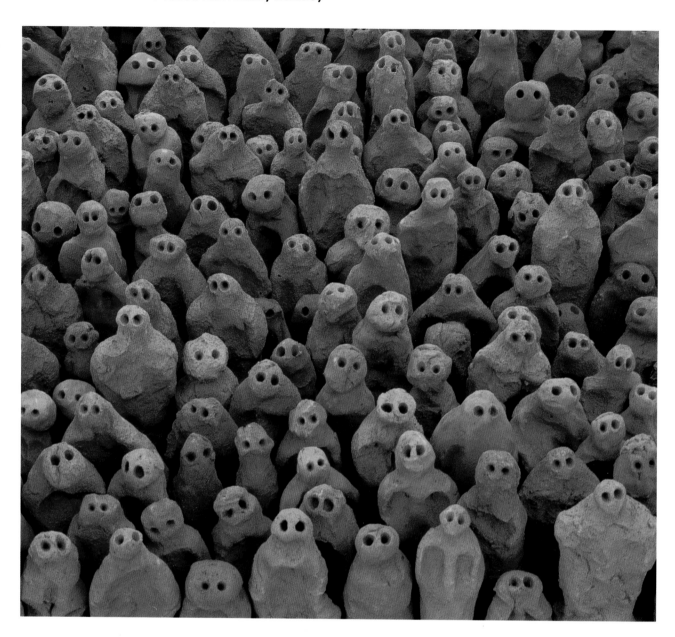

Field for the British Isles (detail)
1992
Terracotta, approx. 35,000
figures
Variable size, 8-26 cm each
Collection, the Arts Council of
Great Britain, London

Antony Gormley **You ought to know that it was reading *The Story of Art* at school that I think inspired my interest in art.**

Ernst Gombrich Really!

Gormley **... and made the whole possibility not only of studying art but also of becoming an artist a reality for me.**

Gombrich That's very flattering and very surprising for me.

Gormley **And what I hoped we might do in this conversation was talk about the relationship of contemporary art to art history generally – what is necessary, as it were, to retain and what we can discard from the lessons of that history.**

Gombrich I would like to start, like everybody else, with *Field*. I'm interested in the psychology of perception; if a face emerges from a shape you are bound to see an expression. The Swiss inventor of the comic strip, Rodolfe Toepffer, says

Parallel Field
1990
Cast iron
187.5 × 45 × 35 cm

that oddly enough, one can acquire the fundamentals of practical physiognomy without ever actually having studied the face, head or human contours, through scribbling eyes, ears, and nose. Even a recluse, if he's observant and persevering, could soon acquire – alone and with no help except what he gets from thousands of tries – all he needs to know about physiognomy in order to produce expressive faces. Wretched in their execution perhaps but definite and unmistakable in their meaning. He gives examples of doodles all of which have a strong expressive character. Anyone can discover in studying these doodles what makes for expression. I have called this 'Toepffer's law' – the discovery that expressiveness or physiognomy does not depend on observation or skill but on self-observation.

Gormley **For me the extraordinary thing about the genesis of form of the individual figures in *Field* is that it isn't about visual appearances at all. What I've encouraged people to do is to treat the clay almost as an extension of their own bodies. And this takes some time. This repeated act of taking a ball of clay, and using the space between the hands as a kind of matrix, as a kind of mould out of which the form arises.**

Gombrich Anyone who has ever played with clay has experienced this elemental form. And of course in twentieth century art, not only in your art, this played a crucial role. Picasso did it from morning to night, didn't he? He just toyed with what would come out when he created these shapes. When we loose the constraints of academic tradition we not only create an expressive physiognomy but an expressive shape or a more independent usage; that's what we admire in children's drawings, though I dare say that children do not intend to do so. We cannot help seeing the creations of primitive art in terms of an expressiveness, which is not always the one intended by the maker. In a certain frame of mind we see everything as expressive. The basis of our whole relationship to the world, as babies or as toddlers, is that we make no distinction between animated and inanimate things. They all speak to us, they all have a kind of character or voice. If you think back to your childhood, not only toys but most things which you encounter have this very strong character or physiognomy as Beings of some sort. And I'm sure that this is one of the roots or one of the discoveries of twentieth century art, to try to recapture this. In my view, it was too exciting to discover how creative and expressive the images made by children, the insane, and the untutored were. It's no wonder that artists longed to become like little children, to throw away the ballast of tradition that cramp their spontaneity and thus thwart their creativity. But it's no wonder also that new questions arose about the nature of art which were not so easily answered. Deprived of the armature of tradition and skill, art was in danger of collapsing into shapelessness. There were some who welcomed this collapse, the Dadaists and other varieties of anti-artists. But anti-artists only functioned as long as there was an art to rebel against, and this happy situation could hardly last. Whatever art may be, it cannot pursue a line of resistance. If the pursuit of creativity as such proves easy to the point of triviality then there is the need for new difficulties, new restraints. I believe it would be possible to write the history of twentieth century art not in terms of revolutions and the overthrow of rules and traditions but rather as the continuity of a quest, a quest for problems worthy of the artist's nature. Whether we think of Picasso's restless search for creative novelty, or of Mondrian's impulse to paint, all the

modernists may be described as knights errant in search of a challenge. Would you accept this?

Havmann
1994-95
Granite
10.1 × 3.3 × 2.2 m
Mo-i-Rana, Norway

Gormley **I think it's true that this idea of a reaction against a kind of orthodoxy is no longer a viable source of energy for art today. But I didn't simply want to continue where Rodin left off, but re-invent the body from the inside, from the point of view of existence. I had to start with my own existence.**

Gombrich I think in your art also, you are trying to find some kind of restraint. You want us to respond to the images of bodies, of your 'standard' body?

Gormley **I like that idea of a 'standard' body, but what I hope I've done is to completely remove the problem of the subject. I have a subject, which is life, within my own body. But in working with that I hope that it isn't just a 'standard' body: it is actually a particular one which becomes standardized by the process ...**

Gombrich Because for you, your body is standard. It cannot be otherwise.

Gormley **What I'm doing is realizing, materializing perhaps for the first time, the space within the body. It's certainly a very difficult thing to communicate, but it's to do with meditation.**

Gombrich That has to do with breathing, with breath ...

Gormley **It has a lot to do with breath.**

Gombrich But you can't create what you breathe.

Gormley **No, but you can, I think, try to materialize the sensation of that inner space of the body, and that's what I hope that these large body forms are. They are in some way an attempt to realize embodiment, without really worrying too much about mimesis, about representation in a traditional way.**

Gombrich About this internal body, this is something that must interest anybody, but the question of whether it can be externalized is still another one, isn't it? It starts from the most trivial fact that when we feel the cavities of our own body, let us say the interior of the mouth, we have an entirely different scale. Any crumb in our teeth feels very large and then when we get it out we are surprised that it is so small, and if the dentist belabours your tooth you have the feeling that the tooth is as large as you are. Then it turns out, if you look in the mirror, that it was an ordinary small tooth. In a sense that is true of all internal sensations: the internal world seems to have a different scale from the external world.

Gormley **I think that's a brilliant, accessible example of what I'm interested in. There was a repeated sensation that I had as a child before sleep, which was that the space behind my eyes was incredibly tight, a tiny, dark matchbox, suffocating in its claustrophobic imprisonment. And slowly the space would expand and expand until it was enormous. In a way I feel that experience is**

Heavy Stones
1982
Stone
approx. 40 cm diam. each

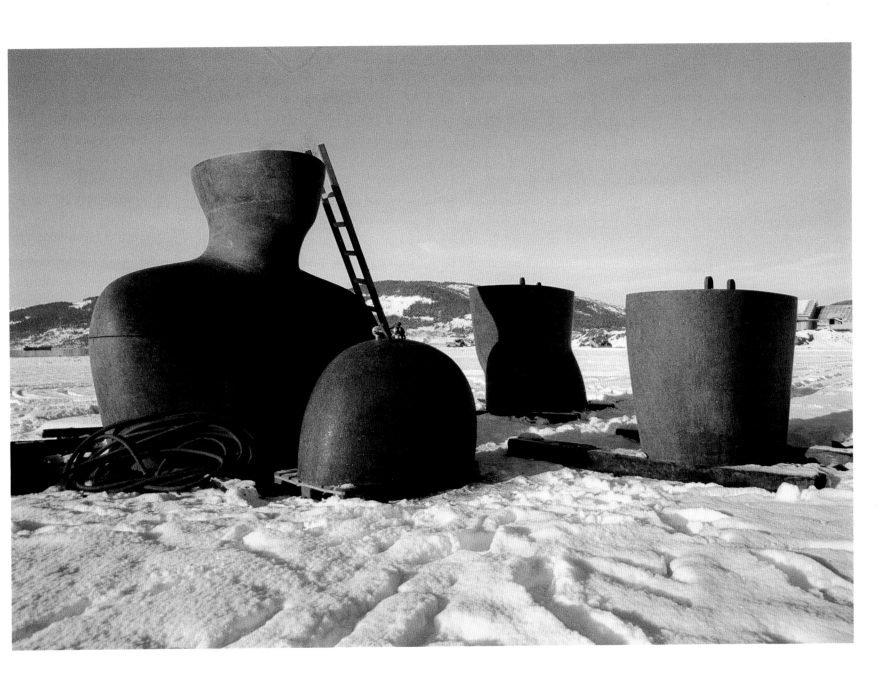

still the basis of my work. This recent piece, *Havmann*, a 30-foot high black body mass, will read as a black hole in the sea, but it is made massively of stone. It's put at a distance from the viewer – 150 feet from the shore. Because there's an indeterminacy of scale in relation to the landscape, it is difficult to judge its actual size, which is an attempt to realize exactly the sort of thing you were saying.

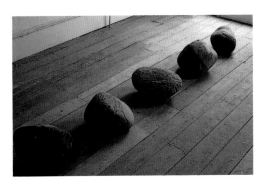

Gombrich Of course, as you indicate, falling asleep, or even in dreams, this kind of sensation takes over. We are very much governed in our sleep by these body sensations which we project into some kind of outside world and see as things which they aren't. And you say that in Buddhist meditation this is also so, but it's not, because in Buddhist meditation you try to get away from thingness.

Gormley What I was trying to describe was the first experience of this inner body which was in my childhood. I think then the experience of learning Vipassana with Goenka in India was something very much more disciplined,

but had to do with it. The minute you close your eyes in a conscious state you are aware of the darkness. With the Vipassana you explore that space in a very systematic manner. First of all you ...

Gombrich You have to learn to relax.

Gormley **Well, it is an interesting mixture. Anapana, or mindfulness of breathing, gives you concentration. You then use that concentration to look at the sensation of being in the body, and that is a tool that I have tried to transfer to sculpture.**

Gombrich Yes, but my problem is how you bridge these very intense experiences which we can call 'subjective', a word which isn't very telling, and what you want the other to feel.

Antony Gormley in India
1973

Gormley **That for me is the real challenge of sculpture. How do you make something out there, material, separate from you, an object amongst other objects, somehow carry the feeling of being – for the viewer to somehow make a connection with it. In a way, where you ended in *Art and Illusion* is where I want to begin. That idea that in some way there are things that cannot be articulated, that are unavailable for discourse, which can be conveyed in a material way, but can never be given a precise word equivalent for.**

Gombrich Certainly not. Our language isn't made like that. Our language serves a certain purpose, and that purpose is orientation of oneself and others in the three dimensional world. But I cannot describe the feeling I have in my thumb right now, the mixture between tension and relaxation. Sometimes if you go to the doctor you feel this helplessness in describing what your sensations are, there are no words. And that is a very important part of all human existence, that we have these limits. But your problem as far as I see it is to transcend these limits.

Gormley **I want to start where language ends.**

Gombrich But you want in a sense to make me feel what you feel.

Gormley **But I also want you to feel what you feel. I want the works to be reflexive. So it isn't simply an embodiment of a feeling I once had ...**

Gombrich It's not the communication.

Gormley **I think it is a communication, but it is a meeting of two lives. It's a meeting of the expressiveness of me, the artist, and the expressiveness of you, the viewer. And for me the charge comes from that confrontation. It can be a confrontation between the movement of the viewer and the stillness of the object, which in some way is an irreconcilable difference, but also an invitation for the viewer to sense his own body through this moment of stillness.**

Gombrich In other words, what in early textbooks was called 'empathy', a

Still Running
1986
Cast iron, air
168 × 66 × 102 cm
Collection, Ume Dalen Sculpture
Foundation, Umea, Sweden

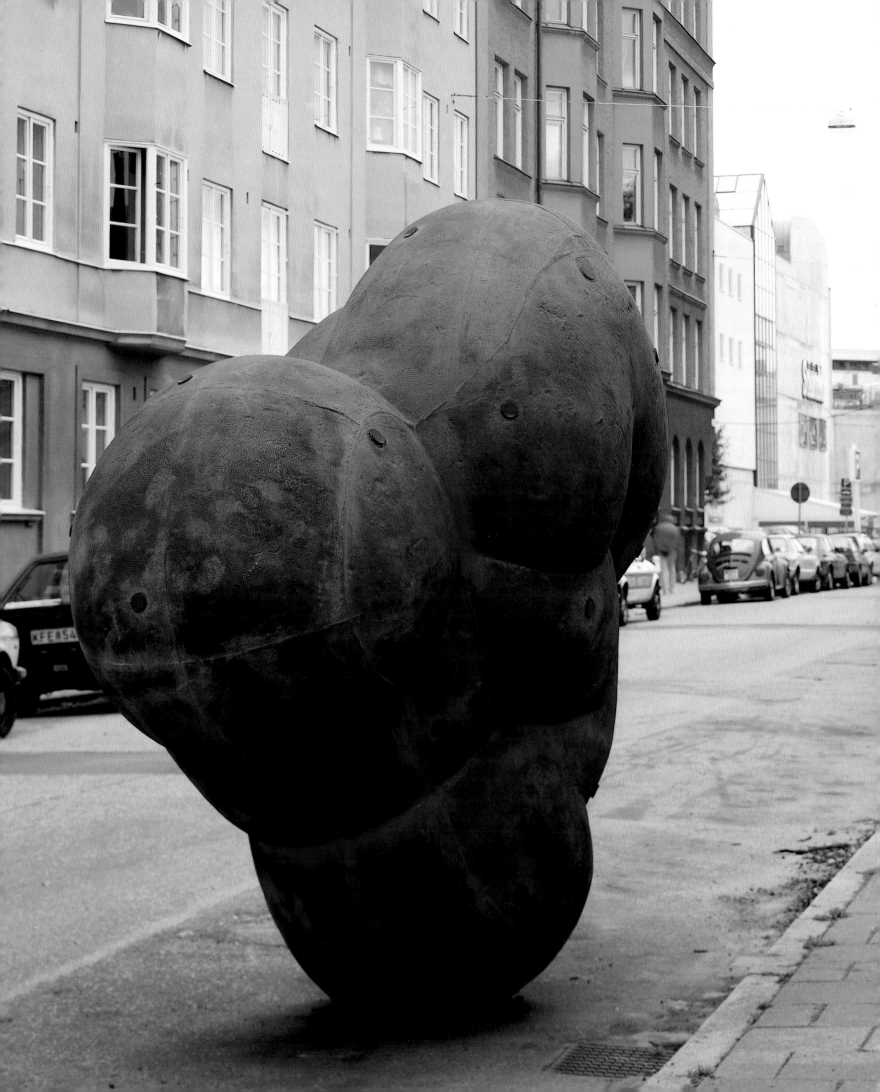

feeling that you share in the character of a building, or a tree, or anything. I am always interested in our reaction to animals, because there we react very strongly. The hippopotamus has a very different character from the weasel, there is no doubt; we also talk to them in different ways. Our response is inevitable when dealing with the world around us.

Gormley **I think you are saying two things there. One is the anthropomorphizing of external stimuli and the other thing, which I am more interested in, is the idea of body size, mass; that a hippopotamus is huge and has rather a simple shape, and a weasel is like a line and sharp. It is also to do with speed; bodies themselves carry feeling which is in itself a kind of information that isn't available so easily to analysis. I want to use that empathy or embodiment in my work, and what I am trying to do is treat the whole body in the same way as perhaps portrait painters in the past have treated the face. I simply use my body as a starting point. I don't want to limit my sculptures autobiographically. On one level it is not dissimilar to choreography and the dancer's body. It is using the body as a medium.**

Gombrich It is not self-expression.

Gormley **I am interested in discovering principles. In a piece like *Land, Sea and Air* there is one standing body case, *Sea*, with the eyes open looking out to the horizon; *Land* is the crouching one which has ears and listens to the ground; and *Air*, the kneeling one, has its nose open. What I was trying to do there was find a bodily equivalent for an element through a perceptual gateway. I think that underlying my return to the human body is an idea of**

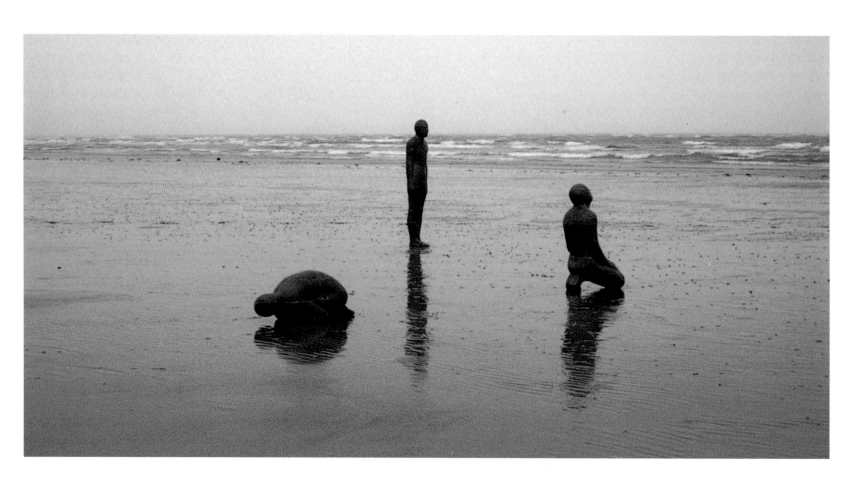

re-linking art with human survival. There isn't just a problem about what we can do next in art terms. In a sense this is where your field and my field mix. You have always been concerned with finding a value in art, the application of rational principles to the understanding of an emerging language, and I think that there has been a sense where art – certainly in the earlier part of the twentieth century – took a view of that history in order to validate its own vision. I think that it is more difficult to do that now. All of us are aware that Western history is one history amongst many histories, and in some way there now has to be a re-appraisal of where value has to come from. Subjective experience exists within a broader frame of reference. When you think about what happens next in art, it is very hard not to ask the question: what happens next in the development of global civilization?

Gombrich I agree with you in that the values of our civilization and the values of art are totally linked. One cannot have an art in a civilization which believes in no value whatever, therefore I quite agree with you in the central question. I think that all our response to art depends on the roots of our own culture, that is why it is quite hard to get to the root of Eastern art. I think that sometimes we can't understand the art of our own culture just as we don't understand the letters in Chinese calligraphy. Don't you agree?

Gormley **I think that it is invariably misunderstood, certainly at first experience, but my reply to the Chinese calligraphy question is my reply to anyone who finds it impossible to understand any one artist's work today. I think that if there is some sympathy there, then the invitation is to get more familiar. The idea that in some way value can only come from judging it from its own tradition, from which it may have escaped or never belonged to at all, is going to be less useful than looking at the organic development of an individual language and seeing if that has a universal significance. I would be interested to know whether you feel that it is possible to convey a notion of embodiment without mimesis, without having to describe, for instance, movement, or exact physiognomy.**

Gombrich I have no doubt that not only is it possible but it happens in our response to mountains, for example, we lend them our bodies. I think that the greater problem is the limit, because in a certain sense it happens all the time: it happens in the nursery, it happens in regressive states of the mind. The problem is not so much whether we can make people respond in this almost elemental form to shapes, but how to distinguish a work of art from a crumpled piece of paper, which also has its physiognomy and its character. I think there is partly still a feeling of a person behind it, which adds to the confidence of the viewer, that here is an embodiment and the viewer is interested in engaging in it.

Gormley **Yes I think that that idea of purpose is embodied in the way that something is put together, not just in its form. In some way that sense of purposefulness has to do with how clear the workmanship is, how ...**

Gombrich How manifest ...

Gormley **Yes.**

Land, Sea and Air II
1982
Lead, fibreglass
Land (crouching) 45 × 103 × 53 cm,
Sea (standing) 191 × 50 × 32 cm,
Air (kneeling) 118 × 69 × 52 cm

Gombrich It is really the 'mental set' in twentieth century art which is behind all these problems. You have to have a certain feel of what is going on there, otherwise it's just an object like any other.

foreground, **Heart**
1986
Lead
14.4 × 26.4 × 18 cm
background, **Room**
1986
Concrete
208 × 51 × 60 cm

Gormley **I think that we all are very visually informed these days. Maybe classical education within the visual arts has now been replaced by a multiplicity of visual images that come through computers and advertising and all sorts of sources.**

Gombrich Then you have the weirdest forms on TV, which I don't possess, and the sometimes amusing shapes created for advertising or whatever else. That is just the problem, the problem of the limits of triviality.

Gormley **Yes exactly. How do you condense from this multiplicity of images, certainly in sculpture, something that is still, silent, maybe rather complete, and therefore rather forbidding because it isn't like a moving image on a screen. It is not telling you to buy something. It's something that has a different relationship to life. And that for me is the challenge of sculpture now, that it may have within it a residue of 5,000 years of the body in art, but it must be approachable to somebody whose main experience of visual images is those things.**

Gombrich You want them to feel the difference between a superficial response of amusement and mild interest, and something that has a certain gravity.

Gormley **Yes, I think it should be a confrontation** *(laughs)*.

Gombrich Coming to terms with it.

Gormley **And through coming to terms with it, coming to terms with themselves.**

Gombrich Yes, perhaps that is a different matter.

Gormley **But that question of the difference between subjective response and the object is absolutely the essence of what I'm trying to get at. Whether this is something accessible to discourse is another matter. But for me, the idea that the space that the object embodies is in some way both mine and everyone's is very important, that it is as open to the subjective experience of the person looking at it as it is to me, the possessor of the body that gave that form in the first place.**

Gombrich You'll agree that everybody's experience is likely to be a little different.

Gormley **Absolutely. We have moved out of the age where you would argue that, yes that is a Madonna, but, well, the drapery isn't quite fully achieved. Today we have moved from signs that have an ascribed meaning and an iconography that we know how to judge, to a notion of signs that have become liberated. Now that has a certain annoyance factor** *(laughs)*, **but it also has a certain invitation for an involvement that was not possible before.**

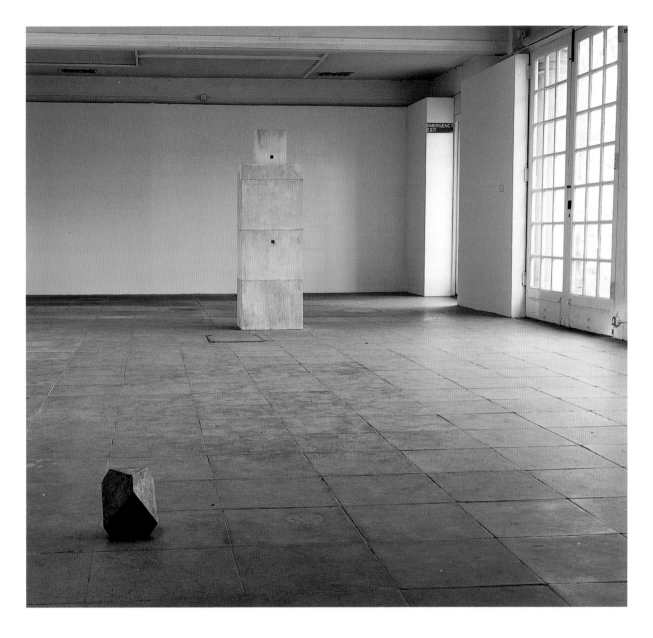

Gombrich But it was with architecture.

Gormley **Yes that's true. And it's interesting that you mention architecture because I think of my work, certainly in its first phase, as being a kind of architecture. It's a kind of intimate architecture that is inviting an empathetic inhabitation of the imagination of the viewer.**

Gombrich But in architecture there was the constraint of the role of the tradition and purpose of a building. This is a church, and this is a railway station, and we approach them with slightly different expectations. The problem I think, which is not of your making, but is for every artist working today, is to establish some kind of framework wherein the response can develop.

Gormley **I'm working on it! I'd like us to talk a bit more about casting.**

Gombrich Well, did you know that it has turned out that part of Donatello's *Judith* is cast from the body? It's astonishing. I remember Rodin was charged

with casting from the body, so it was considered a short cut, seen as very lazy or mean, or cheating.

Gormley **Absolutely, there's a prejudicial negative attitude.**

Gombrich Of course, quite a number of posthumous busts are based on the cast of the death mask that is usually modified. But this practice is not usually condemned.

Gormley **But it is interesting you see, because the in-built morbidity of the death mask is in some way in keeping with the idea of a memorial portrait...**

Gombrich It fits into what you call the context.

Gormley **But the interesting thing is that idea of trace. Certainly as a child, probably the most potent portraits which affected me in visits to the National Portrait Gallery were the portraits of Richard Burton, which was a rather dark oil painting, and the head of William Blake, which was a cast from life. What affected me as a child was feeling the presence of someone through the skin, where the contact of the skin with whatever was registering it, the impression, was not really as important as an idea somehow of a pressure behind the skin which was both physical and psychological.**

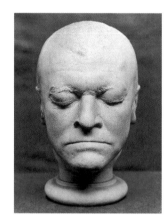

J. S. Deville
Life Mask of William Blake
c. 1807
Plaster
h. 27.6 cm

Gombrich It was alive in other words.

Gormley **No, it was more than that. There is a sense in which there is this pressure inside the dome of the scalp and then also this pressure behind the eyes which gives that work a kind of potency. It was as if something was trying to come through the surface of the skin. In a way the casting process in that instance, and I hope also in my work, is a way of getting beyond the minutiae of surface incident and instantly into that idea of presence, without there being something to do with interpretation. One of the bases of my work is that it has to come from real, individual experience. I can't be inside anyone else's body, so it's very important that I use my own. And each piece comes from a unique event in time. The process is simply the vehicle by which that event is captured, but it is very important to me that it's my body. The whole project is to make the work from the inside rather than to manipulate it from the outside and use the whole mind/body mechanism as an instrument, unselfconsciously, in so far as I'm not aware while I'm being cast of what it looks like. I get out of the mould, I re-assemble it and then I re-appraise the thing I have been, or the place that I have been and see how much potency it has. Sometimes it has none; I abandon it and start again.**

Gombrich What does the potency depend on?

Gormley **The potency depends on the internal pressure being registered.**

Gombrich And how much of this, in your view, is subjective and how much is inter-subjective?

Gormley **I am interested in something that one could call the collective**

Instrument II
1991
Lead, fibreglass, plaster, air,
optical lens
213 × 74 × 51 cm

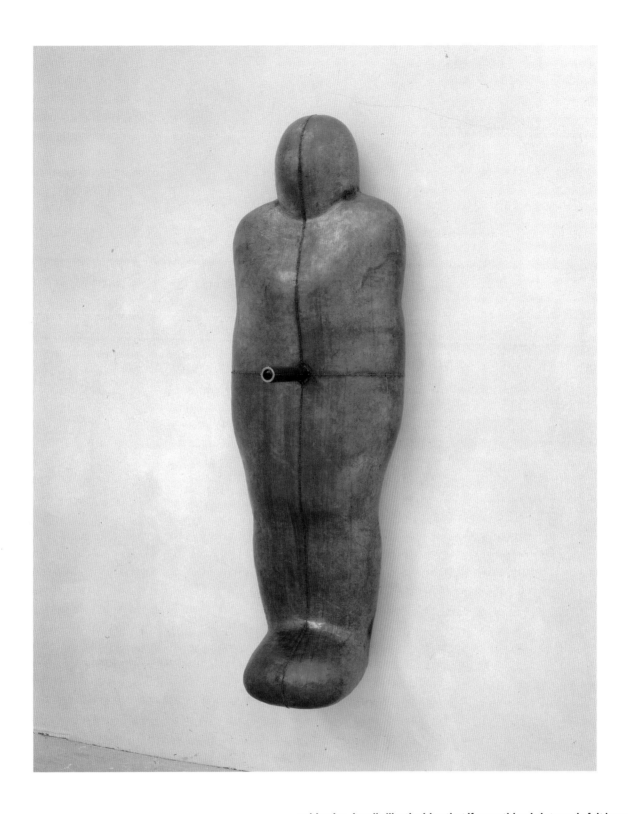

subjective. I really like the idea that if something is intensely felt by one individual that intensity can be felt even if the precise cause of the intensity is not recognized. I think that is to do with the equation that I am trying to make between an individual, highly personal experience and this very objective thing – a thing in the world, amongst other things. It is even constructed by objective principles; the plate divisions follow horizontal and vertical axes, but then they affect the viewer in a very subjective and particular way. I am not sure if I have any right to prescribe what the viewer should be thinking or feeling at that point. I would like to feel that there is a potential for his or her experience to be as intense as mine was, and equally subjective.

Gombrich You work as a guinea pig in a test to find out if it affects you. If the cast doesn't affect you, you discard it.

opposite, **Peer**
1984
Lead, plaster, fibreglass
188 × 50 × 43 cm

Gormley **Yes I think that has to be what I am judging when I see the immediate results of the body mould. What I am judging is its relationship to the feeling that I want the work to convey. Once I am out of it, it does become a more objective appraisal. I work very closely with my wife, the painter Vicken Parsons. Once we have defined what the position of the body will be then it is a matter of trying to hold that position with the maximum degree of concentration possible. Sometimes it's a practical thing; the position is so difficult to maintain that the mould goes limp. I lose it, I don't have the necessary muscular control and stamina to maintain it. More often and more interestingly it isn't those mechanical things but others that are more to do with intensity, and that can have to do with how much sleep I have had or simply with how in touch I am with what we are doing. The best work comes from a complete moment, which is a realization. I then continue to edit the work. It rarely involves cutting an arm off and replacing it with another but it may involve cutting through the neck and changing the angle two degrees. In terms of the process, we are talking about two stages, the first stage – and this is the most important because it is the foundation of the work – is making the mould. Then I go into the second stage which is making a journey from this very particularized moment to a more universal one, which is a process of adding skins. In the past this has meant I used different colours, to make sure that each layer was exactly the same thickness. Now I just rely on my judgement that I have reached the point at which this notion of a universal body and a particular body is in a state of meaningful equilibrium or meaningful balance.**

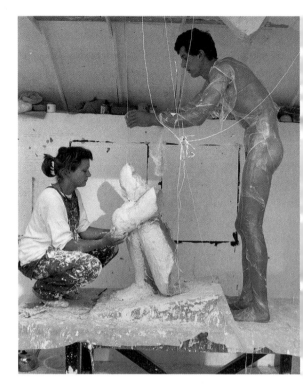

Work in progress
1986

Gombrich What you describe is a little like a painter stepping back from the canvas and judging it, examining it as if it were from the outside.

Gormley **It has to do with making the totality of the work count, as a whole, to deal with the mind/body as one organism, and re-present it as one organism rather than the current orthodoxy of the body in pieces, or the body as a battleground.**

Gombrich Now I will ask you a shocking question: why don't you take a photograph of your body?

Gormley **This is a photograph; I regard this as a three-dimensional photograph.**

Gombrich As you say a three-dimensional photograph, it could be done by holograph, there are methods. Would you accept it?

Gormley **No, that wouldn't interest me particularly. I am a classical sculptor in so far as I am interested in things like mass.**

Gombrich Tactility.

Gormley **Yes the tactility is very important and the idea of making a virtual**

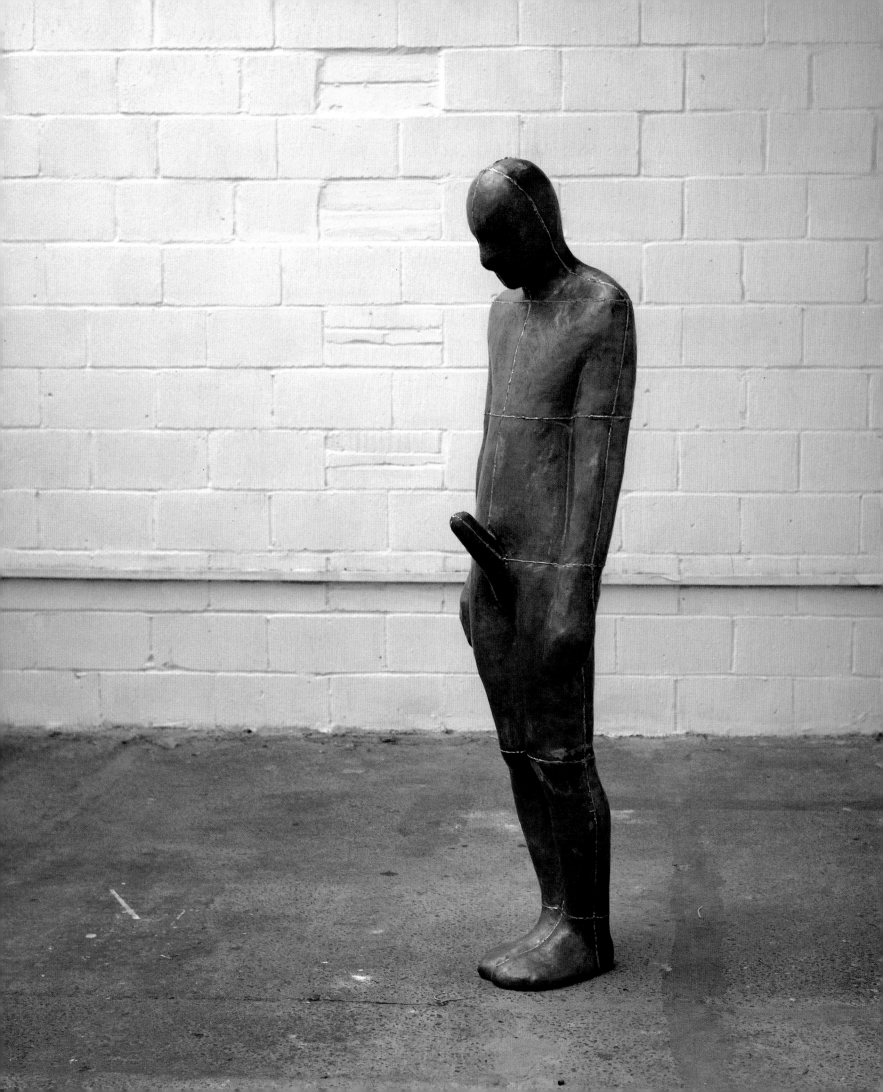

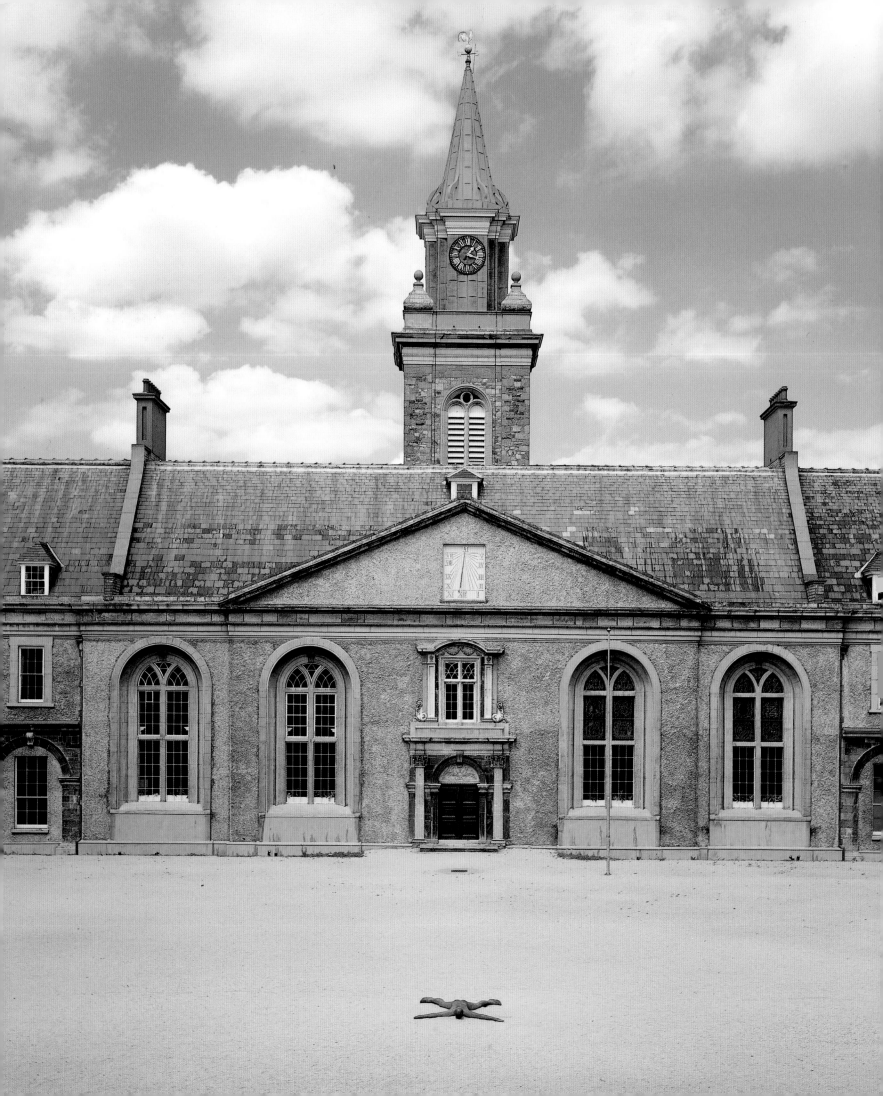

reality for me denies the real challenge and the great joy of sculpture which is a kind of body in space.

Gombrich And of course it is to scale, while the photograph on the whole needn't be and can hardly be demonstrably to scale.

Gormley **The other problem with a photograph is that it is a picture, and I am not really interested in pictures, as I am not interested in illusion. This idea has in a way informed your book: the history of art as a succession of potential schema by which we are invited to make a picture of the world. As we evolve the visual language we continually revise the previous schema in order to find an illusion that works more and more effectively. I feel that I have left that whole issue behind in a sense, as one that has had its story. We have to find a new relationship between art and life. The task of art now is to strip us of illusion. To answer your question, how do we stop art from descending into formlessness/shapelessness? How do we find a challenge worthy of the artist's endeavour? My reply to that is, we have somehow to acknowledge the liberty of creativity in our own time which has to abandon tradition as a principle of validation, to abandon the tradition of mainstream Western art history and open itself up: any piece of work in the late twentieth century has to speak to the whole world.**

Gombrich It may have to, but it won't.

Editor What do you think of the question of your masculinity, vis à vis there being an idea about some universally recognizable experience?

Gormley **In some of the work, the sexuality is declared and relevant to the subject of the work and at other times it isn't. I have tried to escape from the male gaze, if we are thinking about the male gaze both in relation to nature as a place of slightly frightening otherness and the male gaze in relation to the female body as the object of desire, or the object of idealization. I think the idealization of my work and its relationship to landscape are very different from historical models. I am aware that the work is of a certain sex.**

Gombrich Well everybody belongs to a certain gender and a certain age, you can't get out of that and I think it's almost trivial isn't it, if you try to.

Gormley **Yes, but what I am saying is that I think that this is a modified maleness, without trying to be the orthodox new man, a lot of work tests the prescribed nature of maleness in various ways, but I can't deny the fact that it comes from a male body and from a male mind. Part of the reason that so much of the work tries to lay the verticality of the body down, or re-present it by putting it on the wall, is that I am aware that even when a body case is directly on the floor, because I am tall there is this sense of dominance, of a male confrontationality. So a work like *Close* attempts to relocate the body and relate it to the earth, takes what could have been a heroic stance and puts it into the position of vulnerability. *Close*, for me is an image of an adult body put in the position of a child. This could be conceived as being the traditional image of a mother and a child. The mother in this case being the earth, the child being the body that is clinging on.**

Close IV
1992
Iron
25 × 192 × 186cm
Courtyard of the Irish Museum of
Modern Art, Dublin

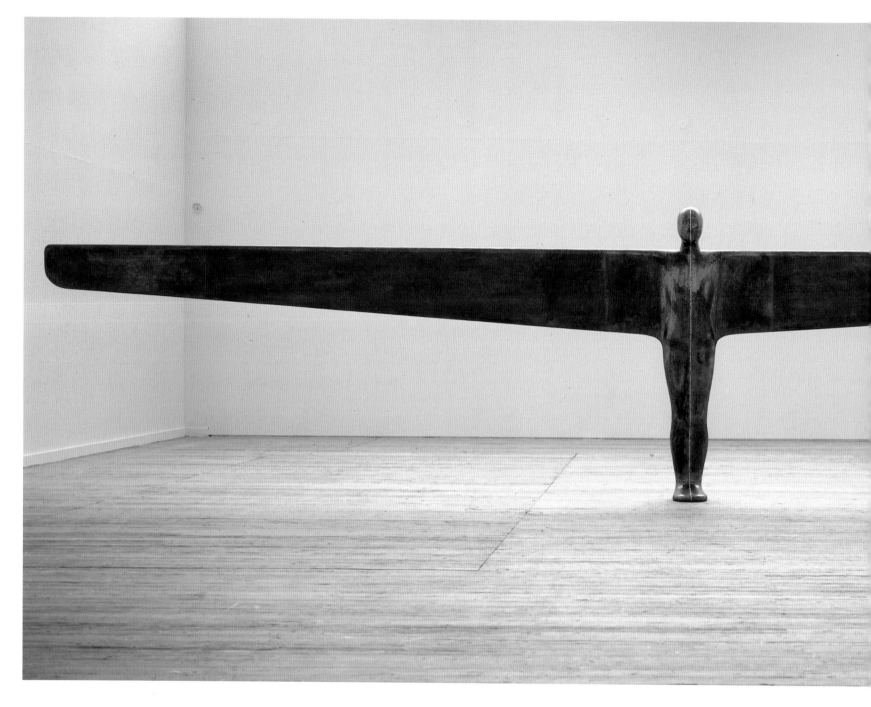

Gombrich You could also say it is a person prostrating himself, which is something different again, because then it is deliberate, humbling.

Gormley *Close* makes the body into a cross, completely fixes it. The body is almost used as a marker of a place, denying its own mobility in order to pick up on the idea that the earth is spinning at 1,000 km an hour around its own axis, and in order to talk about this illusion that we have of fixedness within the phenomenal world where in fact nothing is fixed. Close for me is a way of mediating the two forces, gravity and centrifuge; the body case becomes an instrument through which those forces are made palpable.

Editor You mentioned the cross and here is an angel, both historically symbolic forms. What meaning do they have for you?

A Case for an Angel II
1989
Plaster, fibreglass, lead,
steel, air
197 × 858 × 46 cm

Gormley **I think that this is a question about religion and religious iconography. Religion tries to deal with big questions, and I hope that my art tries to deal with big questions like, 'who are we?', 'where are we going?'. The fact is that I grew up within a Christian tradition, those things are part of not only my intellectual make-up but images of self that were given to me as a child. But I don't see them as illustrations of those images, they are just part of the mental and emotional territory that I have to explore.**

Editor They are not symbolic?

Gormley **I don't want the work to be symbolic at all, I want the work to be as actual as it can be, which is why my version of an angel is a rather uncomfortable mixture between aeronautics and anatomy.**

Gombrich Well the problem of how angels managed to fly with these relatively small wings is always present. But then their bodies probably have no weight; the wings are signs.

Gormley **An interesting point, because it is this idea of a mediator between one level of existence and another**...

Gombrich Of course, the *Angelos*, the messenger.

Post
1993
Cast iron
197 × 53 × 36 cm
Installation, Killerton Park, Exeter

Gormley **We need these means of transmission between one state of being and another. We cannot be bound by traditional meaning but at the same time it's important not to reject something simply because it has been done before, because in some senses we have to deal with everything. That is why I am as interested in placing my work in historical contexts, on the end of a pillar or in a church, as I am in the white cube of the gallery. I think that everything has to be accepted as part of the territory and that means accepting what has been necessary in the past for human beings, finding a way in which those needs can be expressed in a contemporary way that is not divisive or prescriptive in its interpretive function. I think that our attitude to history has changed, the idea of layering which also suggests a support structure has been replaced now by a co-existence of temporality. There is a sense in which my work exists within an understanding of historical precedent but also within a matrix of contemporaneity. I do want to ask you this one important question; I feel that you have done a lot for all of us in terms of making apparent the structures of our own visual culture and I get the feeling that you have a faith in the value of that story. I don't know what your faith is in the art of now, or of the future.**

Gombrich About the future I know nothing. I am not a prophet. About the situation of the arts at present, I think that the framework of art at present is not a very desirable one, the framework of art-dealing, art shows and art criticism. But I don't think that it can be helped, it is part of destiny that art came into the situation and I think it has its own problems. Sensationalism and lack of concentration are not very desirable and not very healthy for art, but I don't despair of the future or at least the present of art. I wouldn't despair of the fact that there will always be artists as long as there are human beings who mind and who think this is an important activity.

Gormley **But do you feel that we are at the end of the story that you wrote?**

Gombrich No, of course not. I do feel that there is a disturbing element in the story, and in the new edition I am working on the intrusion of fashions in art, which has always existed. Romanticism has created an atmosphere that makes it harder for an artist to be an artist, because there are always seductive cries or traps which may tempt the artist, I wouldn't say art, to this kind of sensationalism, like exhibiting the carcass of a sheep – because they are talking points. The temptation to play at talking points becomes the pivot of what the young then want to do, also to have the same talking point. I think this is a social problem rather than a problem of art.

Gormley **It is very difficult not to start talking about such things without sounding sententious and moralistic, but I do feel that art is one of the last realms of human endeavour left that hasn't been tainted by ideologies that have proved constrictive. In some way art does have this potential to be a focus for life which can be removed from the constraints of moral imperative, but nevertheless can invite people to think about their own actions.**

Gombrich It has its own moral imperatives.

Gormley **It does for the artist making it. I think it is very, very difficult then to**

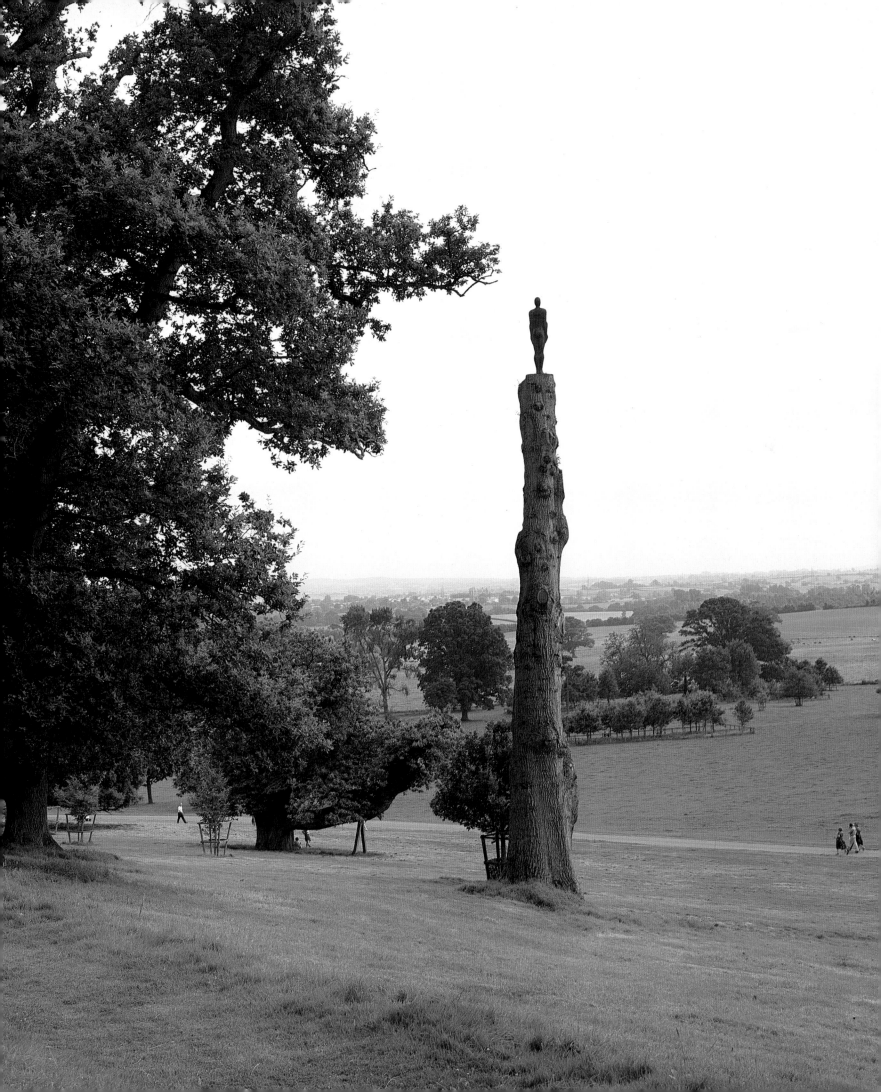

transfer that degree of moral commitment.

Gombrich It is not all that difficult. I mean the artist mustn't cheat. It's as simple as that.

Gormley **And he must take responsibility for his own actions.**

Gombrich And if he feels, as you just said, that something isn't good enough he must discard it. Self-criticism is part of this moral imperative, and has always been. It is the same whether you write a page or whatever you do; if it isn't good enough, you have to start again. It's as simple as that, isn't it? I once said it is a game which has only one rule, and the rule is that as long as you can think you can do better you must do it, even if it means starting again. Of course, from that point of view I don't think the situation has changed very much. I am sure that has always been the case.

Gormley **We keep touching on this problem of subjectivity and I don't think we are ever going to nail it down, but we have to replace the certainties of symbolism, mythology and classical illusion with something that is absolutely immediate and confronts the individual with his own life. Somehow truth has to be removed from a depicted absolute to a subjective experience, where value transfers from an external system that might be illustrated to one in which individual experience is held and given intensity.**

Gombrich I think your faith is a very noble one. I don't for a moment want to criticize it. The question with every faith is whether it holds in every circumstance, and that is a very different matter, isn't it?

Gormley **I think the idea of style as something that is inherited and with a kind of historical development now has to be replaced by an idea of an artist responsible to himself, to a language that may or not be conscious of historical precedent.**

Gombrich Quite, but there is a problem in your faith; would you expect from now on every artist to do what you do? Surely not.

Gormley **No, no.**

Gombrich Exactly, so it's only one form of solving the problem, isn't it?

Gormley **I think that we can no longer assume that simply because the right subject matter or the right means are being used that there is value in an artist's project. I think that the authority has shifted from an external validation to an internal one and I would regard that as the great joy of being an artist. The liberation of art today is to try to find, in a way, forms of expression that exist almost before language and to make them more apparent. I think that in an information age, in a sense, language is the one thing that we have plenty of, but what we need is a reinforcement of direct experience.**

Gombrich I fear this is a false trail; people always say if it could be said it

**Fathers & Sons, Monuments
& Toys, Gods & Artists**
1985-86
Lead, plaster, fibreglass, air
Large figure, 245 × 57.6 × 48 cm
Small figure, 108 × 24 × 22 cm

wouldn't be painted and things of that kind. It is a triviality. Language serves a very different purpose. Language is an instrument, was created as an instrument. Cavemen said 'come here' or 'run, there are bison about', I mean it's quite clear that language is an instrument. Painting a bison is a very different thing from talking about a bison. Language is in statements, art is not. Language can lie. I would say that the majority of experiences are inaccessible to language, but it is astounding that some are.

Gormley **I agree with your idea that in some way language is an orientation, but the point is that once you have oriented yourself, you then have to leap, you have to go somewhere. And then the question is whether you go into the known or into the unknown.**

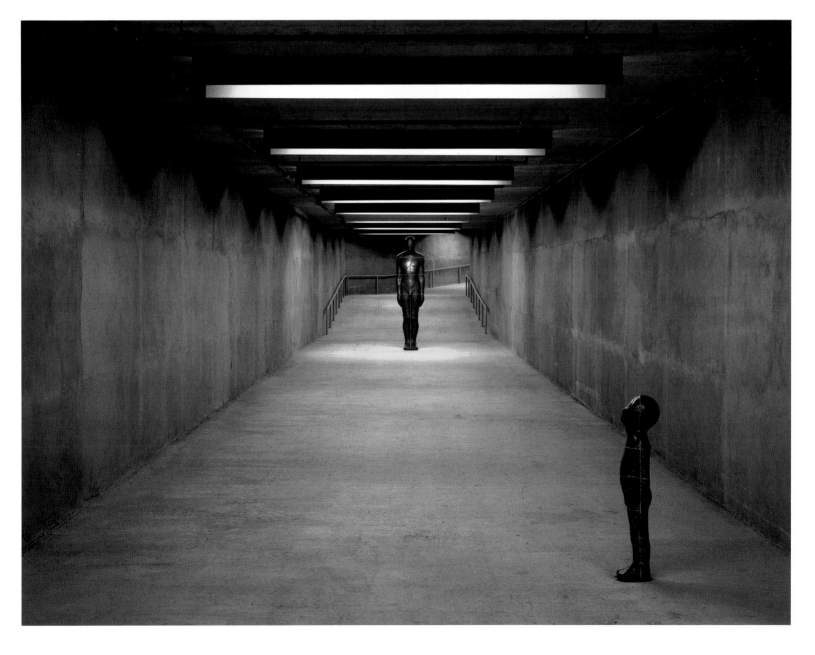

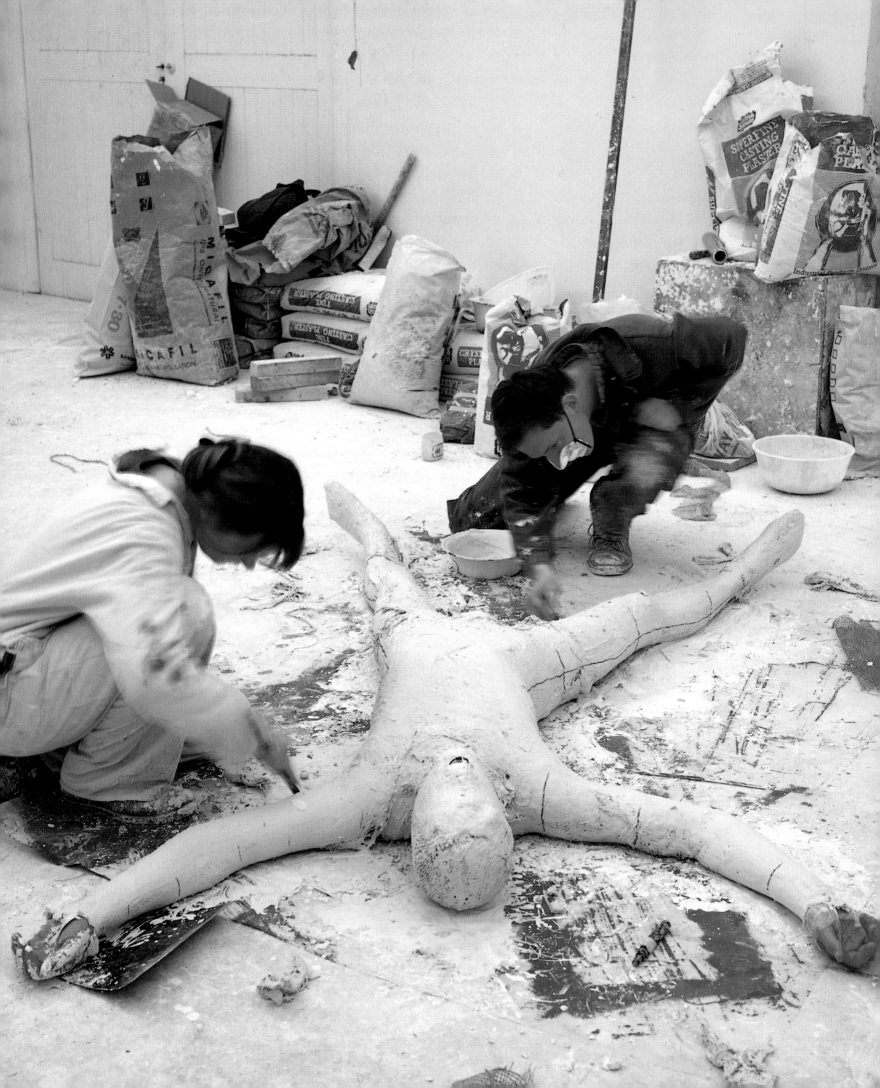

Contents

Learning to See III
1993
Lead, fibreglass, plaster, air
218 × 69 × 51 cm
Collection, Hoffmann Foundation,
Dresden

I

To Meister Eckhart, art was religion and religion art. Artistic form, in his view, was a revelation of essence, a kind of revelation that is both living and active. 'Work', he wrote, 'comes from the outward and from the inner man, but the innermost man takes no part in it. In making a thing the very innermost self of a man comes into outwardness'[1]. The act of making, at its most creative, happens when the self and will are at rest; in that respect, therefore, it is impersonal.

Ananda Coomaraswamy, in his classic book, *Transformation of Nature in Art*, draws some significant parallels between Eckhart's thought and traditional Indian aesthetics. He explains that in India the formal element in art is considered to be a purely mental activity, and that the idea of 'pramana', which implies the existence of 'types' or archetypes, is the basis of properly conceived design. 'Sadrsya', the correspondence of mental and sensational factors in a work of art, is at its heart.[2] What Eckhart, a medieval Christian mystic, and Indian aestheticians have in common is a belief that reality becomes perceptible when the intelligible and the sensible meet in the unity of being, one that is continuous and touches on the transcendent. This unity, like that achieved through yoga or certain mystical practices, is the realization of identity of consciousness with the object of love or attention.

Much of Antony Gormley's art is based on his understanding of Western and Eastern spiritual traditions, and his work resonates when it is placed in this context. Like Eckhart – or, indeed, like Joseph Beuys – Gormley believes that the artist is not a special kind of man, but that every man is a special kind of artist. He would have some sympathy with Eckhart's notion that it as an 'artist-scholar' that man prepares all things to return to God, in so far as he sees them intellectually and not merely sensibly. He works with 'types', with universals, and yet he roots his work in subjective experience. Besides, like classical Indian works of art, Gormley's sculptures have an identifiable 'rasa', or 'essence', with which the viewer must identify, and which can lead to a sense of infinite timelessness. But what concerns Gormley, more than anything else, is the paradoxical manner in which man, while containing infinite space, is also contained by it.

Gormley's project, despite its metaphysical underpinnings, is far from otherworldly. His sculpture deals with what he sees as the 'deep space' of the interior of the body, yet he is also concerned with 'touch as gravity' and 'gravity as the attraction that binds us to the earth'. Its key strength, perhaps, lies in the artist's determination to accept nothing until it has been lived and internalized. Gormley's work is structured and methodical, preconceived to a certain point, and then realized in the process of making.

If it can be said that Gormley's lead body cases create tension between the perception of a body within space and that of a space within the body, then a piece such as *Learning to See* tends towards the latter side of the correspondence. As he has explained, with reference to its genesis, 'I have acknowledged the eyes, which I normally avoid. They are closed but suggest that I am becoming conscious of the space within the body'.[3]

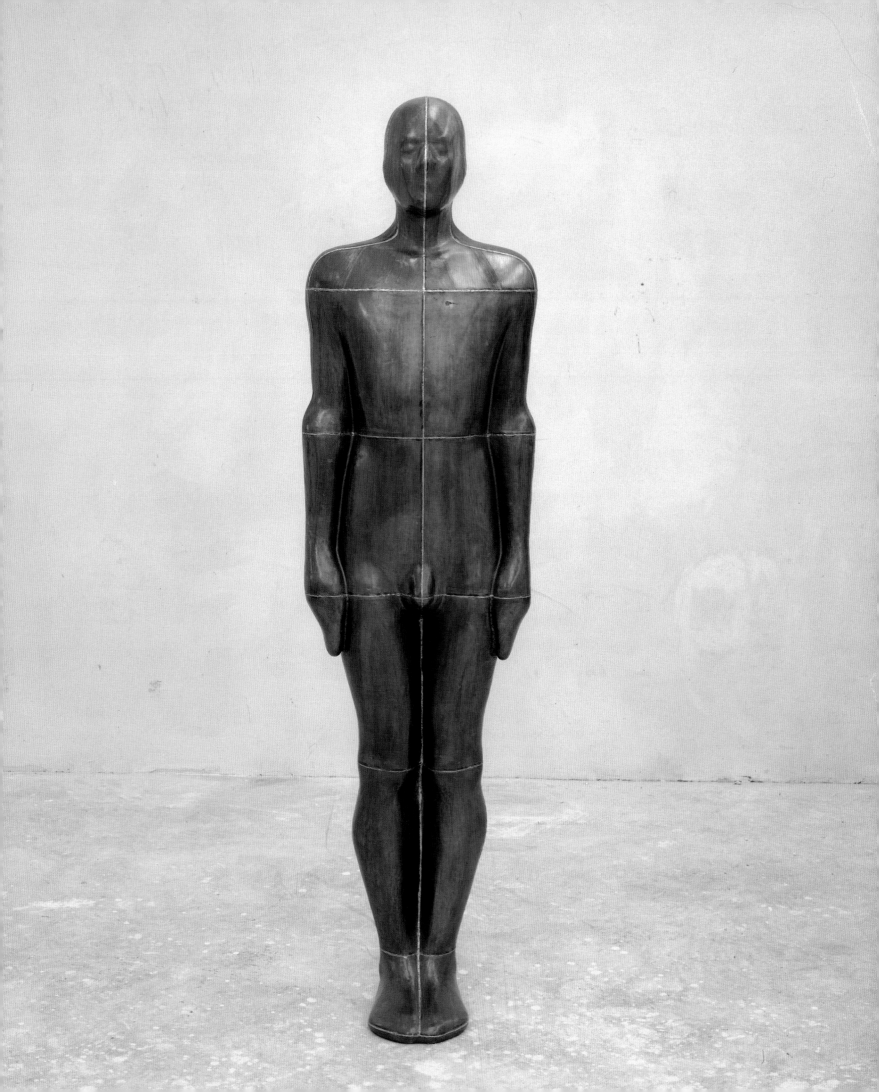

Yet what Gormley has referred to as a 'dynamic' between the body as 'a thing' and as 'a space' could just as readily be seen as an unresolved conflict. In many interviews and writings he has alluded to his belief that the physical body is inseparable from consciousness; sometimes he describes it as a kind of prison, with its various orifices the only conduits between the inner self and the outside world, and occasionally as a 'temple' of being. But although this vacillation between the reluctant acceptance of the body as a temporary home for the spirit and its enthusiastic celebration as one of the wonders of creation may be characteristic of the Catholic ethos in which Gormley was raised, it is not the only – and perhaps not even the main – source of that conflict.

The phrase 'Learning to See', as the title of a piece of figurative sculpture with closed eyes, suggests that the vision in question is inward, not outward. The work's leaden skin, which both seals and protects, allows for no interaction between outer and inner space; it is an impermeable membrane. Significantly, too, the artist has chosen to describe the sculpture as being made from 'air', as well as from lead and fibreglass, as if to stress that what we can't perceive with our eyes is very much an aspect of its construction. 'Seeing', in this context, might therefore be defined as 'insight'.

The word 'insight', coincidentally, is often used as the translation of 'vipassana', a Pali term which, in conjunction with 'bhāvanā', is the name given to the Buddhist meditation practice that Gormley studied for two years in India. This meditational method, based on awareness and attention, eschews metaphysical speculation and encourages the development of 'sati', or 'mindfulness', a kind of unselfconscious awareness of the present moment. Vipassana meditation brings attention to bear on the ways in which ideas and sensations arise and disappear; thus, it is claimed, detachment and freedom are generated. This, in part, is because all Buddhist teachings are posited on the acceptance of 'impermanence' and 'non-self' as laws of life: all things, sensations and thoughts are conditioned, relative, and interdependent. 'Desire', or 'craving', is the energy that keeps the circle of becoming in motion; right 'mindfulness' is one of the ways in which desire can be dissipated and the chain of 'causation' broken.

Gormley has spoken of the influence of Vipassana training on the making of his sculpture, especially in its stress on the development of 'awareness' of the body. The Buddhist idea of 'impermanence', however, is not quite so dominant in his thinking. Gormley's lead sculptures are not unambiguous in their effect on the viewer. Conveying an impression of weight and solidity, his sculptures seem as much the precise registrations of a fixed sense of self as impressions of a constantly mutable body. Nonetheless, as can be seen in the generic, anonymous form of the cases, Gormley also appears to be drawn towards a more impersonal conception of identity. It is here – not so much in a conflict between Christianity and Buddhism, but in the relation between 'I' and 'not-I' – that the energy of his work is born.

To Gormley, the body has a relation to the external space within which it exists as well as to the inner space it contains. And in an installation made for

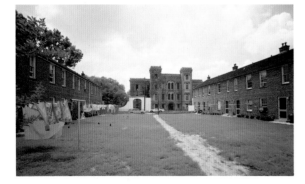

Old Jail, Charleston, exterior

'Places with a Past', a recent exhibition of site-specific art at Charleston, South Carolina, Gormley combined a series of works – *Host, Field, Three Bodies, Learning to Think, Fruit* and *Cord* – in order to explore that relationship. The Old City Jail, which contained and became part of the installation, could be described as having the shape of a body: the original rectangular structure is rather like a torso; its later octagonal addition, like a head. And in order to emphasize its parallels with his body cases, which are sometimes connected to the outside world through orifices, Gormley removed the boards and glazing that had sealed up the prison's doors and windows. This allowed light and sound to enter the prison, to enliven what had hitherto been dark and dormant, and to engage time as an active element in the installation. In the artist's words, 'the building became a catalyst for reflection on liberty and incarceration'[4].

The prison's physical structure, because its floor plan allows for the pairing of spaces, offered Gormley a rare opportunity to develop the dialectical oppositions and correspondences that are central to his project. On the second floor, *Field*, a set of terracotta figurines, faced a similar vast space that contained only *Three Bodies* – large metal spheres, made of steel and air, which the artist has described as 'like celestial bodies fallen from the sky'[5]. Above *Field* was *Learning to Think*, five headless lead body cases that were suspended from the ceiling, in a contradictory evocation of both lynching and ascension. The corresponding space held *Host*, a room containing mud and sea-water – 'The surface of the earth described in Genesis ... the unformed, the place of possibility, a

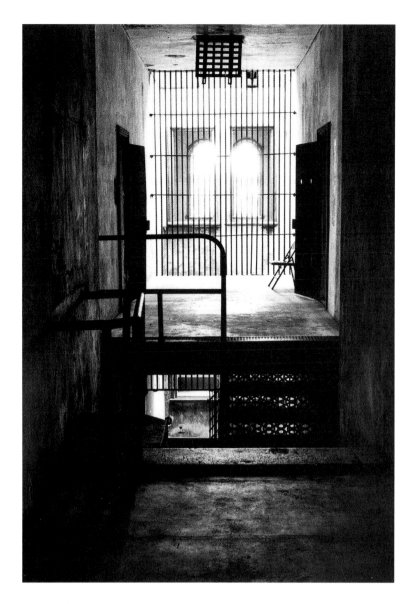

Old Jail, Charleston, interior

overleaf
top left, **Host**
1991
Mud, seawater
Depth, 13 cm

bottom left, **Field**
1991
Terracotta, approx. 35,000
figures
Variable size, 8-26 cm each

right, **Three Bodies**
1991
Steel, air
3 spheres, diam. 123 cm each

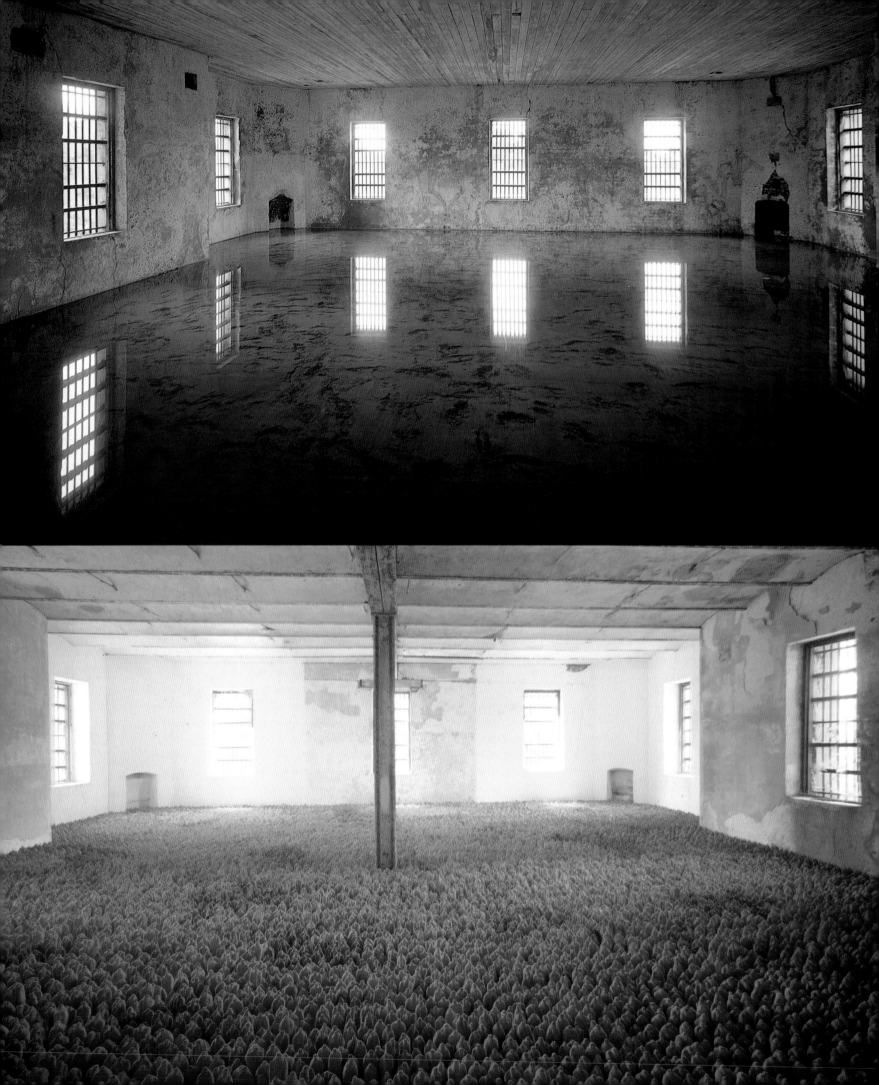

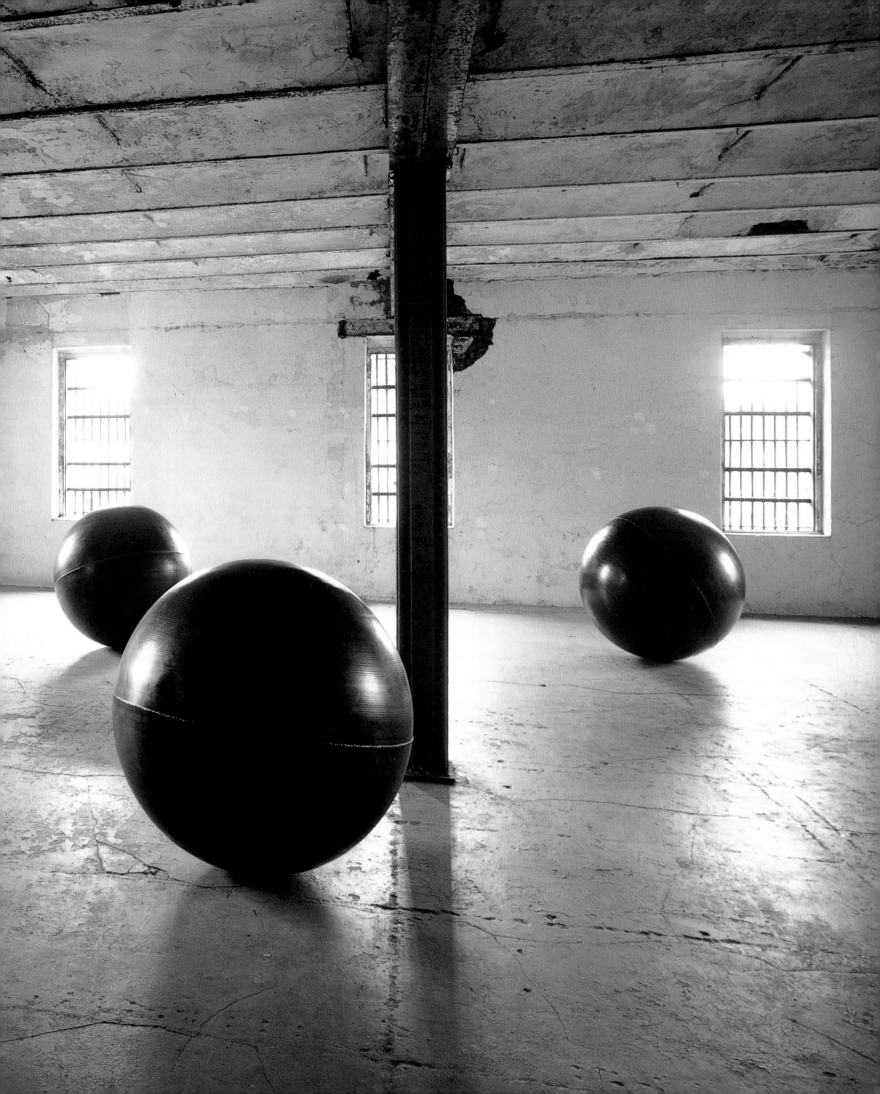

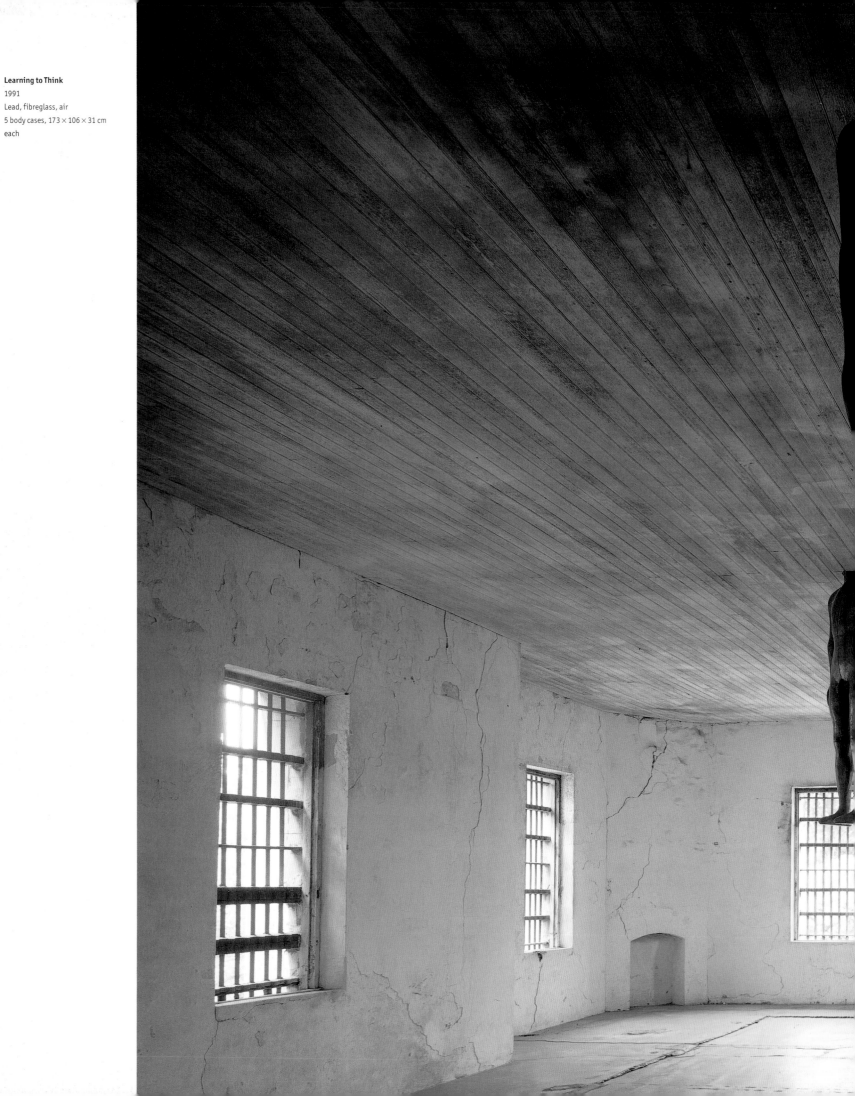

Learning to Think
1991
Lead, fibreglass, air
5 body cases, 173 × 106 × 31 cm
each

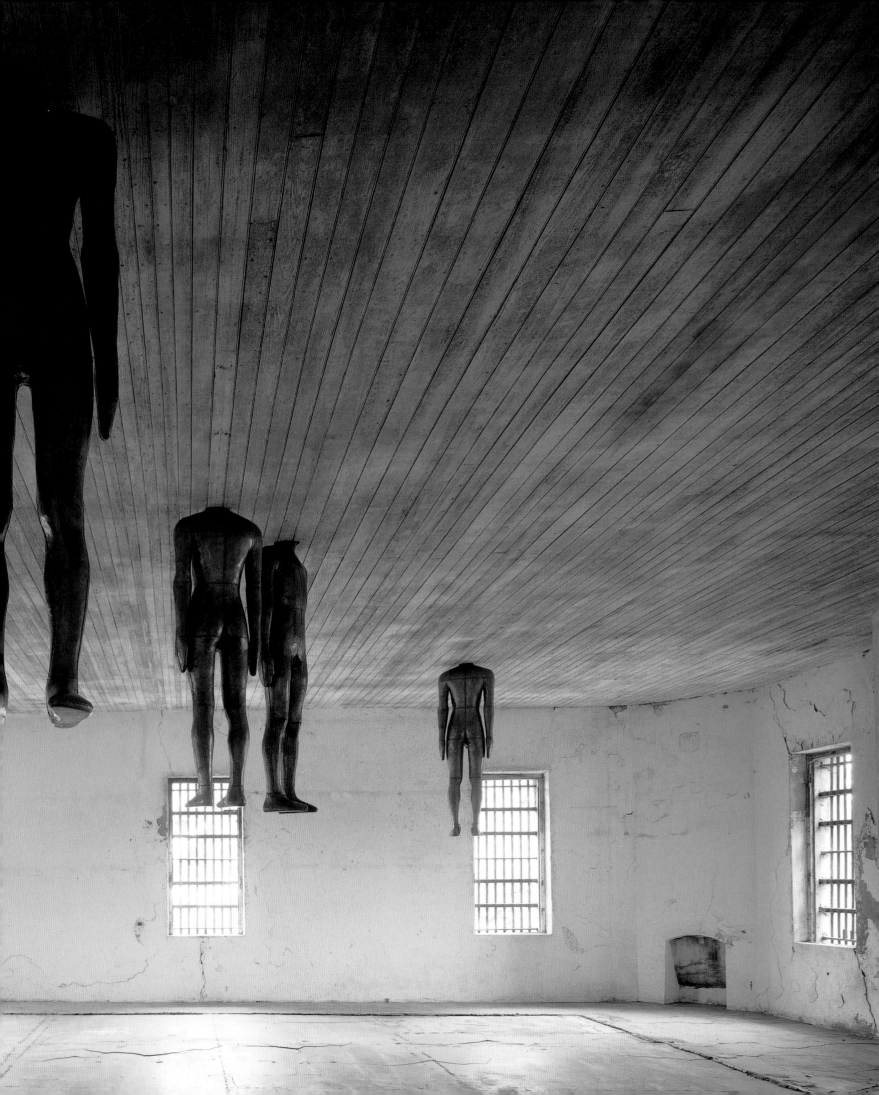

place waiting for the seed', according to Gormley[6].

In the octagonal extension, two related organic forms, *Fruit*, were hung on either side of a wall. Only one was visible at a time, in order 'to reconcile opposites not in terms of differentiation but by mirroring'[7]. Hidden from view, and at the centre of each sculpture, was a space once occupied by the artist's own body, linked to the other side, through mouth and genitals, by steel pipes. The final piece was *Cord*, made of many tubes inside one another – a kind of umbilical lifeline between the 'seen' and 'unseen'.

In this installation, one of great richness and complexity, Gormley brought into play the full panoply of his ambition. Working with lead and clay, as well as with the four elements, Gormley alluded to physical and spiritual containment, body and mind, outer and inner worlds, feeling and thinking, birth and death, growth and decay. And if the contradictions inherent in *Learning to See* give strength to the artist's conception of inner vision, the dualities evoked by the installation at Charleston are subservient to a sense of passage towards expansiveness. The emotional depth of the work can be ascribed to its refusal to exclude either the particular or the universal: it encompasses both historical specificity and a sense of shared human experience. In formal terms, this is achieved by the undermining of the Modernist notion of the self-referential object. While each of the elements of the installation can be separately contemplated, they are most meaningful when perceived as parts of a larger whole. In that sense, they are like parts of a body.

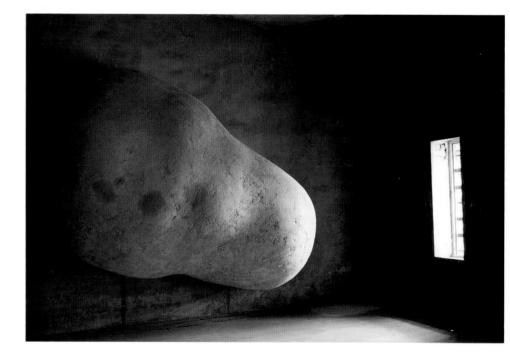

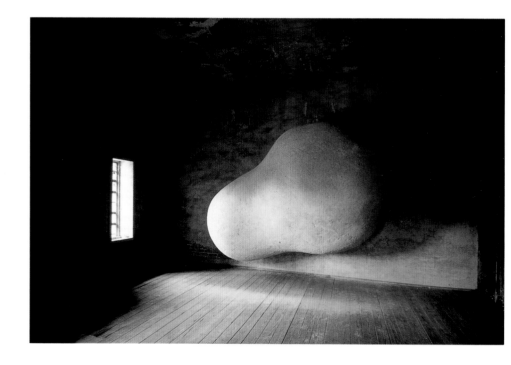

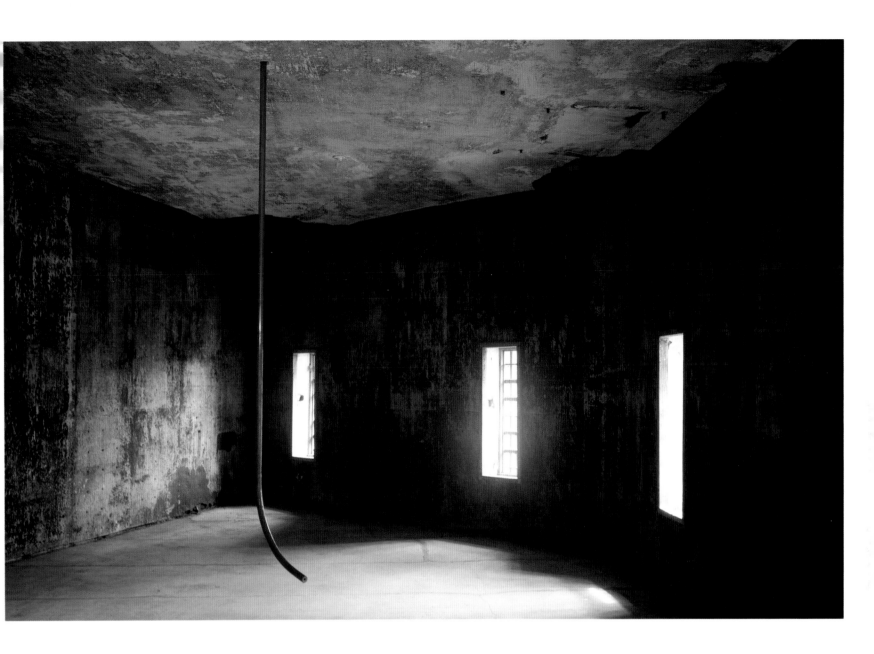

opposite, top and bottom, **Fruit,**
Parts One and Two
1991
Plaster, mica, oyster shell, jute,
wood, steel
370 × 215 × 120 cm

above, **Cord**
1991
Copper, plaster
340 × 0.4 cm

Edge
1985
Lead, fibreglass, plaster, air
25 × 195 × 58 cm

II

Maurice Merleau-Ponty, whose philosophy of phenomenology deeply influenced much art of the 1970s, has written about the 'dialectical imagination' that is marked by a Hegelian drive towards synthesis and synergy. Imagination, he believed, can have privileged access to the hidden dimensions of Being – to what, in his later writings, he calls 'the invisible'. This, he said, can be imagined but not seen; it is not non-existent but pre-exists in the visible. Every 'visible' dimension of being, for Merleau-Ponty, is correlatively connected to an invisible or imaginary dimension; he sought to establish the real and the imaginary as two separate but corresponding realms: separate on the level of ordinary being but corresponding on the level of fundamental Being. Such correspondence applied even to the human body – 'It is not the utilizable, functional, prosaic body which explains man: on the contrary, the body is precisely human to the extent that it discovers its symbolic and poetic charge'[8].

Gormley, like Merleau-Ponty, is much drawn to the idea of correspondence between the visible and invisible; he has also said that his interest in the body was aroused because embodiment, or being-in-the-world, provided him with a way of escaping from the dualism of dialectics. In other words, to Gormley the body is the articulation of meaning; it is that in which sense is given and out of which sense emerges[9].

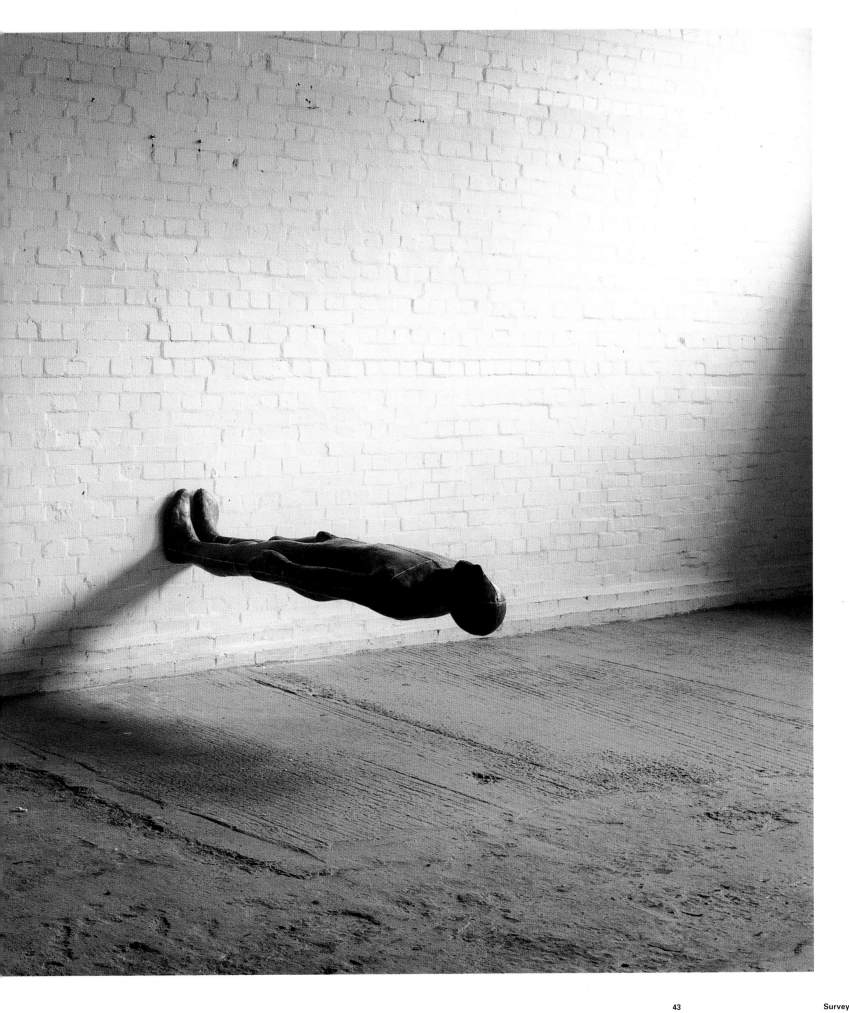

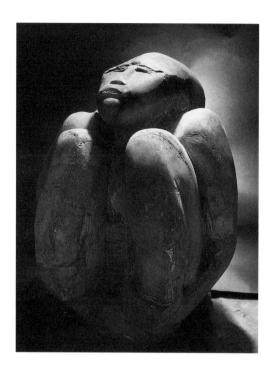

As Gormley understands it, the representation of the body in Western art, at least since the Renaissance, has been centered on the expressiveness of movement: the relationship between mind and body, or spirit and matter, has conventionally been expressed through the tension of man struggling against the forces of nature[10]. This expression, until the onset of Modernism, has always been mimetic. With abstraction, however, came the apparent end of the figurative tradition. Yet, as Stephen Bann has noted, the dominance of abstraction simply marked the end of mimesis, of the 'essential copy' of the figure. And Gormley, according to Bann, has set himself the task of extricating himself from Modernism without breaking the mold.

What Gormley has conspicuously retained from Modernist practice is its utopianism – he believes that art has the power to change things for the good. And being part of the generation that grew up with Minimalism, his thought, as already noted, has certain parallels in the phenomenology that was influential in the 1960s and 1970s. But what is also clear is the way Gormley reads Minimalism not as a rupture in Modernist sculptural tradition but as a reinforcement of its continuities.

As he has acknowledged, Gormley's encounter with Jacob Epstein's sculpture, *Elemental*, in 1981, was a crucial moment in that task of reintegration. This is interesting for two reasons. Firstly, it aligns Gormley with a non-conformist, figurative, strand in British art – one that extends from William Blake, through Eric Gill, to Stanley Spencer. (All of these are artists with whom he has a pronounced sympathy.) Secondly, *Elemental* has a certain primeval, or 'primitive'

quality: it recalls Jean-Luc Nancy's observation that 'the body was born in Plato's cave, or rather it was conceived and shaped in the form of the cave: as a prison or tomb of the soul, and the body first was thought from the inside, as buried darkness into which light only penetrates in the form of reflections, and reality in the form of shadows'[11]. *Elemental* suggests heaviness, slow awakening, and enclosure. It is about beginnings.

While Epstein, in the 1940s, found himself somewhat isolated in his rejection of the Modernist abstraction of Barbara Hepworth and Henry Moore, his determination to restore more 'human' values to British art was not unique. For the best part of two decades after World War II, figurative and humanist work was dominant in the visual arts; only after 1960 did leading sculptors, like Anthony Caro, revive interest in abstract, constructed sculpture. Nonetheless, when Gormley decided, after seeing *Elemental*, to make sculptures that more vividly reflected his own feelings, his shift in direction was unusual: new British sculpture in the early years of the decade was predominantly remarkable for its 'urban' sensibility. Tony Cragg and Bill Woodrow worked with the detritus of contemporary life; Richard Deacon and Alison Wilding had more formalist interests. Gormley's concerns, however, like those of Anish Kapoor, were described at the time as being centred on 'the mystery and wonder of creation, the cycle of life itself and the dichotomy between the physical and the intellectual ... '[12]

Lynne Cooke, writing about Gormley's work during that period[13], perceptively recognized its idiosyncrasies. Gormley, she observed, chose to

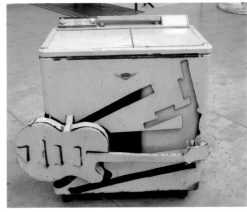

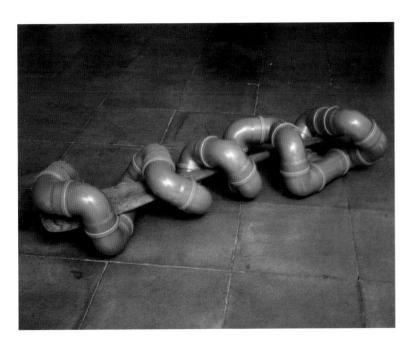

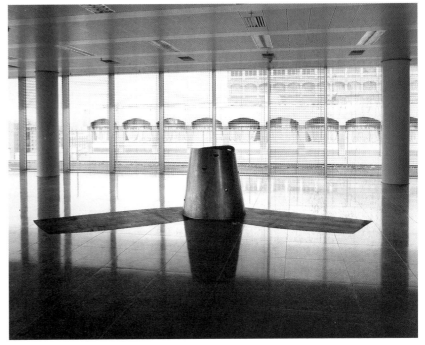

top to bottom

Bill Woodrow
Twin Tub with Guitar
1981
Washing machine
76 × 89 × 66 cm

Tony Cragg
Paddle
1984
Plastic angle pipe and wooden
paddle
34 × 153 × 42 cm

Alison Wilding
All Night Through
1986
Leaded steel, brass, rubber
103 × 500 × 113 cm

Anish Kapoor
1000 Names (No.s 22 to 26)
1981
Wood, gesso, pigment
Five objects,
122 × 183 × 183 cm overall

right, **Pompei figure**

far right, **Digambara Jina**
850-900
Copper alloy
h. 22.5 cm

bottom, **Jacob Epstein**
Lazarus
1947-48
Hoptonwood stone
h. 254 cm

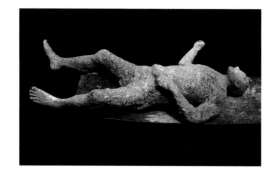

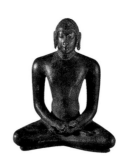

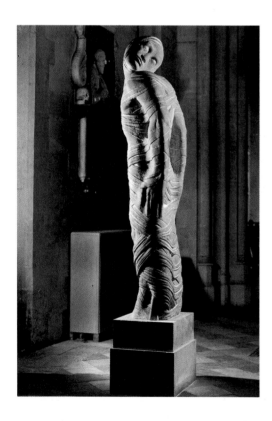

represent 'rudimentary' and 'elementary' experiences, which were neither primitive nor archetypal. Nor were his figures recognizable individuals: 'his casts are not like George Segal's, whose emphasis on modern dress and contemporary contexts they do not share, nor are they in the expressive tradition of Rodin, whose broken surfaces present the body as a "mirror of the soul"'. His body cases were not 'surrogate human beings'; rather, she noted, Gormley's body casts are 'containers', a difference that is emphasized by the joins and welds on their surfaces. His works being less than comfortable in a Modernist context, she suggested that it might be more appropriate to relate them to Indian sculpture and iconic Western art. Gormley's images, Cooke proposed, should be contemplated, not interpreted, and – crucially – brought to life by the viewer's engagement with them.

This kinship with the ideals of Indian sculpture is not, of course, surprising; Gormley has spoken of his admiration for 6th century Jain sculpture and Southern Indian bronzes[14], remarking that he was much impressed by their 'stillness' (a quality that is possessed by the majority of his own body cases). In the same interview, Gormley also drew attention to the twin forces of will and containment that 'create' the feeling of stillness. He explained that, in order to hold a position long enough for the artist, Vicken Parsons, to cover him with clingfilm, followed by scrim and plaster, he makes a concentrated act of attention; then, gradually, the drying plaster becomes substantial and starts to hold him in place. The process, therefore, is a kind of mummification or entombment which, in time,

is followed by release.

Interestingly, Stephen Bann has noted, referring to Jacob Epstein's work of the same name, that 'Lazarus is indeed a precedent to bear in mind when looking at Gormley's sculpture, since the image of the decayed body brought suddenly back to life conflicts so decisively with the ideal, heroic tradition of sculpture which we derive from the Greeks'[15]. Gormley's project, he argues, is central to the revitalization of the figurative tradition, largely because of the 'dynamic relationship which (he) establishes between the work and its spatial context'. Concurrently, Gormley's concern is 'with moving beyond the barrier of appearance, and posing questions about our place in the created world'.

Elsewhere[16], Bann expands this line of thinking. With a work like *Lost Subject*, the viewer is able, he suggests, to establish a direct, unmediated relationship with Gormley's sculpture because it transgresses the line between reality and representation: the figures are 'body cases', cast from the artist himself. This is also a semiotic issue: the figure is an indexical sign, not a symbol. As an example of a comparable sign, Bann mentions the plaster molds taken from the bodies left in the earth of Pompeii after the eruption of Vesuvius. And although the title of the piece is partly a reference to the traditional *circe perdu* technique of casting, its main purpose is to alert the viewer to the importance of filling the 'loss' himself. It also reminds us that *Lost Subject* does not show an ideal body, in the classical tradition, nor is it expressively modernist. Instead, 'it is precisely a body conceived as the mediation between

below, **St. Allard's Foot**
1331
Reliquary

bottom, **Rise**
1983-84
Lead, fibreglass, plaster, air
30 × 58 × 190 cm

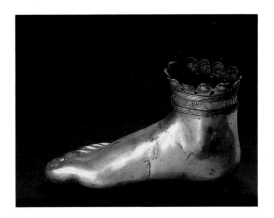

not show an ideal body, in the classical tradition, nor is it expressively modernist. Instead, 'it is precisely a body conceived as the mediation between interiority and exteriority – working through the indexical effect of surface'.

The crux of Gormley's sculptural strategy, according to Bann, is the evocation of 'presence'. As a comparison, he refers to a medieval reliquary which represents the foot of St. Allard. This reliquary, he argues, is both a mould and a container: 'It contains relics of the saint's foot; therefore the inside is crucial, even if we cannot see what is there. It also takes the outward form of a foot – not, however, the foot as perishable flesh and bone, but as part of the glorified body of the martyr'. Quoting the view of German philosopher Hans Georg Gadamer, that religious art – characterized by a deliberate confusion or

contagion between the object and referent – is the type of all art, Bann suggests that the traditional idea of representation is not a norm universally applicable to the arts. Gormley's wish to make sculpture that is 'a vehicle for feeling', he goes on, reflects his rejection of that convention and his proximity to a tradition of imagemaking 'where the prime consideration is not that a sculpture should stand for or represent the body and its parts, but actually indicate the presence of the body'.

In conclusion, Bann proposes that Gormley's work should not be read in modernist or formalist terms, but that it impels us to search for comparisons outside conventional areas of discussion. This also means, he notes, that his sculptures 'require us to look beyond the objects themselves to the systems of belief which underlie representation'.

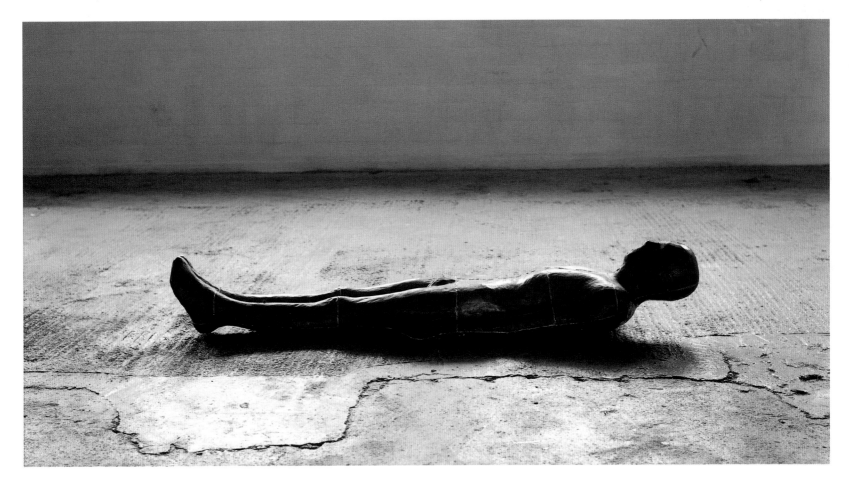

Lost Subject I
1994
Lead, fibreglass, air
25 × 145 × 228 cm
Collection, Israel Museum,
Jerusalem

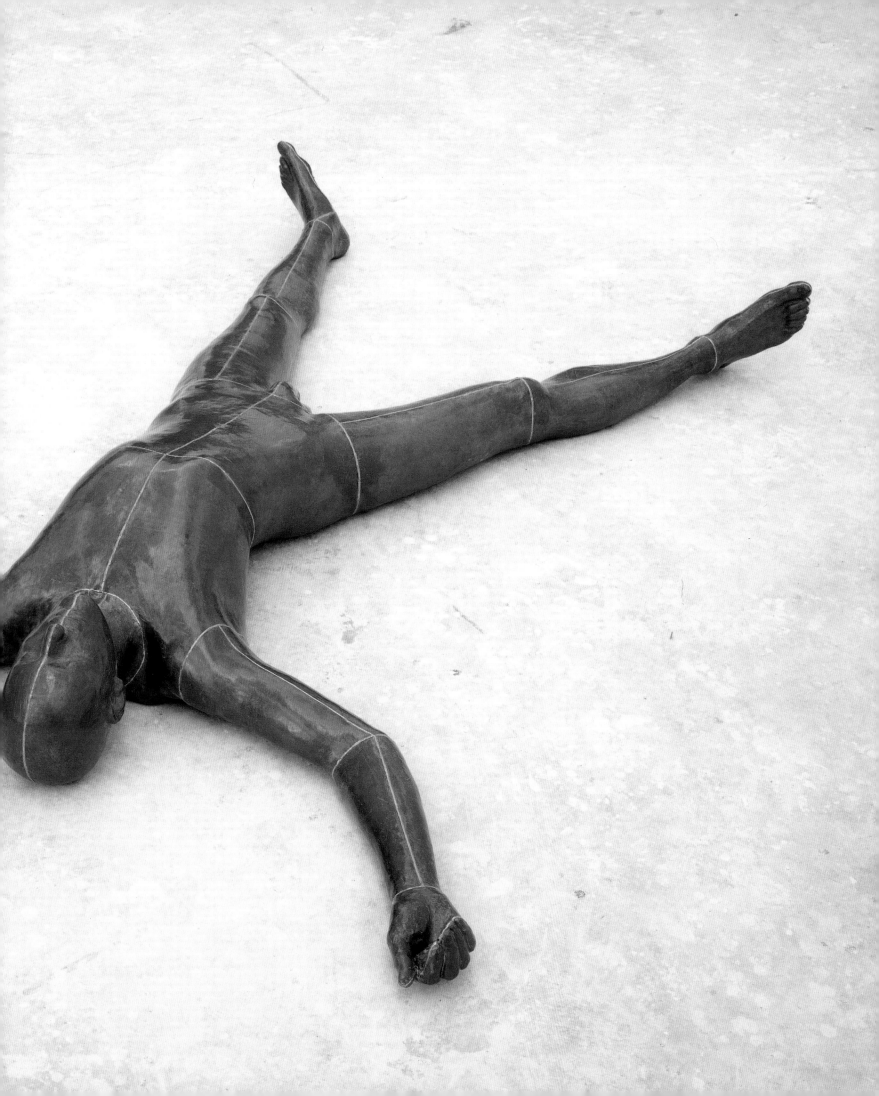

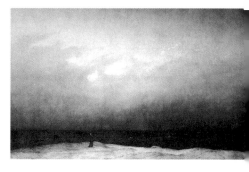

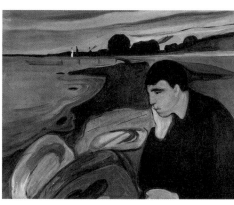

top, **Caspar David Friedrich**
The Monk and Sea
1808-09
Oil on canvas
110 × 171.5 cm

above, **Edvard Munch**
Melancholy
1894
Oil on canvas
81 × 100.5 cm

left, **A View: A Place**
1985-86
Lead, plaster, fibreglass
197 × 57 × 40 cm

III

Antony Gormley's sculptural project reveals an obsession with grand, emotive issues, such as birth, death, and man alone with his fate. In his works on paper, moreover, the artist's intense subjectivism becomes apparent: the body is not so much seen from the outside as felt from the inside; expressive of the physical and spiritual experience of being embodied on earth, they are about fear as well as joy. A typical figure in one of Gormley's drawings, as Michael Newman has written, 'is not standardized and ideal, but can be small or large; it is not isolated and complete in itself but interacts with the space and light and dark areas around itself. The world is a container for the body which in turn is a vessel … The body can be opened up, the inside extruded into the outside, or it can be joined with another body in sexual activity. The process of making the drawing is an analogy to the state of becoming and change in which we all live'[17].

A recurring image in Gormley's works on paper is a solitary person, turned away from the viewer and facing open natural expanses of water or sky. Were their mood one of harmony and self-loss, these drawings would be reminiscent of the sublimity of Caspar David Friedrich, but because their aura tends to be dark and anguished, they are more likely to recall the work of Edvard Munch. In contrast to his sculptures, which – at least in part – act as neutral receptacles for the viewer's own feelings and projections, the inner space of Gormley's drawings attest to the vulnerability of openness. They are predominantly melancholic.

Untitled
1985
Oil and charcoal on paper
25.5 × 34 cm

Home and the World
1985
Oil and charcoal on paper
25.5 × 34 cm

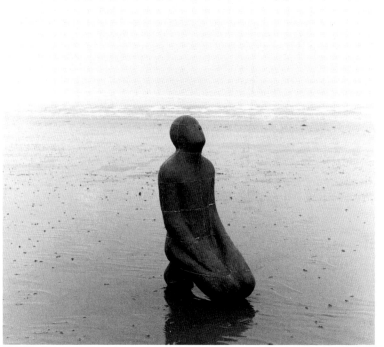

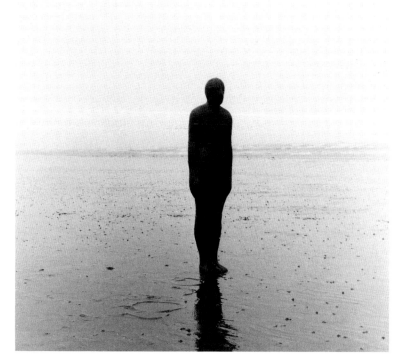

Land, Sea and Air II

above left, **Air**
1982
Lead, fibreglass
118 × 69 × 52 cm

above right, **Sea**
1982
Lead, fibreglass
191 × 50 × 32 cm

left, **Land**
1982
Lead, fibreglass
45 × 103 × 53 cm

Natural Selection
1981
Lead tools, fruits, weapons,
vegetables, objects
Length, approx. 10 m
Collection, Tate Gallery, London

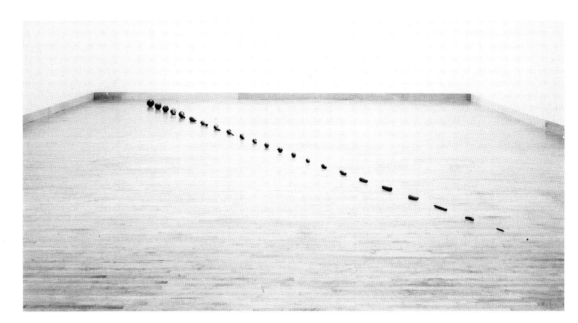

Gormley believes that this melancholia is symptomatic of the general malaise of contemporary Western society which also shows signs of fin-de-siècle disillusion and, albeit to a lesser extent, of pessimistic millenarianism. Shearer West, in her study of these phenomena[18], suggests that their characteristic is a heightened awareness of the passing of time and the sense that history is moving towards a final conclusion. These transitional periods, she proposes, seem to heighten general consciousness of disruptions, disasters, and catastrophes, with a consequent rise in millenium prophesies, utopian visions, and other 'spiritual' occurrences. Thus, at the end of the nineteenth century, following massive growth of European cities and the development of industrial technology, writers and artists of the 'aesthetic' movement rejected the dominant positivist ideology of the day, turning their attention to subjective, symbolic, and otherwise 'decadent' thoughts. A paradigm of the 'fin-de-siècle' mentality, according to Shearer, is Schopenhauer's notion, developed in *The World as Will and Idea*, that mankind is a mass of individuals whose wills are permanently in conflict, and whose only reliable solace is in a contemplative form of religious experience. This is a view with which Gormley would appear to concur.

One of the seminal pieces in the development of Gormley's sculpture is *Land, Sea and Air II*, in which the process of Buddhist 'awareness' is embodied by human figures in three elemental postures: they stand, kneel and crouch. In their original setting – on the seashore – one figure has his ear to the ground, another kneels with his head raised,

as if in awe or supplication, while the third stares out to sea. This configuration (in the artist's view, three is the 'beginning of infinity') evokes completeness and harmony: a sense of atonement with the self and with the world.

Because they are conceived in a positive spirit of stillness and awareness, it is significant that Gormley's body-cases are normally made of lead, a substance that is traditionally associated with Saturnine melancholy. Gormley has given varied reasons for his use of the material; lead, he explains, is ordinary, malleable, dense, undecaying, and permanent. It also has a mercurial property that allows for the creation of surfaces that subtly reflect light while absorbing it, a quality he is careful to maintain by not allowing it to oxidize. Important, too, are its protective qualities: lead is a shield; it is impenetrable visually and radioactively. (In earlier works, such as *Natural Selection*, in which natural and artificial objects were encased in lead, their insulation from radioactive fallout was central to the artist's intention. See page 126-27.) But lead is also heavy, poisonous, and chemically irreducible – qualities that are of relevance in its role in alchemical practice. Another association (which is also crucial in Anselm Kiefer's use of the same material) is its identification, in alchemy and the Jewish kabbala, with primordial matter.

Anselm Kiefer
Outpour
1982-86
Mixed media on canvas

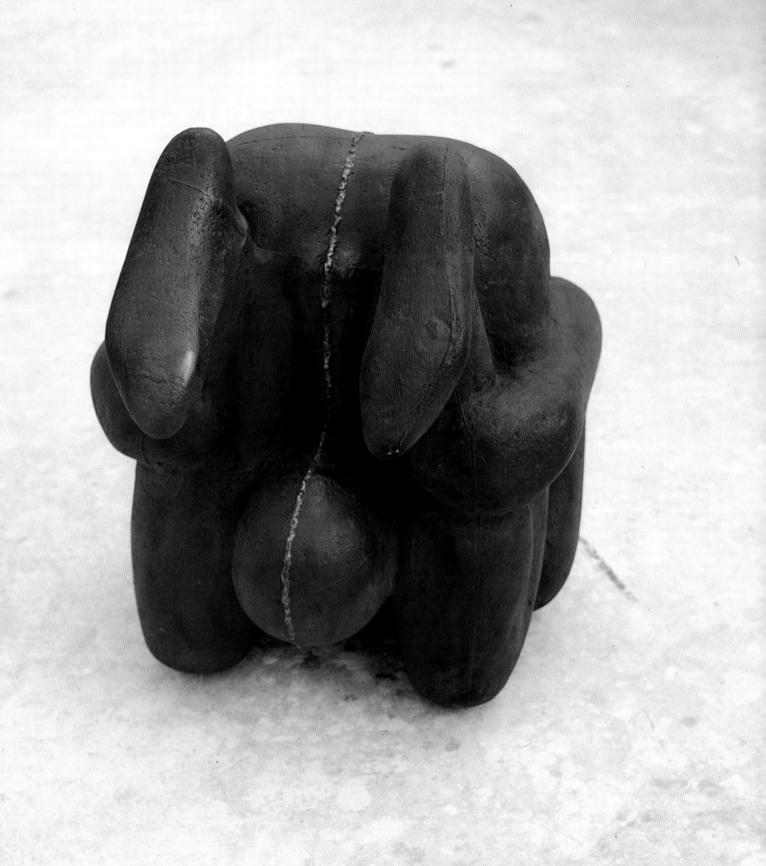

Word Made Flesh
1989
Iron, air
65 × 62 × 53 cm
Collection, Museum of
Contemporary Art, Los Angeles

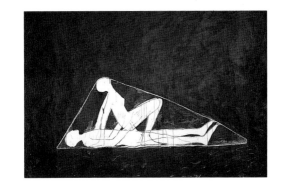

Untitled
1981
Charcoal and oil on paper
60 × 84 cm

While, from some perspectives, the lead body cases appear buoyant and optimistic, they can also be perceived as isolation chambers. They then become suggestive of retreat, either to the tomb or the womb, and seem to be founded on a wish to preserve, untouched, a fragile state of being. As James Hall has pointed out, Gormley's living death wish reminds one of Freud's comments about living burial in his 'Essay on the Uncanny'. For some people, Freud wrote, the idea of ' being buried alive by mistake is the most uncanny thing of all', and yet this 'terrifying fantasy' is only a transformation of another fantasy which has originally nothing terrifying about it at all – the fantasy of intra-uterine existence[19].

The notion of 'entombment', however, is not as negative as it may, at first, appear. In Christian belief resurrection follows death and, in a closer parallel to this reading of Gormley's body cases, alchemical thought describes the regression into the darkness of 'nigredo' as the necessary prelude to rebirth: in a sealed vessel the transformation of the 'prima materia' takes place. (Some commentators[20], interpreting alchemical ideas from a psychological perspective, have suggested that the alchemical sealed vessel is comparable to the state of introversion that acts as a container for the transmutation of attitudes and emotions.)

It is worth noting, too, that *Passage* and *Word Made Flesh*, which are among the more unusual of Gormley's body cases, echo ancient resurrection imagery. In the Egyptian tomb of Sethi the First, there is a drawing of a house guarded by two sphinxes in which the rebirth of the sun god takes place. The sun god is represented as an icthyphallic man lying on his back with an erect phallus. Around him is an Ouroboros, the snake that swallows its own tail. And another comparable work, *Matter*, in which a bulbous clay phallus appears to be growing of its own accord on top of a reclining figure, recalls an old alchemical drawing of the fallen Adam, resting on the ground with a living tree rooted in his loins[21].

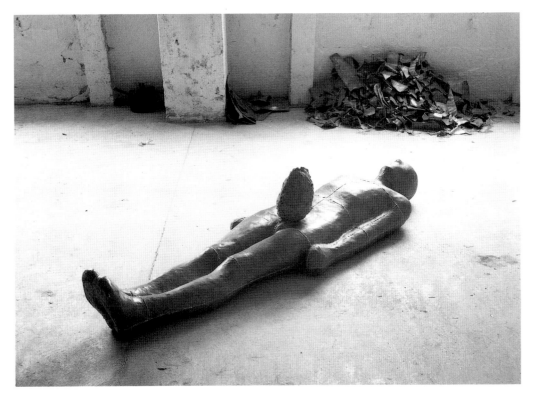

above, **Adam as *prima materia*,
pierced by the arrow of Mercurius**
14th c.

left, **Matter**
1985
Lead, plaster, fibreglass, clay, air
54 × 56 × 208 cm

Body
1990
Bronze, air
202 × 84 × 65 cm
Installed Casino Monte Carlo,
Monaco

Fruits of the Earth
1978-79
Lead, revolver, bottle of wine,
machette
Largest element, approx. 60 cm

IV

There is a shamanic aspect to the ritual of self-entombment that is the first step in the making of Gormley's body cases. Mary Douglas has pointed out that such 'rehearsals' of death, in tribal contexts, are expected to engender beneficial changes in external events. But as the shaman knows well, while punishments, moral pressures and a ritual framework can do something to bring man into harmony with the rest of being, fulfilment is imperfect so long as free consent is withheld. As Douglas describes it, 'escape from the chain of necessity lies only in the exercise of choice'. And 'when someone embraces freely the symbols of death, or death itself, then … a great release of power for good should be expected to follow'[22].

The willing embrace of death, of course, is a heroic undertaking, one that is not easily fulfilled. And although works like *Field* and *Lost Subject* reflect the significance Gormley places on self-abandonment, the latter's companion piece demonstrates the ego's reluctance to yield its position of primacy. According to the artist[23], *Close* illustrates a point of equilibrium between centrifuge and gravity; it represents the idea of a return to the body, and through the body a return to the earth. But as Gormley also acknowledges, the piece is full of contradictions. Does the body cling to the earth out of choice or necessity? Is the pose indicative of humble self-abasement or a desperate desire to cling on to the world ? Or, put otherwise, can the lead case be interpreted as a symbol of resistance to the Christian doctrine of glorification of the body in its materiality? Is Gormley's project nearer to the mythologies of the Greeks and the Romans,in which the body is involved in a process of metamorphosis, as opposed to self-transcendence[24]?

This possibility is suggested by several of the early lead pieces, such as *Fruits of the Earth*, which contain objects that, having been encased in layer upon layer of lead, turn into ovoid shapes; similarly, some of the later cases, like *Body*, expand to the point where they begin to lose definition. (They are subsequently transmuted into the large 'expansion' pieces that have barely any resemblance to the figures they 'contain'.) What these disparate works all reflect is the intimation that while there may be some kind of rebirth after the destruction of the self, this may not take the form of a recognisable 'resurrected' body.

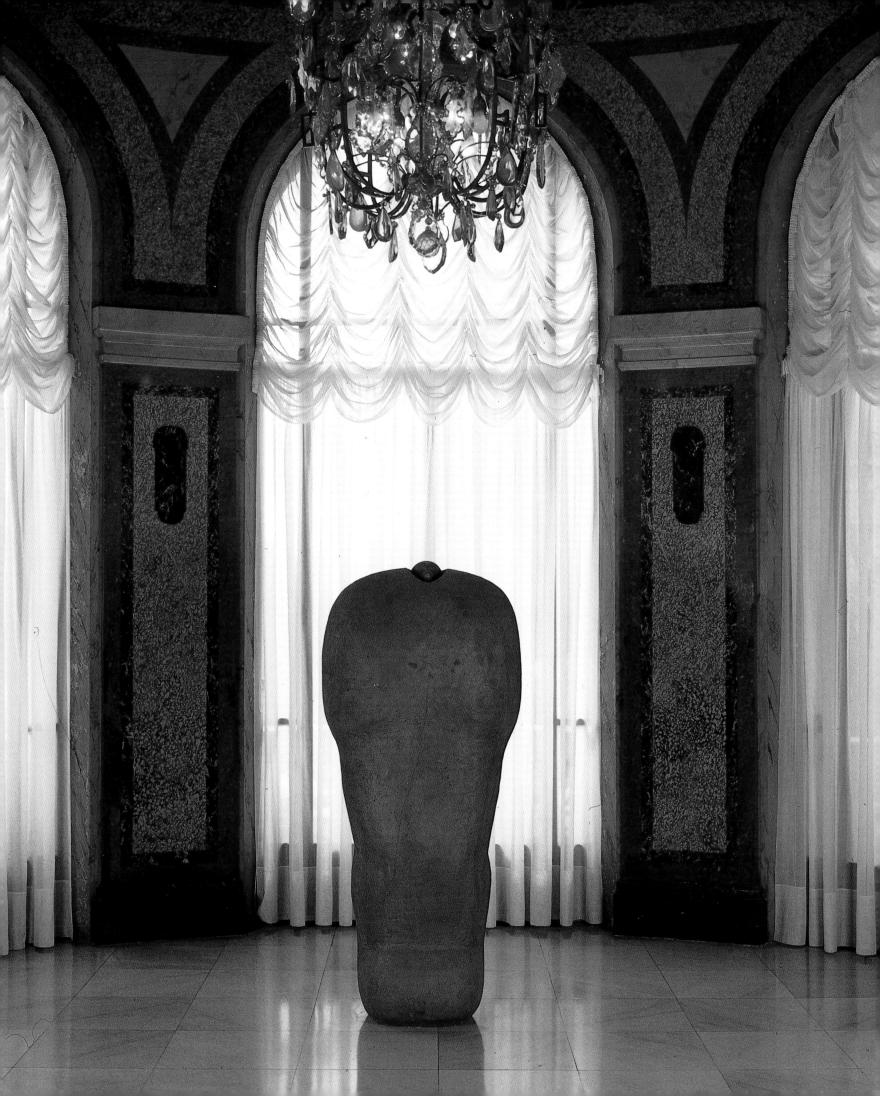

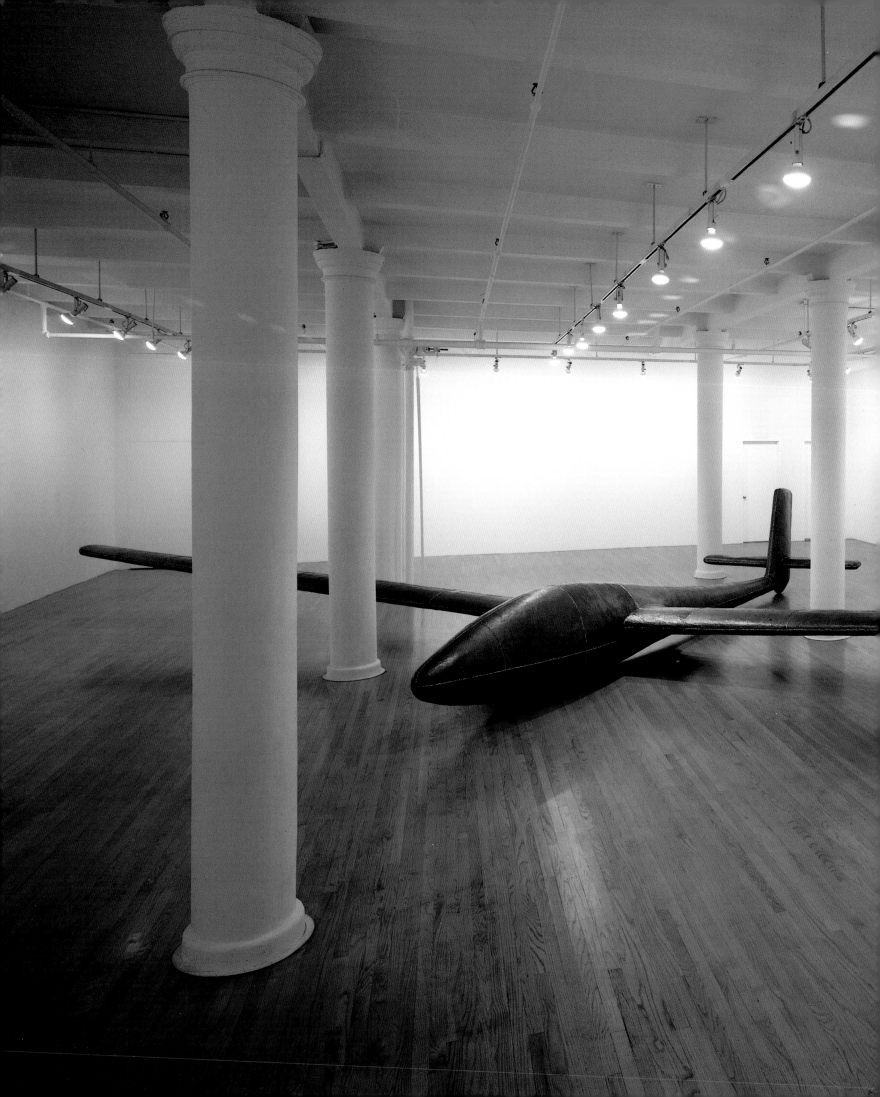

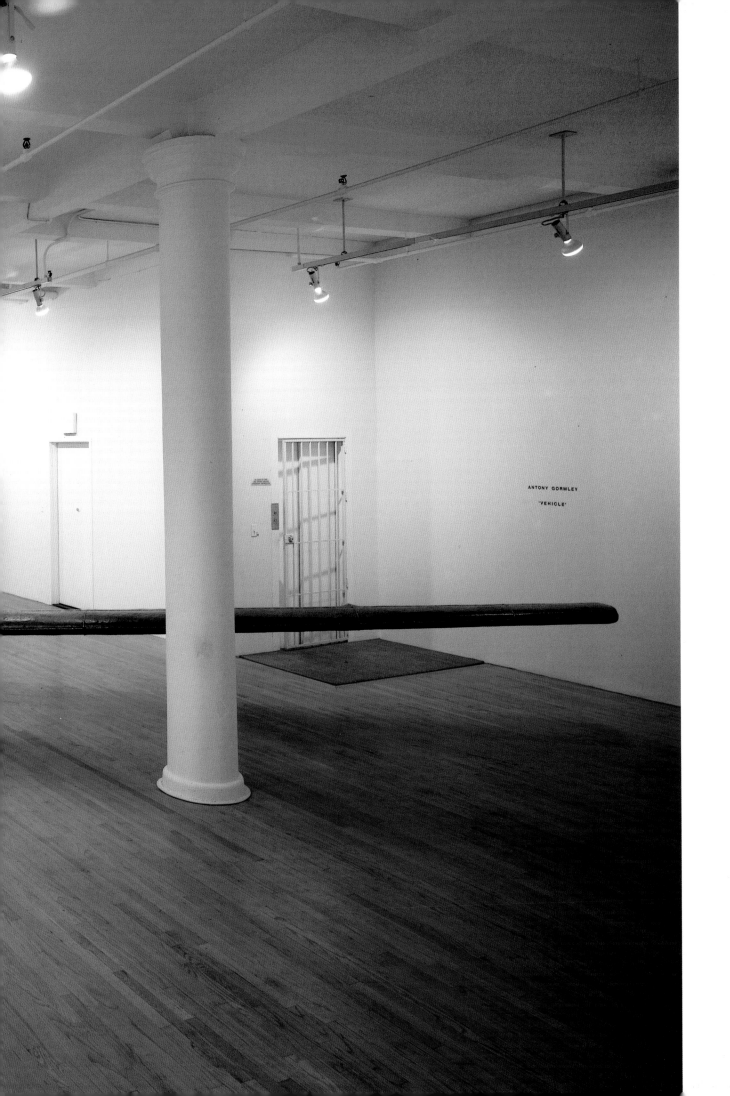

Vehicle
1987
Lead, fibreglass, wood, steel, air
147 × 750 × 1520 cm
Installation, Salvatore Ala Gallery,
New York

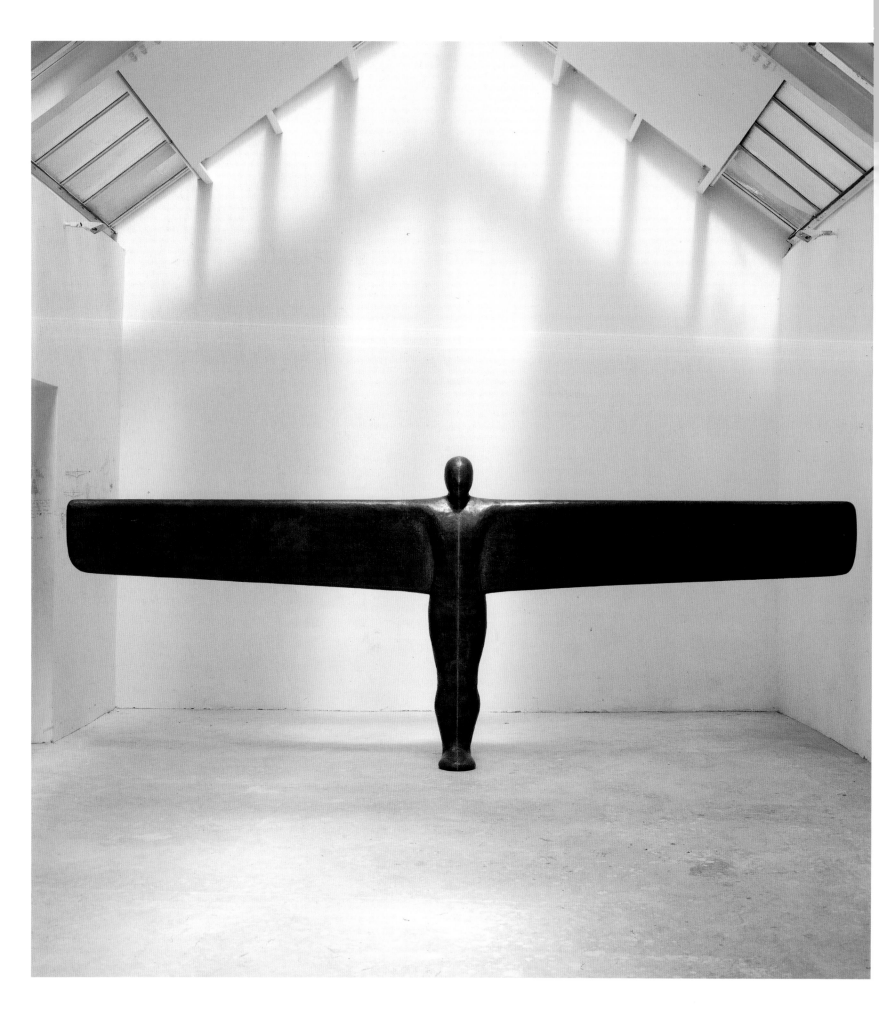

A Case for an Angel III
1990
Plaster, fibreglass, lead, steel,
air
197 × 526 × 35 cm

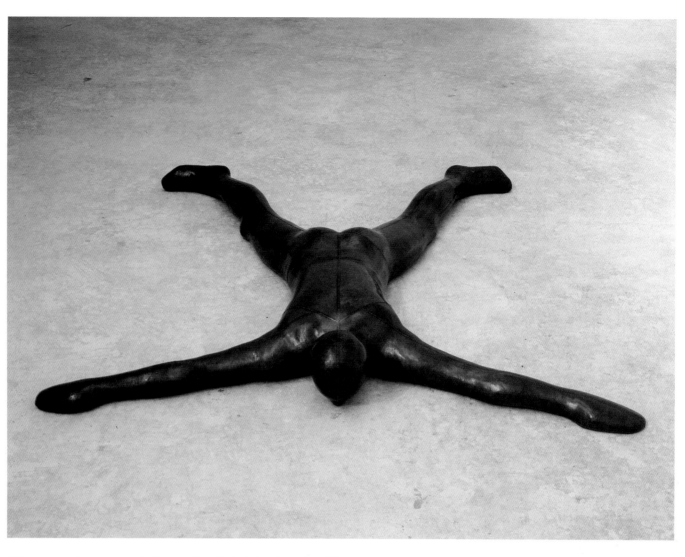

When Gormley speaks about his work as an 'attempt to materialize uncertainty' and 'to isolate some point of contact between consciousness and matter', and when he alludes to 'the dispersion of self through awareness'[25], he is closer to Buddhist thinking than to Christian faith. It has been suggested that a group of works of the late 1980s – a quartet of pairs of lead boxes surmounted by internal organs made of stone – refer to Indian theories about 'chakras', or energy centres[26], but while this may be so, yogic practice is not central to Gormley's project. What is vital, though, is the sense of composure and self-awareness that Buddhism teaches, for this is frequently manifested in Gormley's work. In *A Case for an Angel*, for instance, there is a fine balance between a feeling of reverence at the splendour of mankind's aspirations towards the infinite and the calm acceptance that, as human beings, we are necessarily grounded on the earth. Like *Vehicle*, *A Case for an Angel* is an image of the body as a continuum between spirit and matter; it has been described by the artist as ' a being that might be more at home in the air, brought down to earth ... It is also an image of somebody who is fatally handicapped, who cannot pass through any door and is desperately burdened'[27].

Close I
1992
Lead, fibreglass, plaster, air
25 × 192 × 186 cm

overleaf
Installation, Louisiana Museum,
Humlebaek (Denmark)
1989
l. to r., **Earth Above Ground;
Landing; Meaning; Body and
Light; The Beginning, the
Middle, the End; Present Time;
Fold**

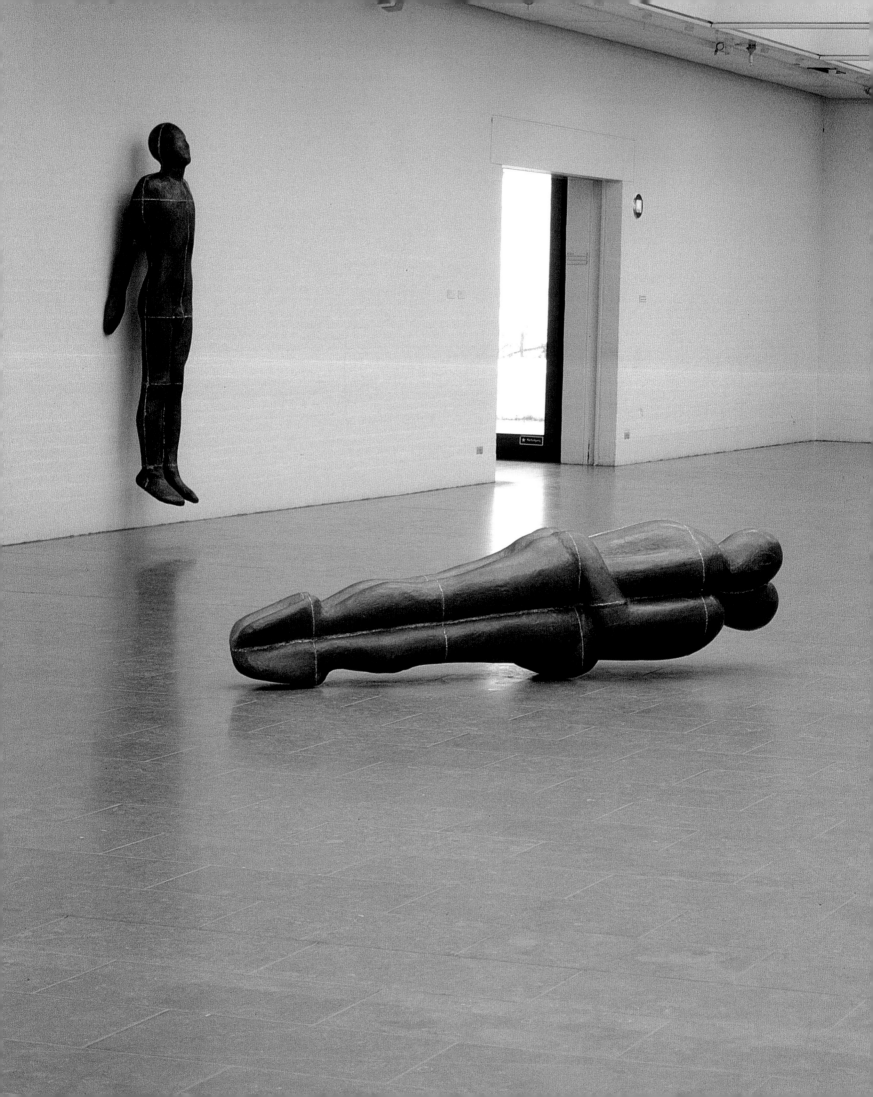

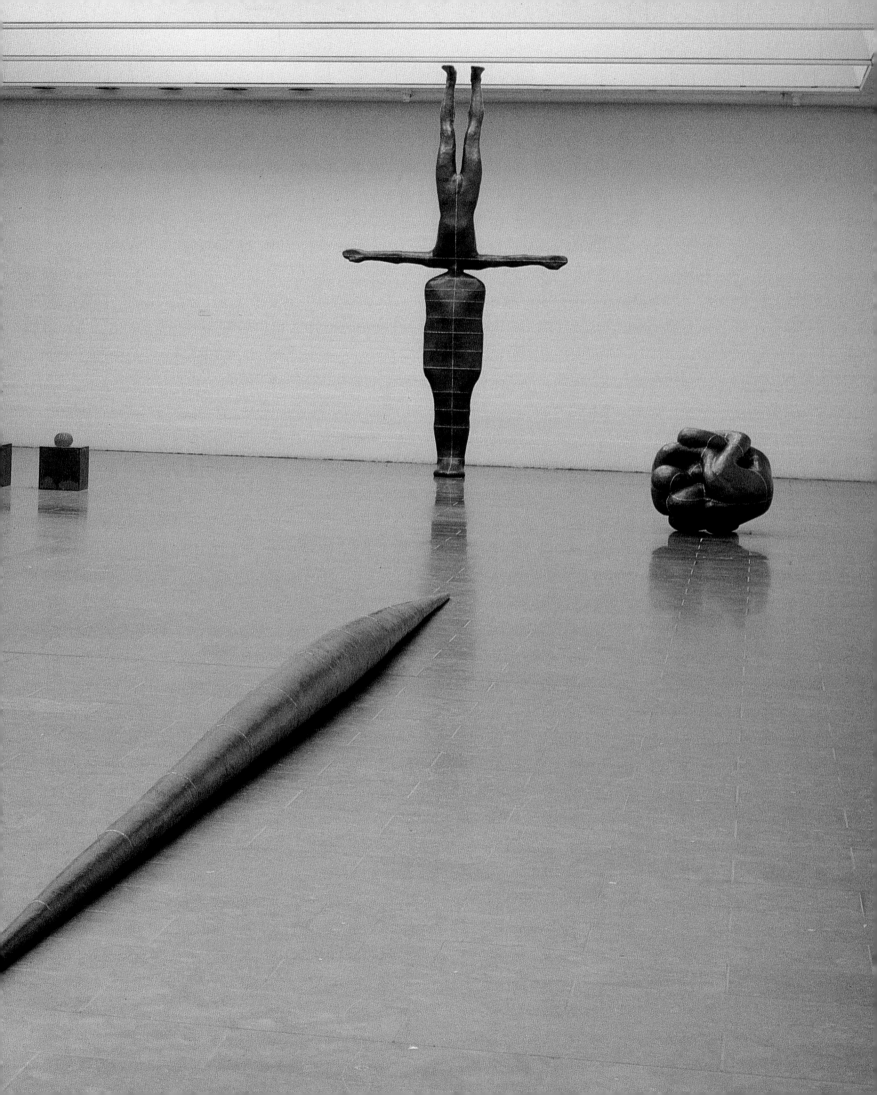

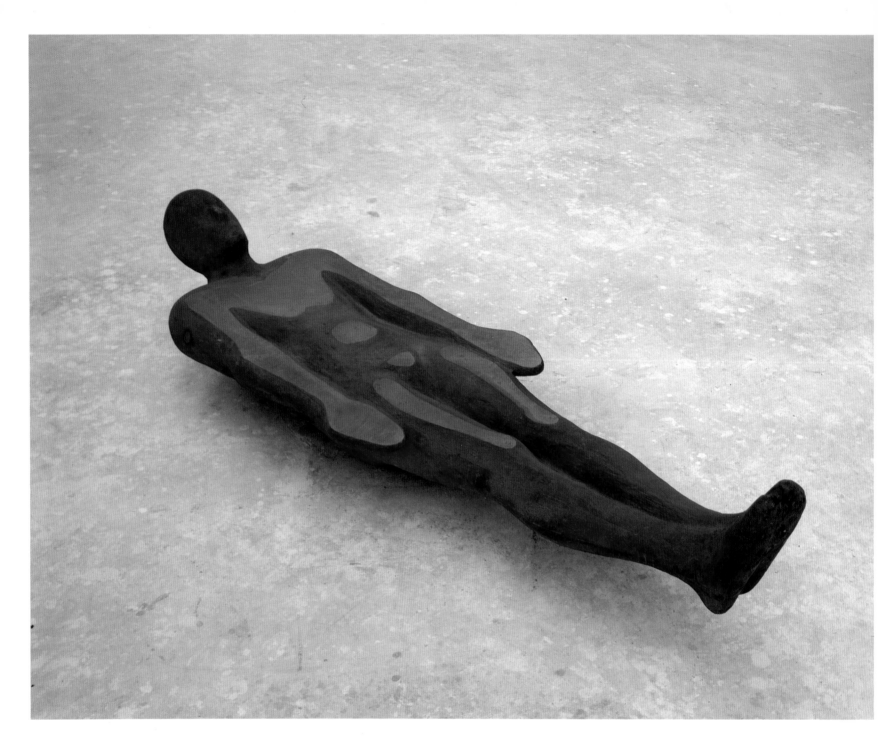

Offering
1992
Iron, air
195 × 64 × 40 cm

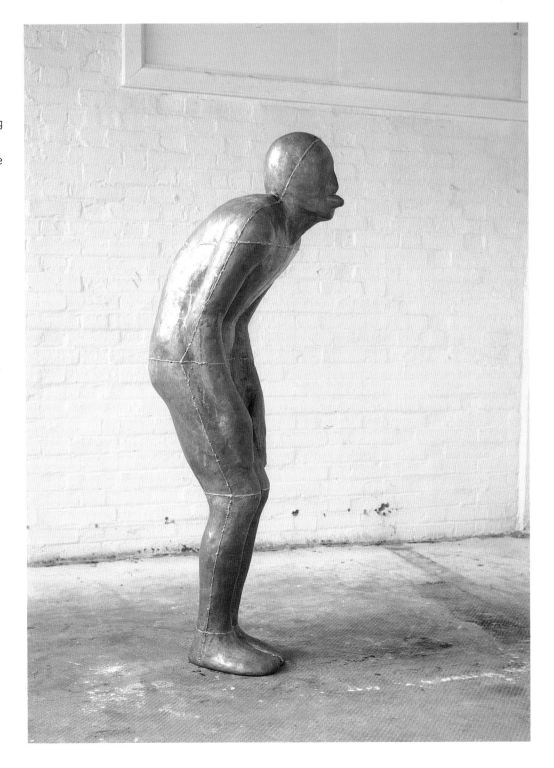

far left
Charles Ray
Family Romance
1993
54 × 96 × 24 cm

left
Robert Gober
Untitled
1991
Wood, wax, human hair, fabric,
fabric paint, shoes
21.6 × 39.6 × 108 cm

below
Address
1984
Lead, fibreglass, plaster, air
168 × 50 × 66 cm

In keeping with both Christian and Buddhist spiritual traditions, Gormley moves to the point where the familiar sense of self has to be abandoned; in a piece like *Field*, that threshold is intrinsic to the work. But the self is adamant; it does not readily lie down to die. Some of Gormley's more beautiful pieces are those, like *Rise, Earth Above Ground* and *Offering*, which most incisively objectify the self's will-to-live. In works like these, as in the recent *Testing a World View*, the overarching humanism of Gormley's project becomes apparent. We are embodied; we are conscious. Everything else is uncertain.

This struggle to come to terms with anxiety and uncertainty gives sinew to Gormley's project, as well as being the cause of unexpected moments of humour: as on a Möbius strip, to travel far enough along one approach to Gormley's work is to find oneself on its opposite. Thus *Word Made Flesh* and *Passage*, their similarities with alchemical imagery notwithstanding, are oddly transgressive; *Peer* and *Tree* have a wonderful sense of absurdity; *Address* is splendidly irreverent. Seen in this light, even the fruitlike 'expansion' pieces can appear scatalogical. From this aspect, Keith Haring, Charles Ray and Robert Gober can be seen to be Gormley's companions along the way; similarly, it becomes apparent that holiness and unholiness need not always be absolute opposites, for as Mary Douglas has observed, 'pollution symbols are as necessary as the use of black in any depiction whatsoever. Therefore we find corruption enshrined in sacred places and times'[28].

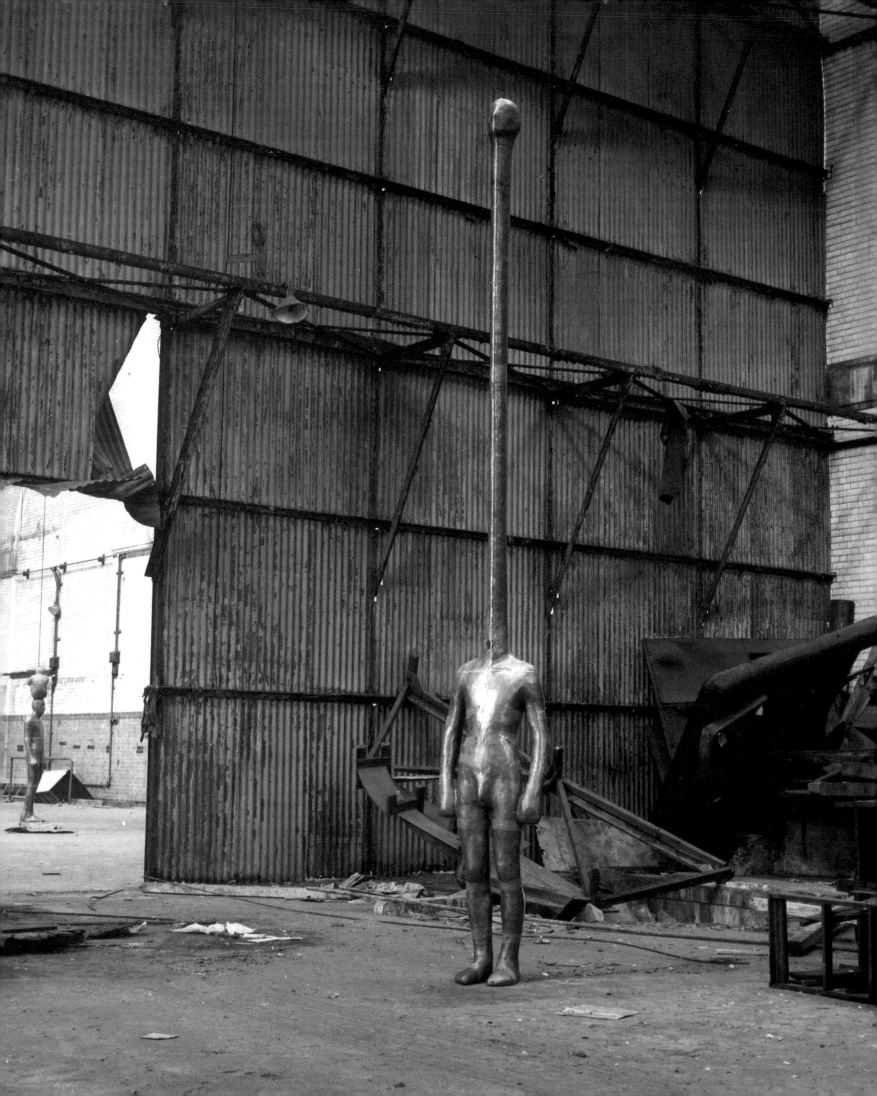

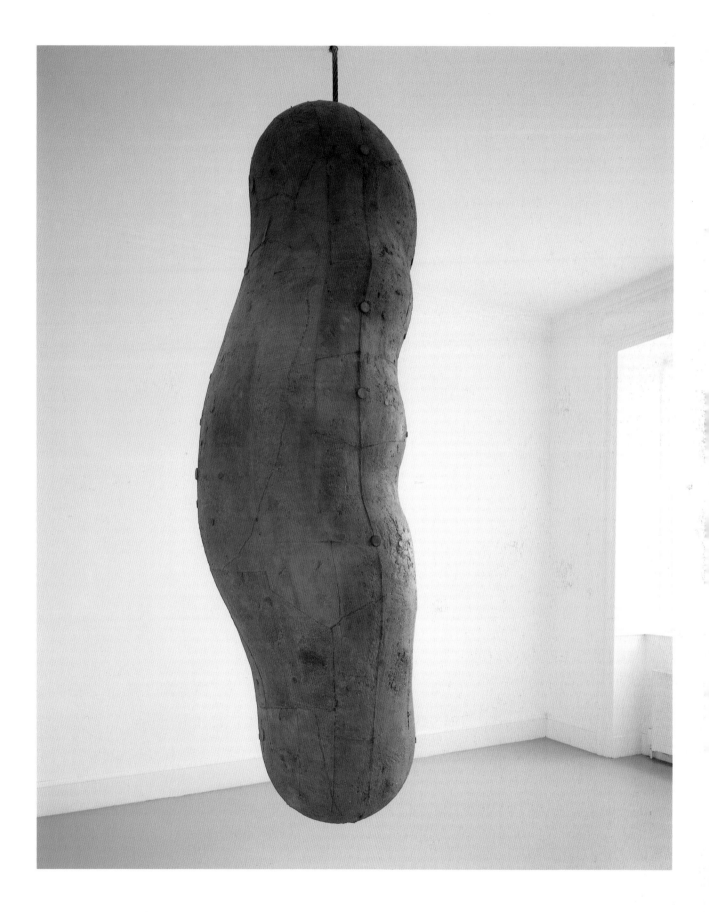

In an early presentation, Antony Gormley spoke about the fundamental premises on which he based his project[29]. His work, he said, called upon the active participation of the viewer; it tried to allow things and materials that already exist to become eloquent rather than generating expressive forms in their own right; and it was a re-presentation of structures in the world. At the end of the talk, in which he described the development of his sculpture upto and including the first lead pieces, such as *Natural Selection*, Gormley mentioned that his approach combined the intellectual and the physical, and that it was predominantly about 'cutting open' and 'making vulnerable'. Sacrifice, he said, seems to be necessary for things to be reborn and seen anew.

One of the more interesting aspects of Gormley's early work is the constant dialectic between the organic materials he employed and his formal strategies, influenced by Arte Povera and Minimalism. Some early works, like *Sleeping Places* and *Bed*, have formal links with Robert Morris, Carl Andre and Mario Merz, just as other pieces, such as *Breadline*, recall Richard Long. *Rearranged Tree*, for example, in which the artist cut up the trunk of a thirty-foot pine and set out the slices in a spiral, is an attempt to suggest a sense of time using the idiom of space. *Bed*, a piece that is both elegiac and humourous, contains two impressions of the artist's body – the spaces having been eaten out of an ordered 'mattress' of processed bread.

top right
Mario Merz
Alligator
1989
Glass, steel, neon numbers
Installed, MoCA, Los Angeles

above
Carl Andre
Equivalent VIII
1966
Plaster
229 × 12.7 × 68.6 cm

right
Richard Long
Clearing a Path, A Six Day Walk in
the Hoggar, the Sahara
1988
Photography and text
79.2 × 108 cm

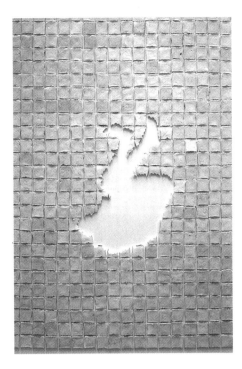

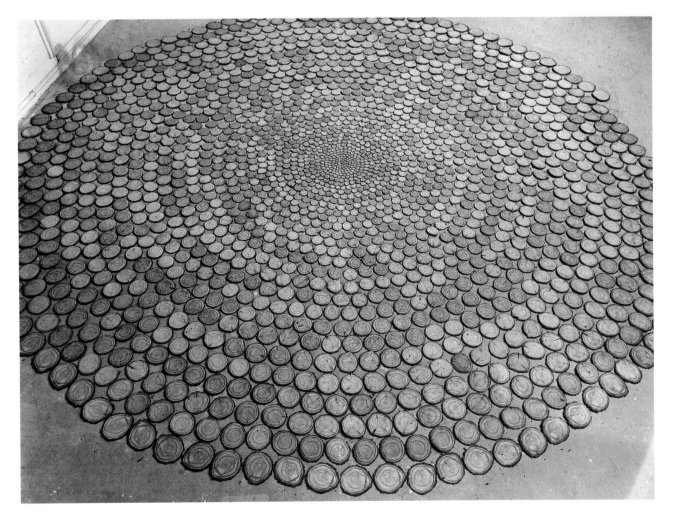

above, far left
Mothers Pride
1982
Bread, wax
305 × 190 × 0.8 cm

above
Bread Line
1981
Bread
1 × 1500 × 3 cm
Installation, 'Objects and
Sculptures', ICA, London,
also showing works by Richard
Deacon, Anish Kapoor and
Peter Randall Page

left
Flat Tree
1978
Larch wood
6.78 m diam.

overleaf
Bed
1981
Bread, wax
28 × 220 × 168 cm

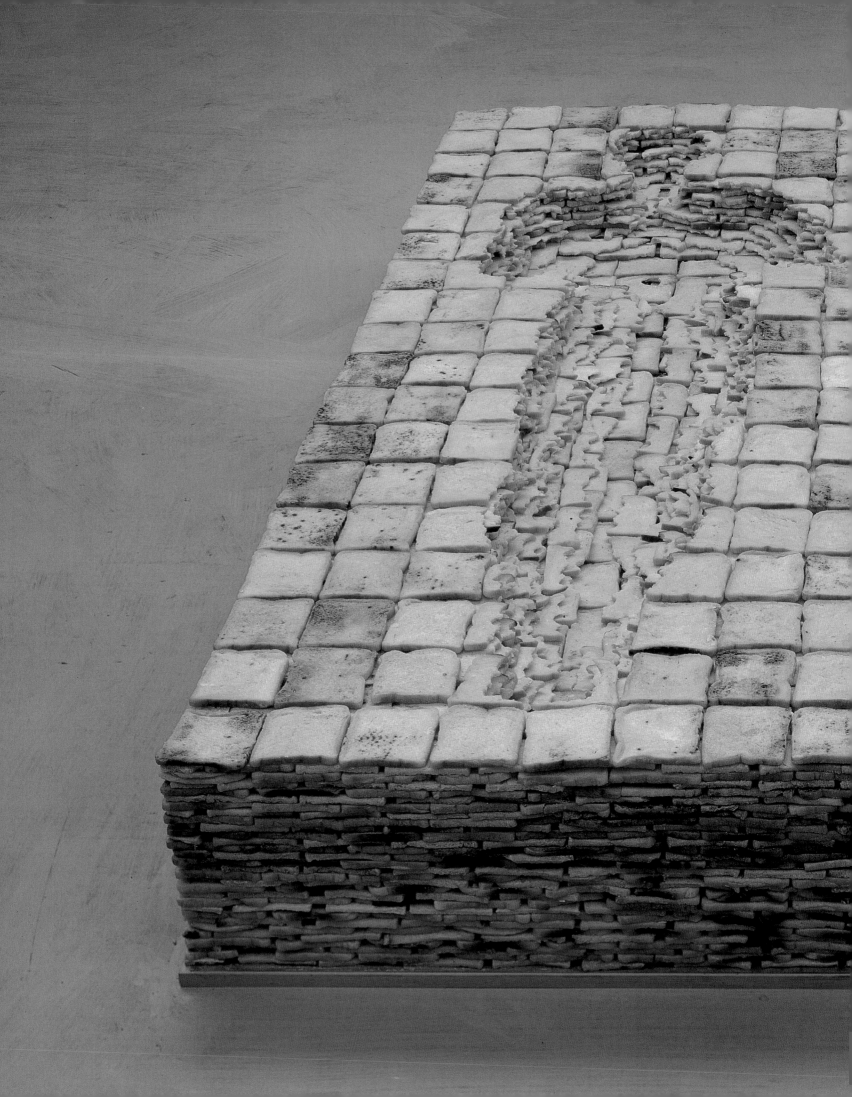

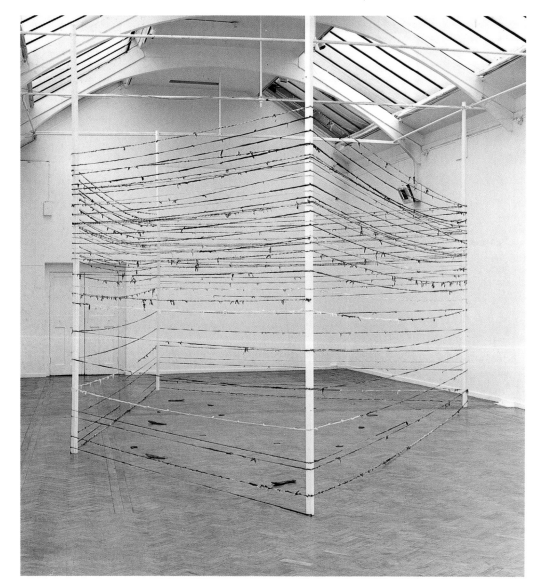

Room
1980
Socks, shoes, pants, trousers,
shirt, pullover, vest, jacket, wood

this period, 'the mystery is with the skin ... In Gormley's aesthetic, nothing lies 'inside' anything. *Full Bowl* is a bowl where the inside is described by the same means as the outside; there is no final edge ... The skin on a body or the meniscus on water are physical manifestations of Antony Gormley's actual mystery: the edge between definitions; the place where surface begins or ends ...[30']

He also identifies an interest that was shared by many contemporary British sculptors. 'After more than two decades the biomorphic form has again become a central concern within British sculpture', Stuart Morgan wrote. 'In the early fifties this concern was characterized by an interest in structure, in the skeleton as the framework of the body. Today ... we find a comparable fascination with surface, with the skin as an envelope of the form. The skin is the visible appearance, the surface which establishes the boundary, the defining edge, the volume within and the space without ... In all (this) work is an underlying but pervasive sense of flux, of objects changing in form, shape or appearance. The skin becomes the visible manifestation of this process ... [31']

This point is clearly realized in the *Sleeping Places*, which are among the most beautiful of Gormley's early works. Inspired by seeing people sleeping on the platforms of railway stations in India, these pieces, made from sheets covering recumbent bodies and immersed in plaster, convey a strong sensation of inner space – and, like *Bed*, of the ambiguous line between absence and presence. The *Sleeping Places* were nothing but skins, the fragile containers of private space.

But perhaps more enduring, at least in terms of the subsequent development of his work, were his observations about skin, which he described as a container of 'personal space'. This idea informed *Room*, a continuous strip of cut-up clothing which enclosed a twenty-foot square, and *Exercise between Blood and Earth*, which was a 'diagram of the active influence surrounding a man'. Starting with an image of a running figure, Gormley expanded the drawing's contours until they conformed to an almost perfect circle described by the radius of his arm. And as Stuart Morgan remarked, writing about another work of

Exercise between Blood and Earth
1979-1981
Chalk on wall
184 cm diam.

below
Full Bowl
1977-78
Lead
6 × 17 × 17 cm

right
Full Bowl (dismantled)
1977-78
Lead

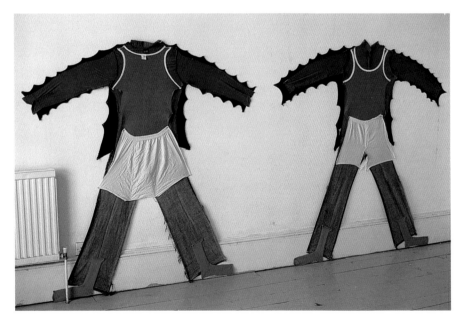

left
My Clothes
1980
The artist's clothes: shirt, jumper, vest, pants, socks, trousers

below
Sleeping Place (destroyed)
1973
Plaster, linen
60 × 76 × 152 cm

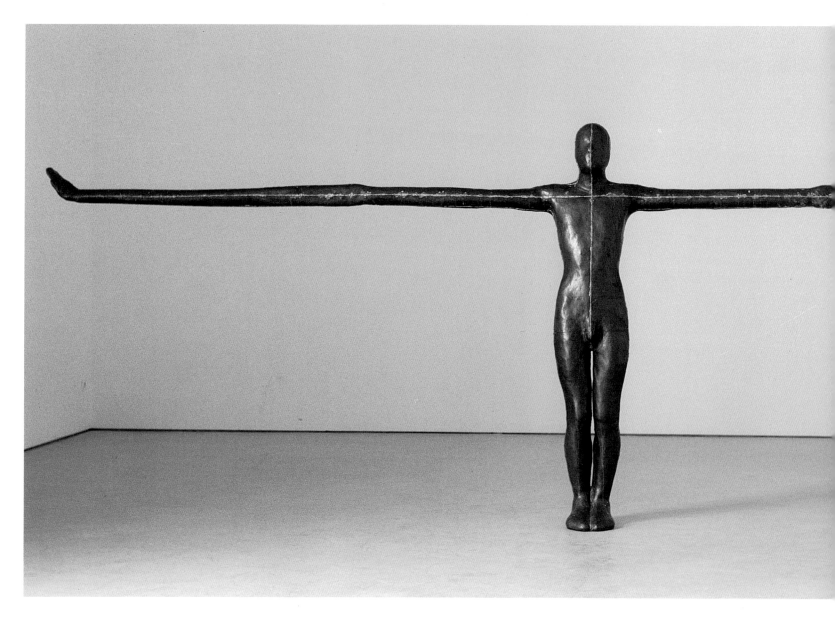

It can be argued that Gormley's initial quest was for intellectual knowledge and understanding of the world around him; he worked with objects which were cut open or flayed – skins were subtracted. At first, nothing was hidden; subsequently, as objects came to be covered – skins added – nothing was revealed. And although it was only a short step, in formal terms, from the enclosure of objects in sheets of lead to the encasing of bodies in the same material, this focus of attention on the figure coincided with a radical shift in the artist's

priorities: it reflected a growing desire to embody experience rather than knowledge. Gormley had decided to explore, in sculpture, what it feels like to be human, to create images that mirrored states of being.

Many of the artist's drawings provide an especially keen sense of Gormley's experience of 'innerliness': they suggest that man can be seen just as clearly with the inner eye as with the outer, and that within the container of the skin lies a world of polarities, oppositions and a plethora of feelings and emotions. In Gormley's drawings bodies freefloat, as if in a womb or in outer space; they interact with each other and yet still remain fundamentally alone. They also appear to have overcome the division between body and spirit.

The impression that Gormley's view of inner space is more fluid and expansive than his perception of outer reality is corroborated by a number of lead pieces made during the mid-1980s. *Tree* and *Field*, for example, which were direct translations from drawings, are simultaneously fantastic and uncanny. (Commenting on the elongated limbs and necks of such pieces, Gormley has said, 'To make concrete the life that goes on inside the head one can't stay within classic proportions'[32]). And *Present Time*, in which two headless body cases are joined at the neck – one is upside down, with arms outstretched and legs slightly astride, the other, on the ground, is tautly self-contained – has the disorienting effect of true surrealism. *Mind* similarly encapsulates the paradoxes that flow from this position: it is evocative of an enlarged, floating brain and, besides, of a small, leaden cloud.

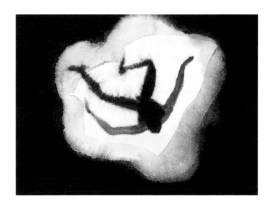

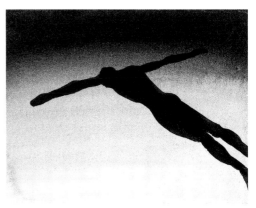

Earth
1994
Ink on paper
14 × 19.5 cm

Into
1994
Ink on paper
14 × 19.5 cm

Field
1984-85
Lead, fibreglass, plaster, air
195 × 560 × 66 cm

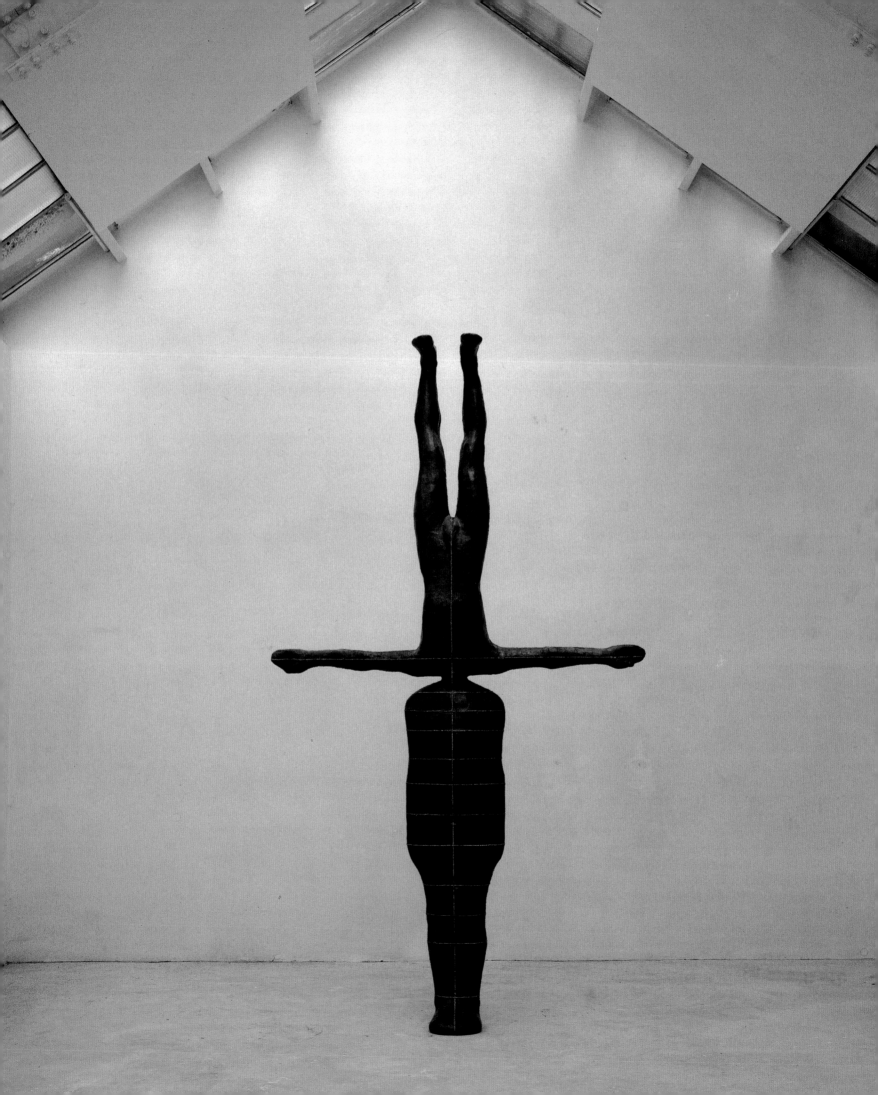

opposite

Present Time

1987-88

Lead, fibreglass, plaster, air

342 × 192 × 35 cm

Collection, The Scottish National

Museum of Modern Art, Edinburgh

right

Mind

1983

Lead, fibreglass, lifting gear

155 × 440 × 275 cm

Installed, Riverside Studios,

London

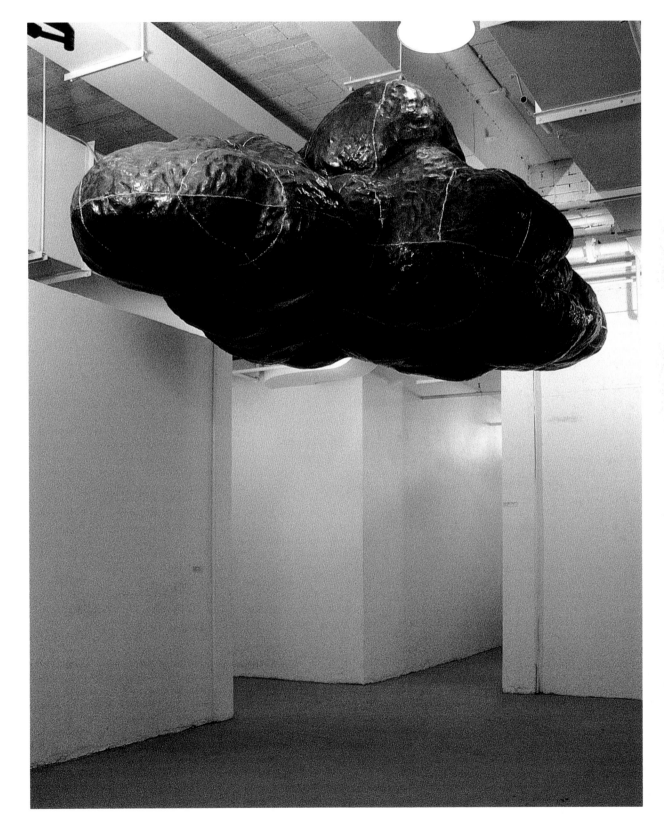

Rearranged Desert
1979
Death Valley
before, A centrally placed cairn
made of stone cleared from a
circular area, the radius being the
distance of a handsized stone
flung as far as possible;
during, throwing the stones as far
as possible in all directions from
the central cairn;
after, Rearranged Desert

But Gormley has also – and strongly – been drawn to the outside world, usually as part of a quest to find correspondences to his experience of inner space. Among his early pieces were a work, constructed with sticks in the mouth of a cave in Greece (revealingly, he has described this as an attempt to 'reactivate its interior') and another, called *Rearranged Desert*, that he made in Arizona. The latter, in which he 'tested' the boundaries of his reach by throwing stones as far as he could, involved the 'relocation of earth' – a process that was both literal and symbolic, as one of Gormley's basic principles is that everything that exists, including man, can be defined as 'earth above ground'. It was also an echo, in a different context, of the idea he expressed in the drawing *Exercise between Blood and Earth*.

Since then, Gormley's search for correlatives to the expansiveness of inner space has led to the siting of many pieces in unusual architectural settings and in the landscape. Their locations have been varied, ranging from a plaza in Rennes, to the flooded crypt of Winchester Cathedral to the city walls of Derry (page 81), and, most recently, to an ambitious project in a Norwegian fjord (page 11). (In placing work in these locations, Gormley seems to be inviting the community at large, and not just the individual, to 'inhabit' their inner spaces.)

Open Space
1994
Body case, iron, 46 x 105 x 36 cm
Disc, concrete, diam. 30 m
Public commission in Rennes,
France

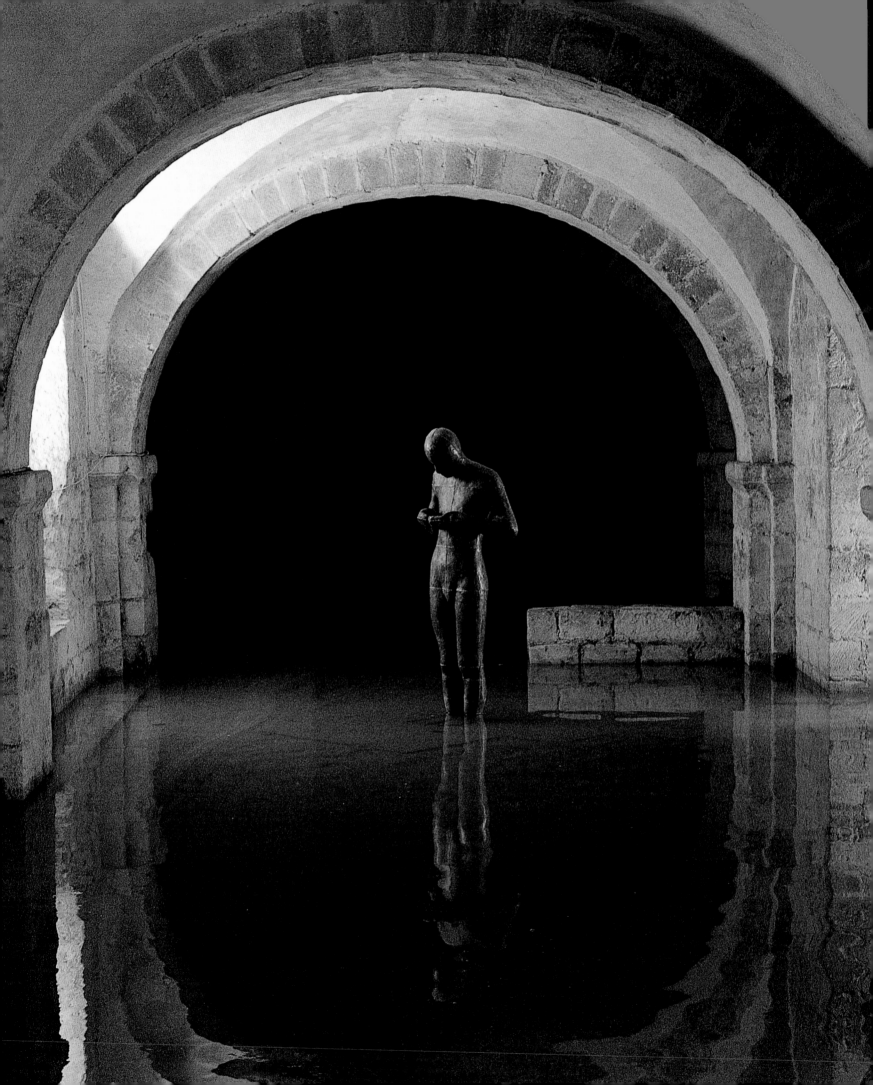

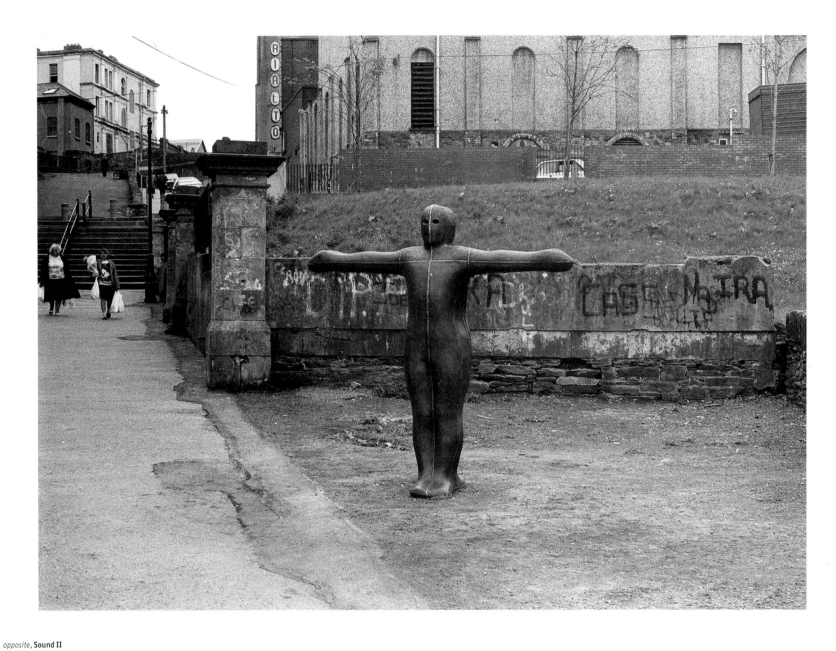

opposite, **Sound II**
1986
Lead, fibreglass, water
188 × 60 × 45 cm
Collection, Winchester Cathedral

above, **Sculpture for Derry Walls**
(detail)
1987
Cast iron, three double figures
196 × 193 × 54 cm

top right, **Sculpture for Derry
Walls** (detail showing
vandalization with burnt tyres)

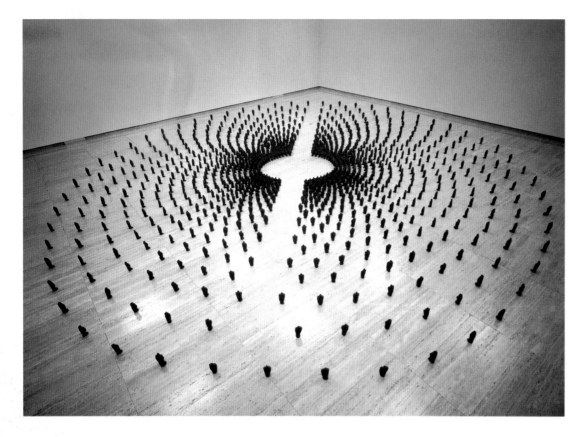

symbolized his wish to maintain contact with
the outside world. This box, a concentrated and
simplified form, as Anthony Bond put it, 'articulates
the focussing potential of man in the land'[34]. At the
same time, many miles away in the Gallery in New
South Wales, he placed 1,100 figurines, made from
clay drawn from the same pans in the centre of
Australia. Each one, individually fashioned, was
unique. Positioned in two hemispheres around
a central path that crossed the Gallery space
diagonally, they were spaced most densely near
the centre of the room and radiated out like the
lines of force of a magnetic field. The viewer,
inevitably attracted to the centre of the space,
was then positioned in the middle of a field of
energy, surrounded by figures with upraised eyes.

While earlier work, such as *Rearranged Desert*
or the many body cases set in outside locations,
seemed to focus on the potential transformative
power of human presence, the *Room* created an
awareness of the massive, and threatening, energy
of the earth. The concrete casing and the crouched
figure within it were as nothing compared to the
emptiness of the desert; inner space, hitherto
conceived as infinite, could be perceived as more
confining than the potential of the outside world.
In contrast, the embodied viewer, positioned at the
centre of *Field*, was made to feel vastly greater than
the fragile figurines, all of whom gaze upwards, as
if in supplication. Taken together, these pieces
reflect a new spirit of openness, humility, and a
willingness to accept the responsibility of being a
fallible human in a material world.

But besides the installation at Charleston
Old Jail, possibly Gormley's most complete
exploration of the complexities of space can be
found in two parallel works he made in 1989.
These pieces, driven by the artist's conviction
that 'if we are to survive we must balance outer
action with the inner experience of matter'[33], are
A Room for the Great Australian Desert, and *Field for
the Art Gallery of New South Wales*. Here, as in the
early *Full Bowl*, Gormley succeeded in eliminating
the boundary between inner and outer space.

On a flat expanse of red dust and clay pans
in central Australia, Gormley placed a concrete
box – a container proportioned in such a way
that it could accommodate the figure of a man
crouching on the ground with his knees close to
his chest. The two-inch shell was closed, except
for four orifices – ears, mouth, and penis – which

above, **Field for the Art Gallery of
New South Wales**
1989
Terracotta
23 × 1140 × 1050 cm

Survey 82

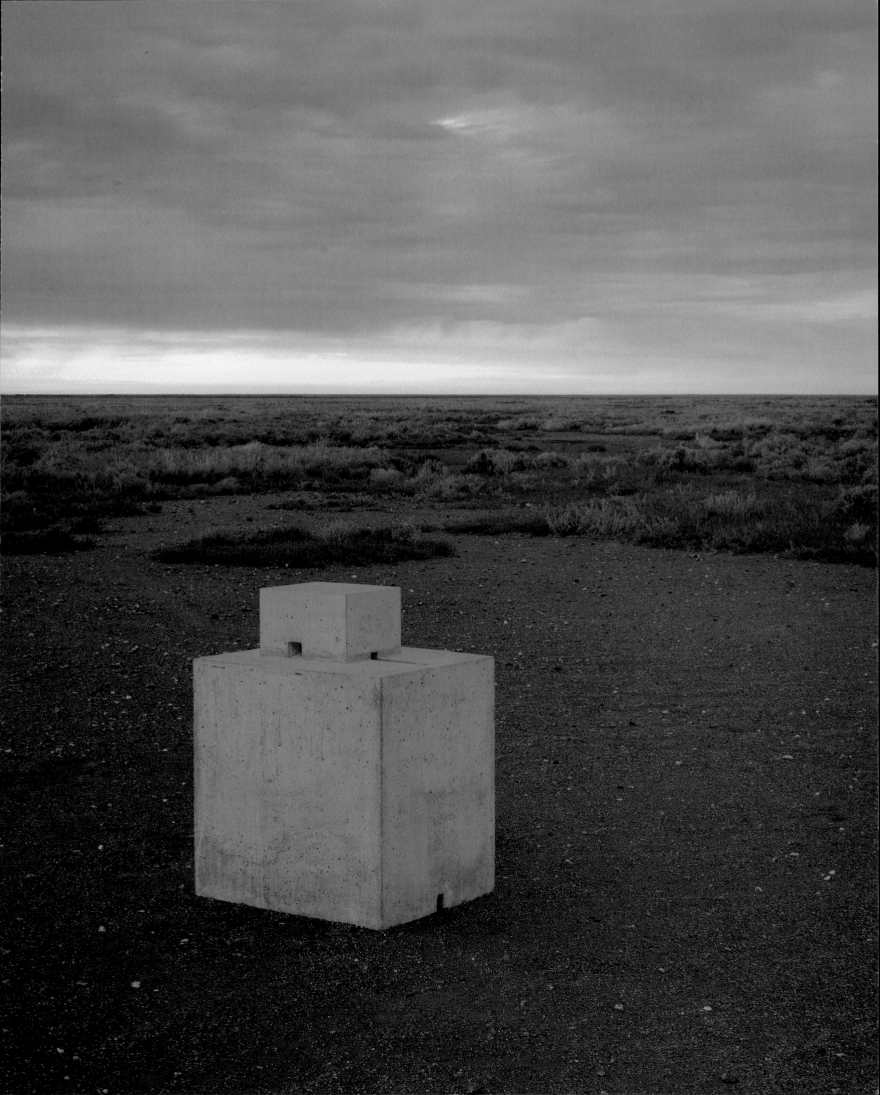

Untitled (for Francis)
1986
Lead, fibreglass, plaster
188 × 119 × 34 cm
Installed, Maenz Psychiatric
Clinic, Germany
Collection, Tate Gallery, London

VI

There is a steady rhythm to the development of
Antony Gormley's art; the whole body of work
breathes. Some pieces suggest inner expansion,
as though they are the result of in-breaths; others
have the generosity and breadth of exhalation.
Broadly speaking, the lead body cases are like
inhalations, while the works in clay are more
effusive. What makes the difference is the 'skin'
of the piece the skin being the threshold, or
boundary, that both describes and identifies
the subject.

If the impetus behind the body cases reflected
the artist's determination to discover his own most
fundamental responses to the world, uncluttered by
the business of thinking, this withdrawal from the
movement of the mind also signalled a certain
isolationism. (Sometimes their 'existential'
aloneness can be reminiscent of the sculpture of
Giacometti.) Their contemplative stillness, like that
of deep concentration or meditation, maintained
distance from the chaos of the everyday world, as if
to preserve a living and vulnerable being in a state
of quiescence. Most of the lead cases are silent and
sealed; the energy they contain is inaccessible.

But many of the body cases are perforated.
Some, like *Three Ways*, have holes that correspond to
the body's orifices, which suggest interaction
between the outside world and the presence within
the leaden skins. In others, such as *Untitled (for
Francis)*, the eye-shaped holes look like wounds, or
stigmata. One work in particular, *Sovereign State*,
brings both these characteristics together. Gormley
describes its conception as follows: 'I wanted to
make an image of power deposed. Of a king pushed

to the floor, lying next to his support mechanism
which echoes his biological internal mechanism.
In expanding the body case, it began to look like
an astronaut's suit. In destroying the hierarchy
between the stratosphere and the earth, between
the king and his subjects, one of the principle
transitions of the work is to make the viewer himself
the subject of the work, and that is also part of the
sovereignty that the work depicts'[35].

While *Sovereign State* is the most complete
example of the breakdown of Gormley's belief in
the invulnerability and self-sufficiency embodied
by the lead cases, his works in concrete pieces are
also a manifestation of a growing desire to engage
with the world. As the artist has explained, 'the
block describes the space between the body and
a compressed notion of architecture, and what I
find makes them quite tender is that the principle
gesture of all those works is touch ... The concrete
has become, as it were, a necessary conditionality.
The work has always identified the minimum space
necessary for a man to occupy, but I think the
concrete pieces do it in a more intimate, open,
and direct way. There is a real point of contact with
the particularity of my body – slipped from life into
art, with every wrinkle of the knuckles embedded in
the concrete'[36].

There is a shift of emphasis, too, which is
reflected by Gormley's increased use of iron
instead of lead, and especially by his 'expansion'
pieces. Iron, closer to earth than lead, responds
to changes in the atmosphere; it rusts, corrodes,
and eventually disintegrates. At the same time,
iron is solid and relatively impenetrable. And it is
significant that Gormley's use of cast-iron is at its

Sovereign State
1989-90
Brass, lead, plaster, fibreglass, air,
rubber hose
Figure, 66 × 172 × 98 cm
Hose length, 30,000 cm

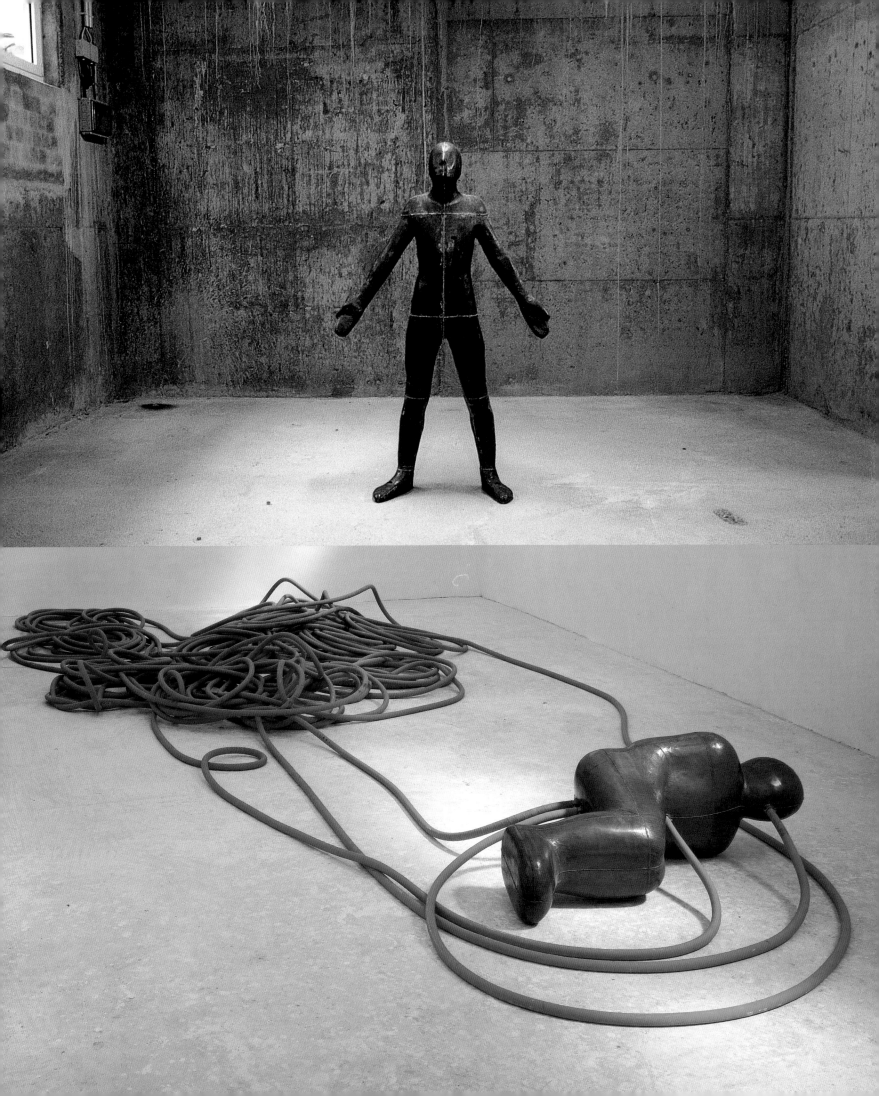

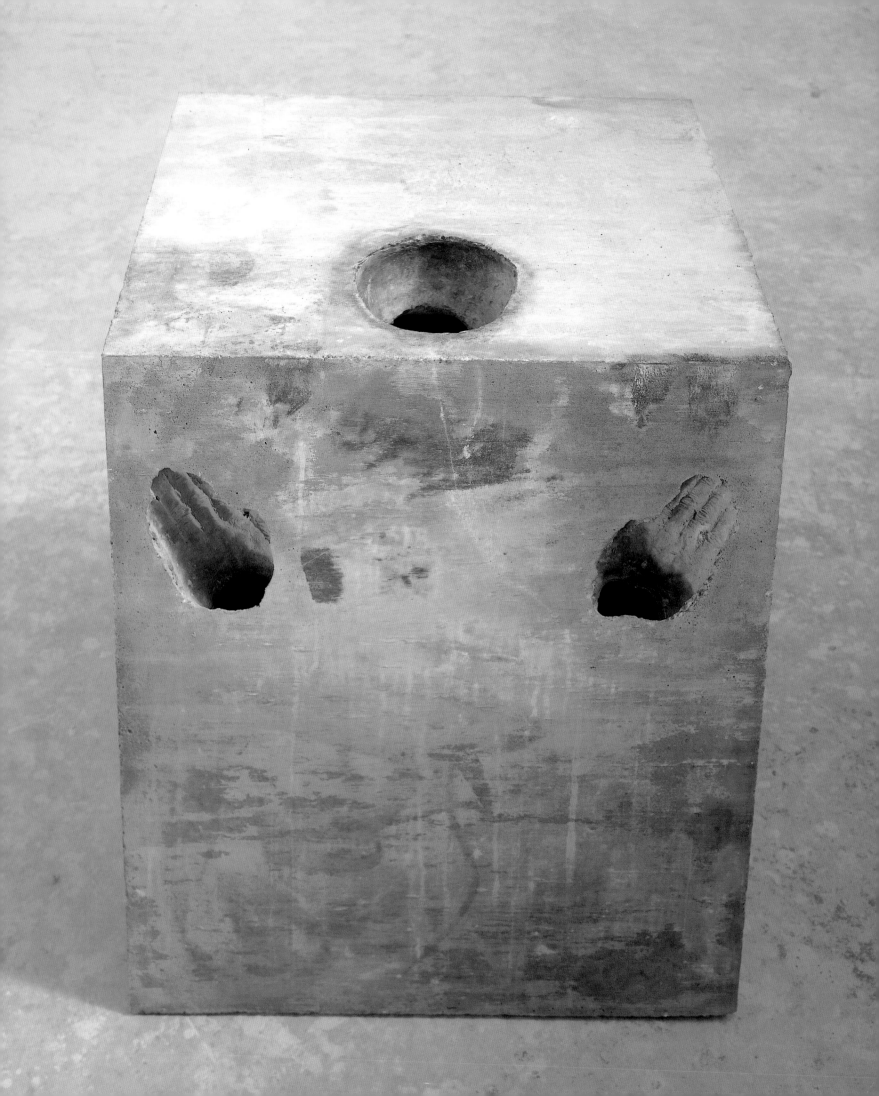

opposite
Sense
1991
Concrete
74.5 × 62.5 × 60cm

below
Flesh
1990
Concrete
36 × 198 × 174 cm

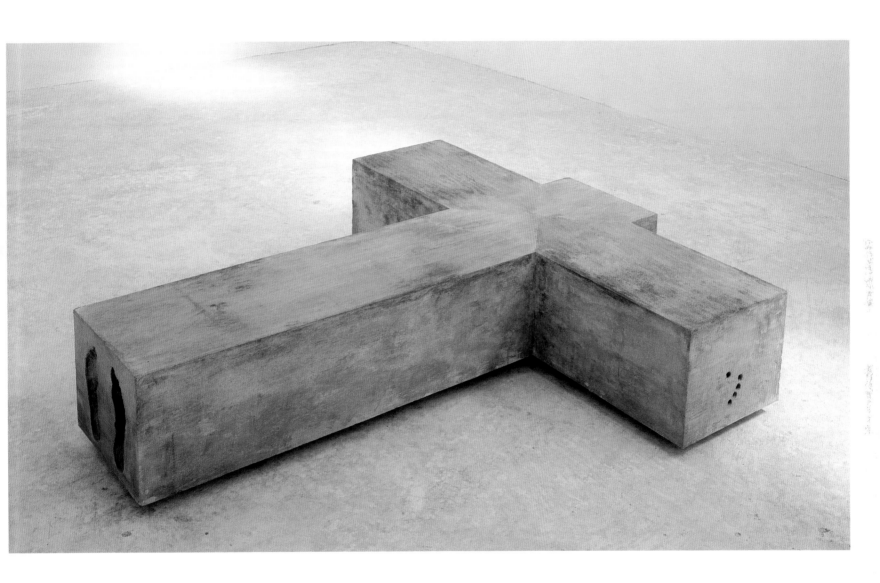

overleaf, l. to r.
Earth
1991-93
Cast iron, air
312 × 230 × 290 cm

Fruit
1991-93
Cast iron, air
104 × 125 × 120 cm

Body
1991-93
Cast iron, air
260 × 200 × 280 cm

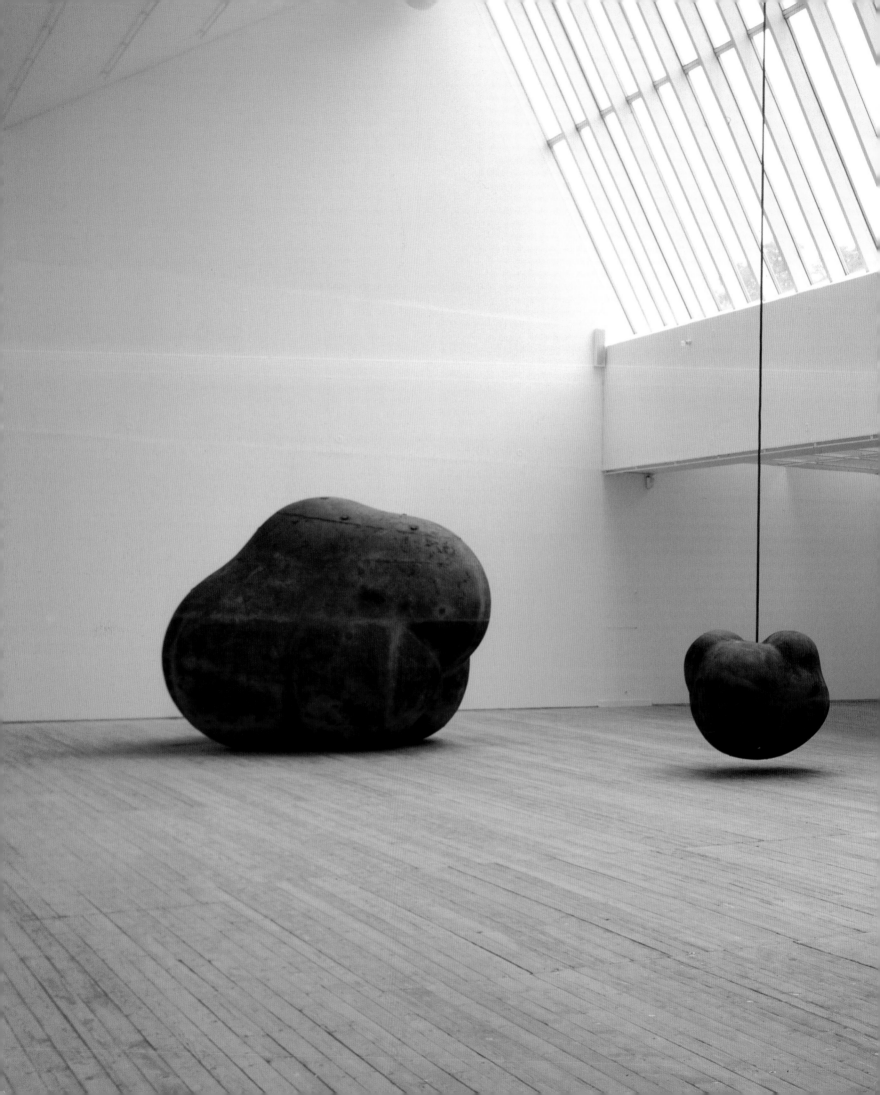

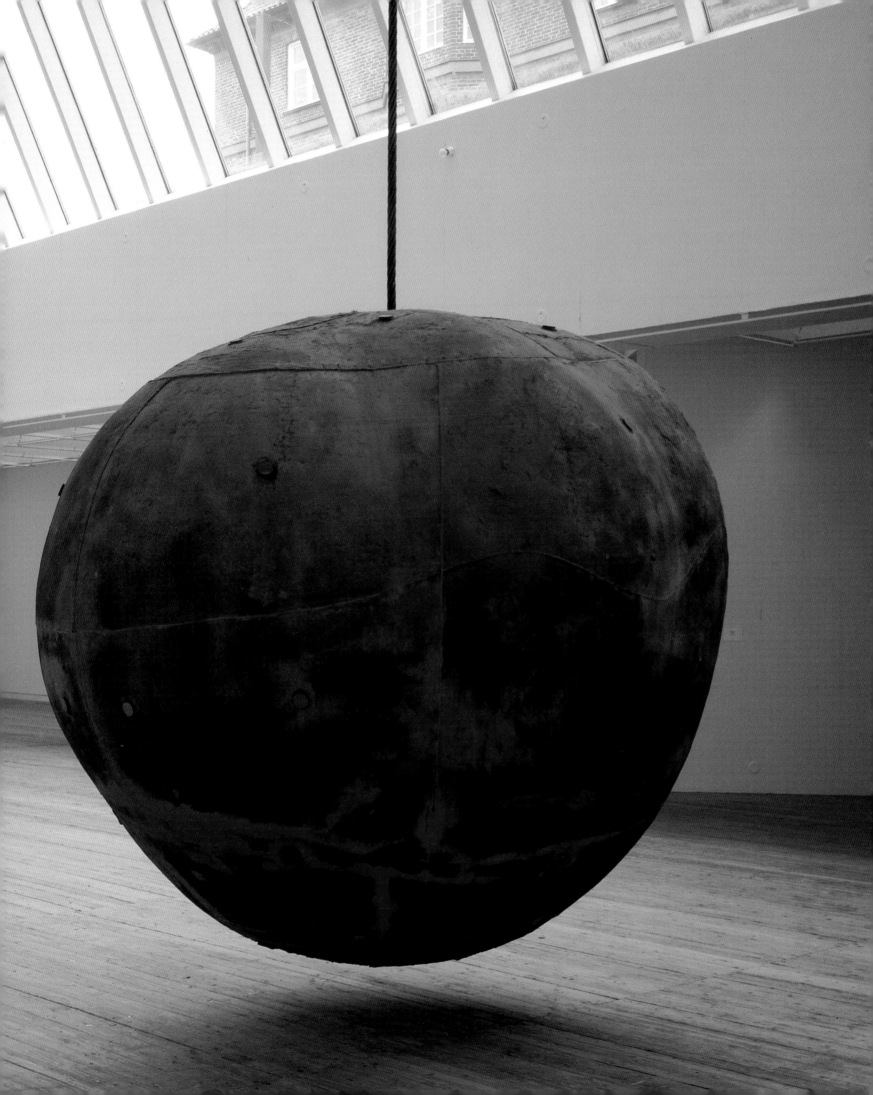

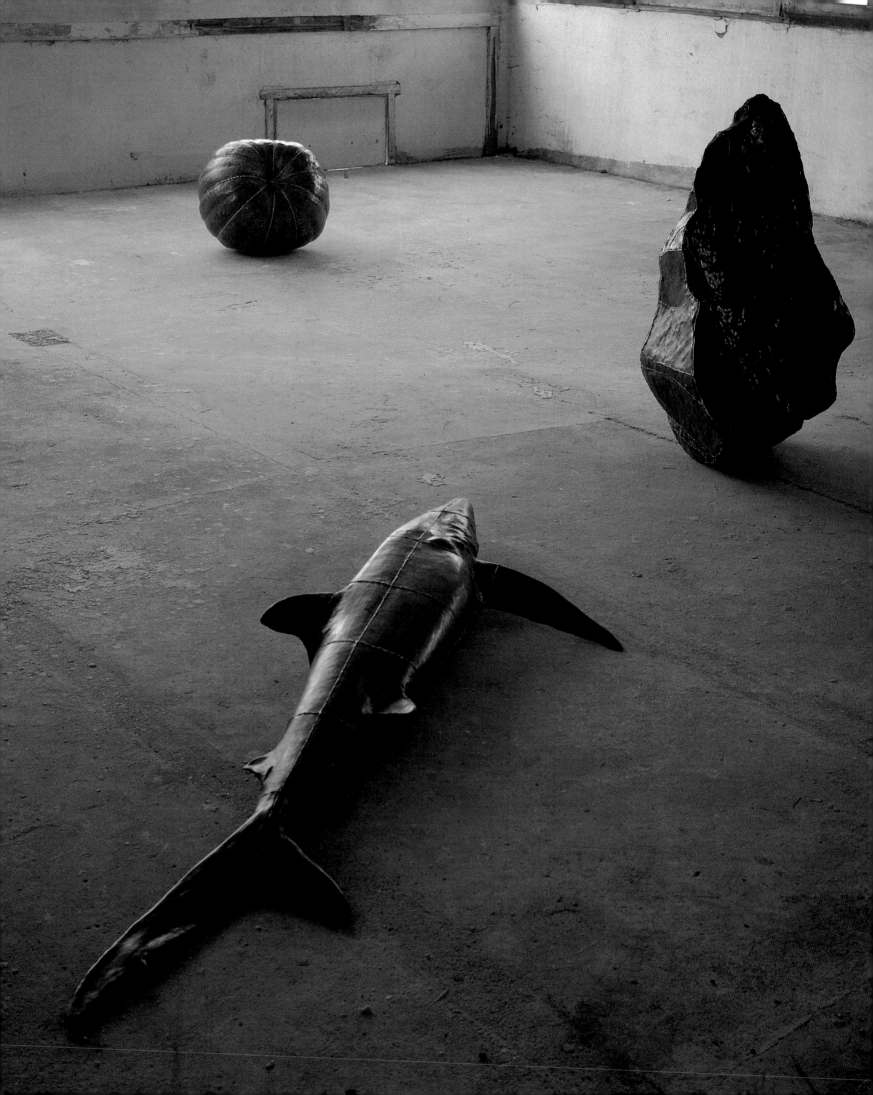

Three Bodies
1981
Lead, fibreglass, earth
Rock, 96 × 60 × 54 cm
Pumpkin, 80 cm diam.
Shark, 18 × 193 × 60 cm

most effective in the 'expansion' works, which hold within them, albeit invisibly, the imprint of the artist's body. In these pieces, as in the early drawing, *Exercise between Blood and Earth*, the body's 'energy-fields' have expanded to the point where they begin to resemble ripe fruits that can barely be contained within their skins. *Earth* and *Body* are like chrysalises: they are in transition, about to generate new life. And as Gormley once wrote about them, the 'expansion' pieces have much to do with 'mind and its sensibilities not fitting completely comfortably in the skin'[37].

Gormley's exploration of the idea of 'expansion' is most fully expressed in the works made of clay. Veit Loers has noted that, in the mid-1980s, the idea of transformation was dealt with narratively, adding

clay as a new creative element, also pointing out that this element was invisibly present as earth in the early *Three Bodies*[38]. And in pieces like *The Beginning, the Middle, and the End* and *Out of This World*, schematic terracotta figurines escape, unprotected, from their lead body cases.

That Gormley associates clay, or earth, with a sense of freedom is indicated in works as different as *Man Asleep* and *Room for the Great Australian Desert*, where the ground itself acts as an undifferentiated source of energy. It is in *Field*, however, that what Gormley has referred to as a 'return to desire' has its fullest expression, for if the lead body cases can plausibly be read as images of withdrawal from the chaos of the outer world into a state of still awareness or contemplation, *Field* could be said to be their opposite.

Out of This World
1983-84
Lead, terracotta, fibreglass, plaster
140 × 85 × 140 cm
Collection, British Council, London

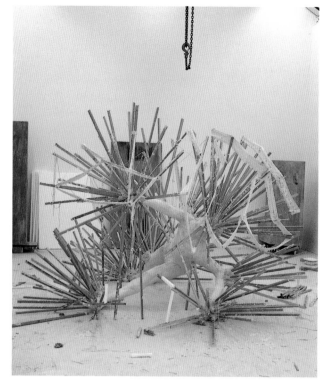

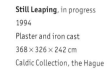

Still Leaping, in progress
1994
Plaster and iron cast
368 × 326 × 242 cm
Caldic Collection, the Hague

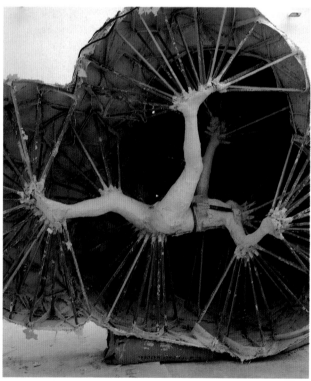

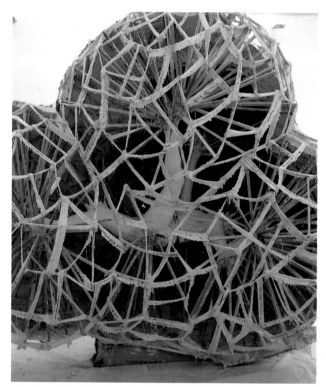

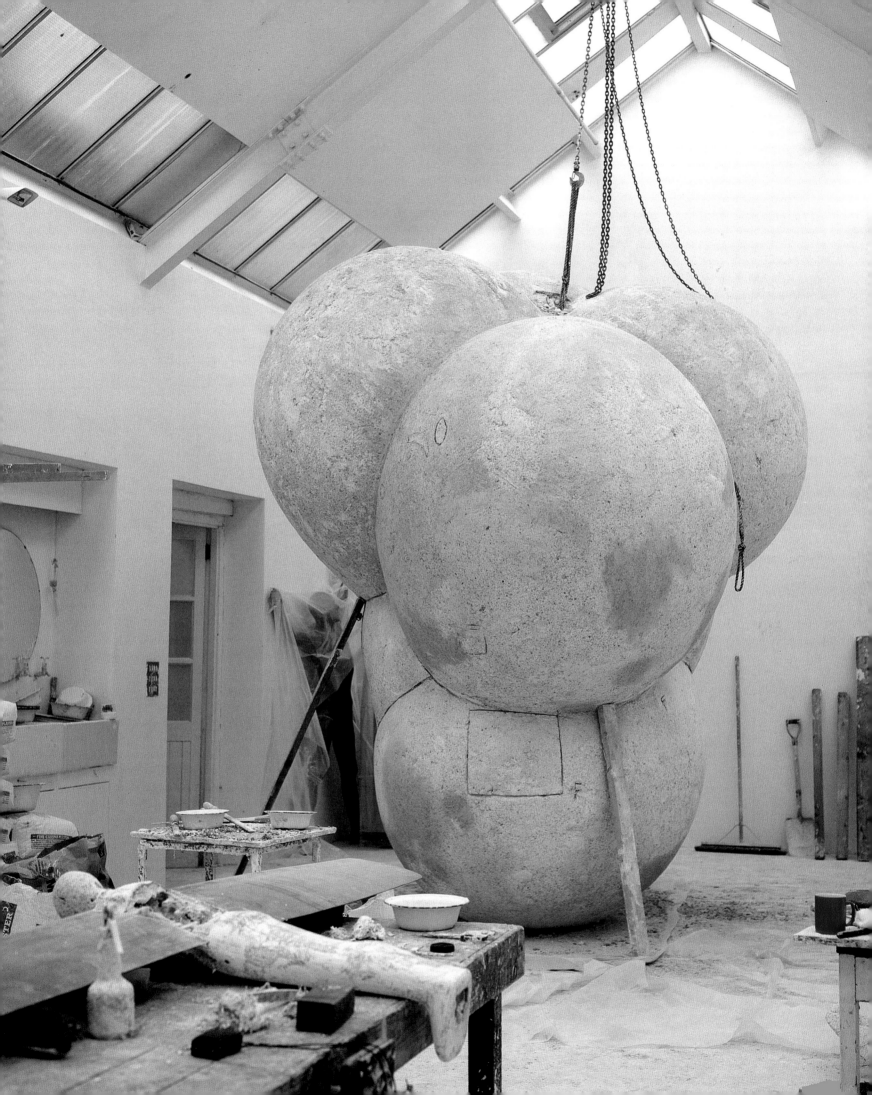

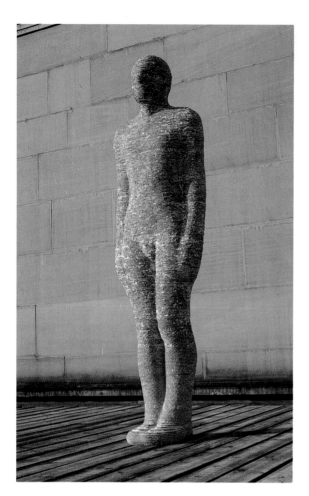

Brick Man (Model)
1987
Terracotta, fibreglass, plaster
196 × 50 × 38 cm
Collection, Leeds City Art Gallery

Field is based on a simple idea: a group of people are brought together to work with earth and to create a collective body (in that respect it echoes the motivation behind Gormley's unrealized plan, to build a gigantic *Brick Man* in Leeds). The parameters within which the figurines are created are precise, yet unrestrictive: each one handsized and similar in proportion, but of necessity has its own character. They are a celebration of community, of everyday humanity; and when brought together en masse, with their eyes turned towards the thresholds of the spaces in which they are shown, they bring the viewer into the configuration as well. *Field*, like the rest of Gormley's work, causes the viewer to become self-aware – but, in this case, to be aware of the self as being immensely important and, simultaneously, only a minute part of the collective body of mankind.

Because it represents something close to the fulfilment of many of his artistic and ethical aspirations, the importance of this work in Gormley's artistic development can scarcely be overestimated. Having rejected its focus on the unique individual creator and the singular art object, *Field* breaks through the limitations of the Western sculptural tradition; it also, just as importantly, reflects a movement away from the self to dealing with others, and from making something finished to undertaking a task that will never be completed.

The tension between the 'self' and 'not-self' that characterizes the body-cases is resolved, in a most unexpected fashion, by *Field*. While the body-cases have a strong, self-contained beauty, in *Field*, as the artist has put it, 'placeness' has overcome 'objectness'[39]. It alludes to the intense fragility of the 'skin of living matter' and to the interconnectedness of life; it represents the 'invasion' of cerebral purity by the chaos of the earth, and of Western 'civilization' by 'the remote, the marginal, the dispossessed, the unacknowledged'[40]. It is reminiscent of Biblical stories about creation and the end of the world, just as it is evocative of the Buddhist doctrine of 'anatta' or 'no-Soul'.

Antony Gormley's personal and artistic ambition, which is nothing less than the transformation of the individual and communal body, has found its most complete expression in these inchoate masses of terracotta figurines, made by hands other than his own. *Field*, as the artist has remarked, accommodates two factors: 'the spirit of the ancestors; the primal population made of the earth, where mud takes on the attributes of sentience and the evocation of the unborn – those who are yet to come'[41]. And perhaps the reason why these works are so affecting is because *Field* is a landscape of gazes, 'which look to us to find their place'[42]. And the figurines, almost uniquely in the body of Gormley's sculpture, are possessed of eyes, the outward expression of insight.

1 Quoted in Ananda R. Coomaraswamy, *The Transformation of Nature in Art*, New York, 1956, p.76

2 ibid., p.95

3 Interview with Roger Bevan in catalogue, *Learning to See*, Galerie Thaddaeus Ropac, Paris, Salzburg, 1993, p.38

4 Catalogue, *Places with a Past – New Site-specific Art at Charleston's Spoleto Festival*, 1991, p.120

5 ibid., p.123

6 ibid., p.123

7 ibid., p.124

8 Quoted in Richard Kearney, *Poetics of Imagining*, London, 1991, p.114

9 The philosopher, Jean-Luc Nancy, develops this idea in *The Birth to Presence*, Stanford, 1993, p.192.

10 '(The) attitude of man struggling against the forces of nature … to impose an order through understanding (of a particular kind) is the attitude that created the enlightenment and the Newtonian world view. Descartes' Cogito is the opposition of the mind to the world – my job is to reintegrate it'. Interview with Ewa Ayton, *Art and Business*, Warsaw, March/April 1994, p.75

11 Nancy, op.cit., p.191

12 Nicholas Serota, introduction to *Transformations – New Sculpture from Britain*, São Paulo and Rio de Janeiro, 1983-84, p.10

13 Lynne Cooke, essay in catalogue, *Antony Gormley*, Salvatore Ala Gallery, New York, 1984

14 Interview with Ewa Ayton, op.cit., p.75

15 Stephen Bann, 'The Raising of Lazarus', in catalogue, *Antony Gormley*, Malmö Konsthall; Tate Gallery, Liverpool; Irish Museum of Modern Art, Dublin, 1993-94, p.40

16 Stephen Bann, 'Sculpture/Interpretation: The Space Outside and The Space Inside', unpublished lecture, 1994

17 Michael Newman, 'Antony Gormley's Drawings', in catalogue, *Gormley*, Seibu Contemporary Art Gallery, Tokyo, 1987 (unpaginated)

18 Shearer West, *Fin de Siècle – Art and Society in an Age of Uncertainty*, London, 1993. This book was drawn to the writer's attention by Antony Gormley.

19 James Hall, 'Frame Game', *The Guardian*, London, 7 November, 1994

20 C.G.Jung, as well as the Jungian analyst, Marie-Louise von Franz, have written extensively on the subject.

21 The former is described, the latter illustrated, in Marie-Louise von Franz, *Alchemy*, Toronto, 1980.

22 Mary Douglas, *Purity and Danger*, Harmondsworth, 1966, p.210

23 Interview with Ewa Ayton, op.cit., p.71

24 Stephen Bann raises this issue in his unpublished lecture, 'Sculpture/Interpretation: The Space Outside and the Space Inside'.

25 Interview with Declan McGonagle, in catalogue, *Antony Gormley*, Malmö Konsthall; Tate Gallery, Liverpool; Irish Museum of Modern Art, Dublin, 1993/1994, pp. 44-45

26 Lewis Biggs, 'Learning to See – an Introduction', ibid., p.25

27 Interview with Declan McGonagle, op. cit., p.46

28 Mary Douglas, op.cit., p.210

29 Antony Gormley, slide/tape presentation

30 Stuart Morgan, 'The Genesis of Secrecy', in *Transformations -New Sculpture from Britain*, São Paulo and Rio de Janeiro, 1983-84, p.42

31 ibid.

32 Quoted in Sandy Nairne, 'Such Stuff as Dreams are Made of', in catalogue, *Antony Gormley*, Stadtische Galerie Regensburg and Frankfurter Kunstverein, 1985, p.58

33 Antony Gormley interviewed by Anthony Bond, in the catalogue, *A Field for the Art Gallery of New South Wales and A Room for the Great Australian Desert*, Art Gallery of New South Wales, Sydney, 1989 (unpaginated)

34 ibid.

35 Interview with Declan McGonagle, op.cit., p.47

36 ibid., p.51

37 Letter from Antony Gormley to the writer, August 27, 1994

38 Veit Loers, 'Calling upon Matter', in the catalogue, *Antony Gormley*, Stadtische Galerie Regensburg and Frankfurter Kunstverein, 1985, p.42

39 Interview with Marjetica Potrc, in the catalogue, *Field for the British Isles*, Oriel Mostyn, Llandudno (and elsewhere), 1994, p.61

40 ibid., p.73

41 ibid., p.62

42 ibid., p.62

Contents

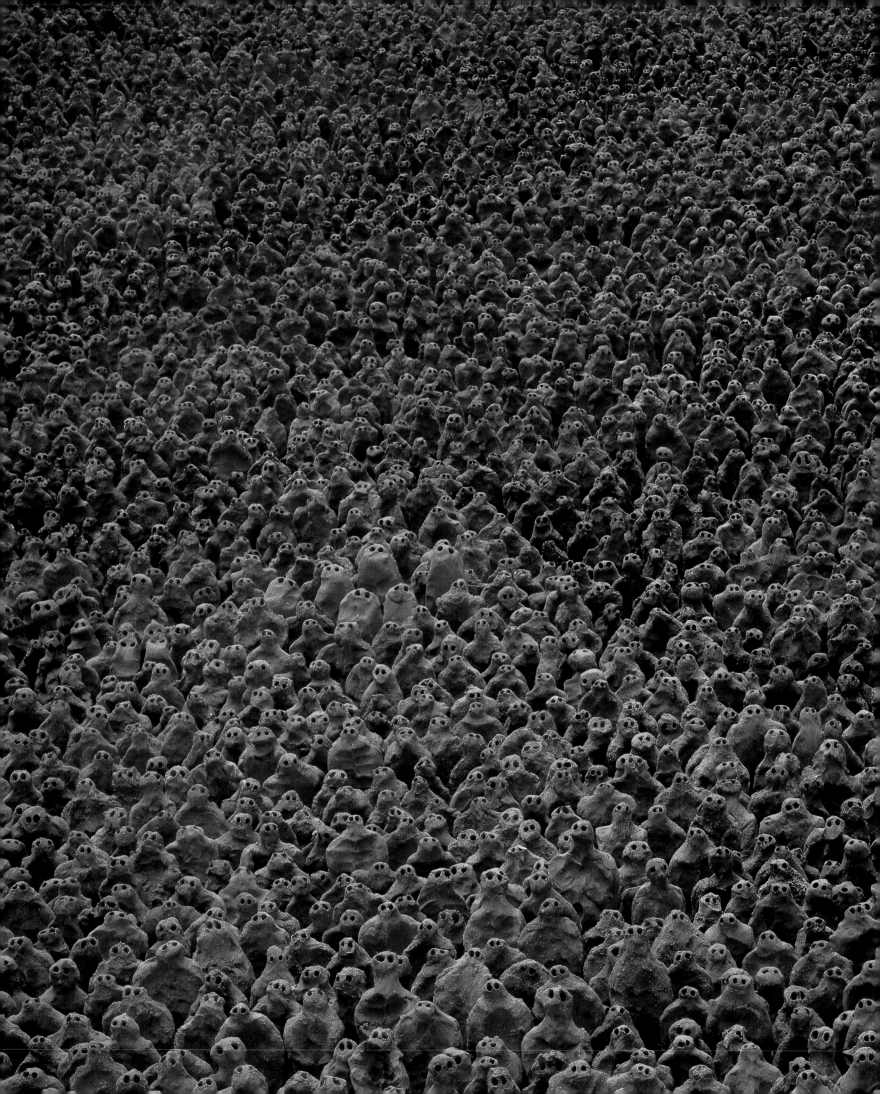

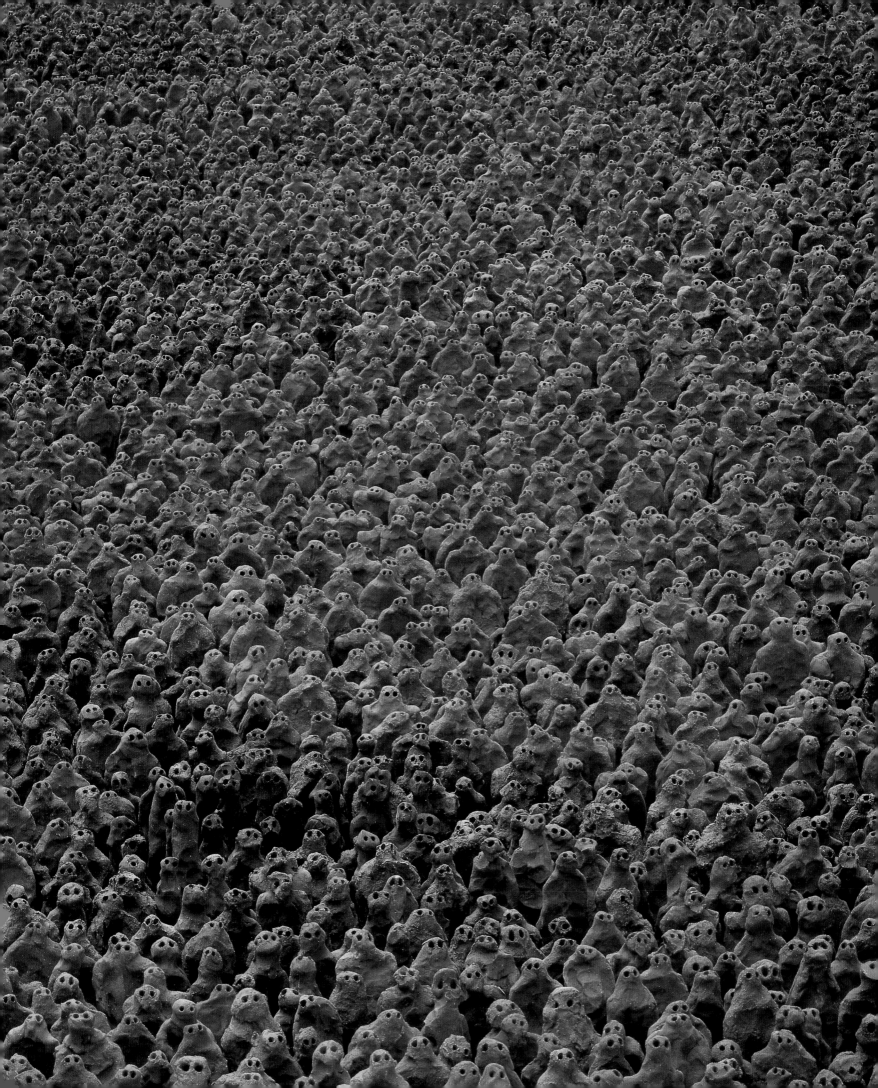

It's raining. At noon I step from the bus, into a puddle which surrounds the entrance to the main Post Office, at the busiest bus stop in Ljubljana; whether people want to make a call or send a letter, cross to the far end of the city or arrive in the central marketplace, go to the bank, or maybe just have an appointment for lunch at this, the beginning of the busiest hour of the day, they must all wade through it. The puddle is not a cavity full of water in the pavement at all, but jets of water spraying around the knees and bouncing off shoes; splashing off the pavement they look like barbed wire, here, on the busiest corner in Ljubljana.

Even though I wear rubber boots, my feet are soaked as I stand at the crossroads, waiting for the green light. A street stretches out in front of me, so straight that where it climbs a hill in the park, I can see, despite the motley crowds in the foreground, a very short and a very thin, white gravel line, that leads above their heads, to the mansion. The sky becomes brighter, it turns from grey into blue, the colours still cold, the sun not yet broken through the canopy of clouds.

A flood of people tows me on, a lady with her shopping bag filled to bursting pushes me and I hold my long umbrella close, so as not to pierce her bag. As I walk across the street the wind starts blowing. Droplets on my calves turn cold. I wipe them away as I pass the shop-windows and avoid the people, who loiter in front of them. I do not manage to wipe myself dry because the thin web of my stockings keeps the water on my skin; my feet are damp and my stockings wet. At ground level I feel unpleasantly cold.

There are fewer and fewer people and more and more daylight around me as I walk out of the town centre. The building of the Opera becomes, no longer ochre, but yellow. The beige ornaments on its facade become white. The buildings are lower and don't eat the sky away any more; the sky has become completely blue. Even the pavement is drier and beneath it, by the side of the road, there is a little puddle which is absolutely smooth, waiting for the wheel of a car.

I run obstinately towards it. I poke it with the tip of my umbrella and stir it, so that the water rises up into the air and falls back splashing, although it does not leap even as high as my ankles. 'Hey, no more wet feet', I say to myself.

I turn my back on the gazes of the passers-by and walk across the street again. There is nobody on this side. I stop at the beginning of the gravel pathway which now seems

overleaf
European Field
Terracotta
approx. 35,000 figures, 8-26 cm each
Installed, Konsthall Malmö

opposite
American Field, Forming a figurine
December, 1990
St. Mathias, Cholula Mexico

broader than the distance between the finger-tips of my outstretched arms.

It is impossible to see the mansion because it is blocked by a concrete bridge over which runs a railway. The hill looks like the lid of a pot placed over the bridge's iron railings. The forest, burdened under the weight of the rain which is still in the tree-tops, spreads over the hill; a blueness flutters over it caressing me with its soft light.

The only day of the week when the Ljubljana natives can stroll around here is Sunday. This is when they take time out for nature, God or art. If it wasn't for this a taste for adventure might remain unappeased. I turn left into the Museum of Modern Art and here I am, having passed the porter, alone again. I want to see the little statues that the English sculptor is exhibiting here. 'In the show-room at the end', the porter directs me. Familiar with the place, I boldly proceed, but am forced, immediately, to stop. From one wall to the other, right up to the door, the large room is filled with thousands of simians no taller than two palms of a hand. Their bodies are formless bulks that are burned through; their heads are raised and together, they fix on me with their cavities, two holes that pierce me inside more unavoidably than any kind of look.

These figurines form a field, which, with a forbidding power, deflects the visitor's attention away from their fragility, and onto his or her inner being. My defensive stare in the face of this confrontation with this crowd of repeated forms becomes a weapon, which turns on me. In front of me there is a light which I can feel. It is not as rapturous as it was outside, but it glows, the motionless, luminous guardian of a reddish army which stands to attention.

American Field, Figures drying
December, 1990
St. Mathias, Cholula Mexico

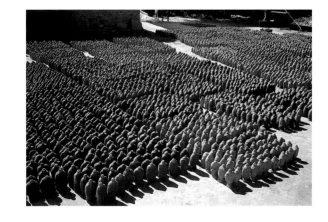

inside me, where my tongue touches the roof of my mouth, is the pad of taste. it is cold and smooth. it feels metallic and sticky, so that my tongue cannot move. saliva accumulates under it and pours like a tide across it as far as my throat. the foam of saliva neutralises the acidity of the spot where my palate is corroding my tongue. the taste in my mouth was not caused by fruit which my teeth would crush, so that's why it isn't sour; the taste in my mouth is not a trace of soup, which would slide down my throat, which is why it isn't salty; the taste is the lesion of time, bent into the mould of my body, a body made vulnerable by the constant assault of time.

time, confined into blind caves or extended through tunnels, responds to the call of infinity, which teases with its promise of freedom. outside the body, time is a pair of compasses in the hands of eternity, but inside it is a pendulum, fastened to the heart. the heart takes its measure from the lengthening swing of the pendulum surveying what time is left. in its own rhythm time spreads itself wildly here and there and is crippled elsewhere. its unequally distributed weight wounds my body - that is how the particularities of my life are manifest.

my body sustains many injuries, it is furrowed by the fluids I secrete, the air that

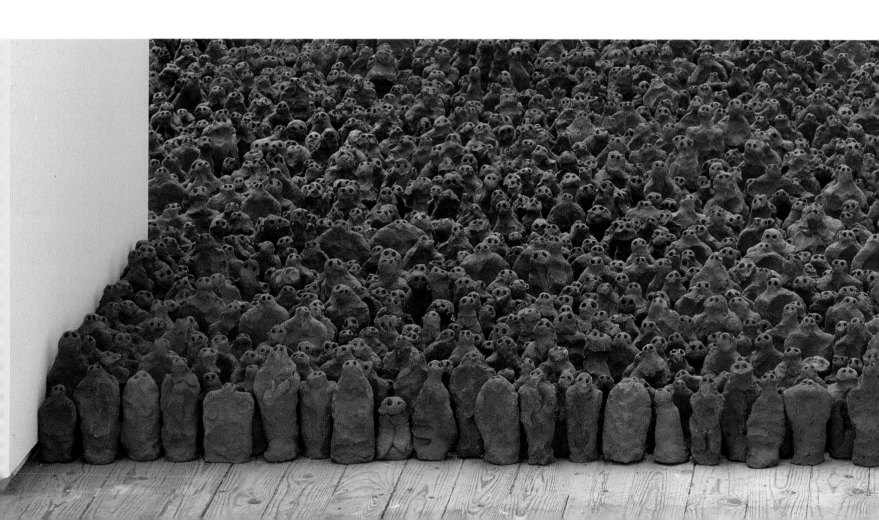

European Field (detail)
1993
Terracotta
approx. 35,000 figures, 8–26 cm each
Installed, Malmö Konsthall

time sucks into me. my inner being is so corroded that it is as if it was turned inside out. only the vessel of flesh models the space into a form that looks like me. in the beginning the body moves towards the other, full of an expectant pulse. but the rhythm of blood becomes increasingly more convulsive. the procedures of osmosis make the body expel the blood from the shelter it seeks. i am drawn into the infinite procedures of removal. fatally attracted, my body is swallowed up, transformed, so that sinews become unentwined from the supple bands that exchange substances. they stop responding to stimulation and atrophy turns to alabaster.

time insinuates itself into all that exists. fragments shaped by the particularities of existence are united by the seal of sameness. that is why i cannot restore my body as a border. time occupies the body, consuming and chiselling it into patterns of transition.

the lesion of metallic stickiness in my mouth becomes as heavy as lead and forces my tongue back into my throat. the heart guards this opening as the only exit among the many doors of the body. between two lives which are linked together - the eternal and the transitory - the mouth is a safety valve which stops one rejecting the other. language, a form which eternity alone is unable to create, passes through the mouth into the world.

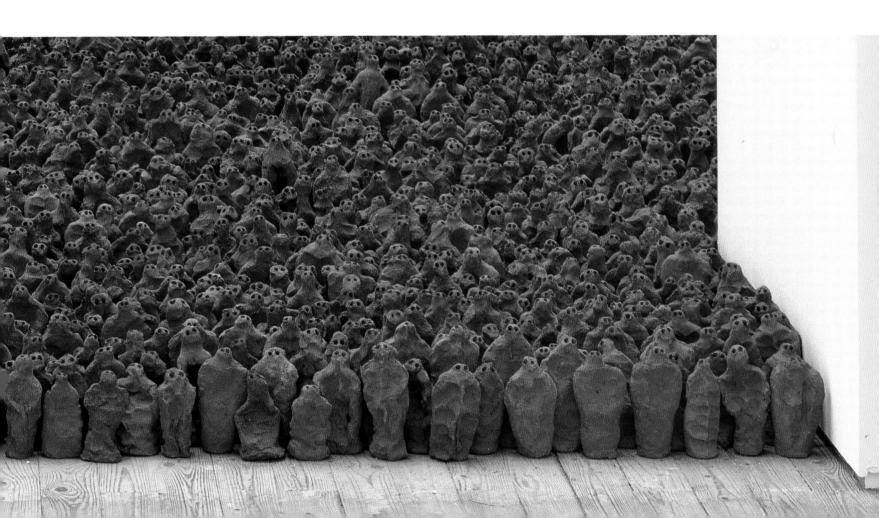

The fist in which I've been squeezing my umbrella starts prickling. I change hands and loosen up my knees; I've been standing bolt upright all this time. I lean on my right leg and start feeling a mellow relief in the muscles of the left one. In front of me the figures become more prominent against the light. The statuettes are no longer a compact mass of earth that won't allow me in, pitting their thousands of eye cavities against me. In spite of the resistant pressure of their gaze, I endured, transcended their otherness and entered their space. The threat evoked by their stillness has disappeared. I obeyed their imperative, to enter myself; I watched them from inside.

The flames have sublimated the individual litheness of each figure so that together they make even the light gleam; it confronts and combines with the presence of the morning rain its footsteps still visible on my overcoat. The army from the stove has lost its vigilance and gained the mellowness of grapes spread out after the vintage. My foot could not harm these heads now. I was ready to undergo their process of becoming, to burn myself to the core. The clay is becoming blue in colour. As if it is sharing, with me, a need to leave this box, and return to open space.

As I am leaving, the rubber of my boots squeaks on the parquet. The porter is already waiting for me so he can close the Museum. At the top of the stairs before the exit I spot a brown dachshund no taller than two palms of a hand, as he pokes his snout inside. The door slams behind me, the dachshund jumps back and runs away, even though the rain is coming down from the sky again. Yet the sky doesn't become grey, its massed clouds make it soft and it stays sky-blue. I do not use the umbrella against this rain. Instead of returning to the town, I turn to the wood. In a shelter under the railway bridge the dachshund stops. His powerful, penetrating look reminds me of the unexpected reception in the Museum, but he quickly loses interest in me. With his ears poking forward he drifts off, waving me away with his very short and very thin white tail. As he disappears, I wade through the first puddle and slowly, scraping its bottom, watch how the waves lap one against the other just like a storm at sea. This is happening low, low around my boots, not reaching my legs at all.

European Field
1994
Terracotta
approx. 35,000 figures, 8-26 cm
each
Installed, Muzej Surremene
Umjetnosh, Zagreb

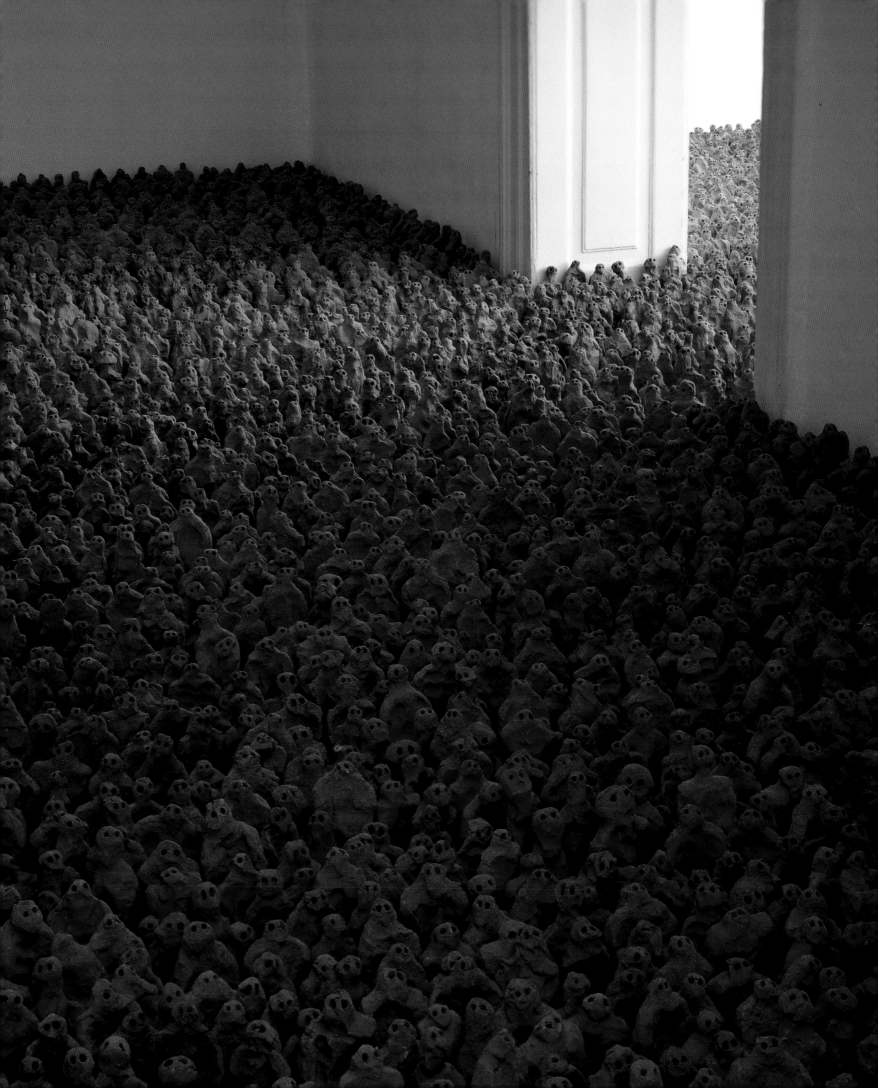

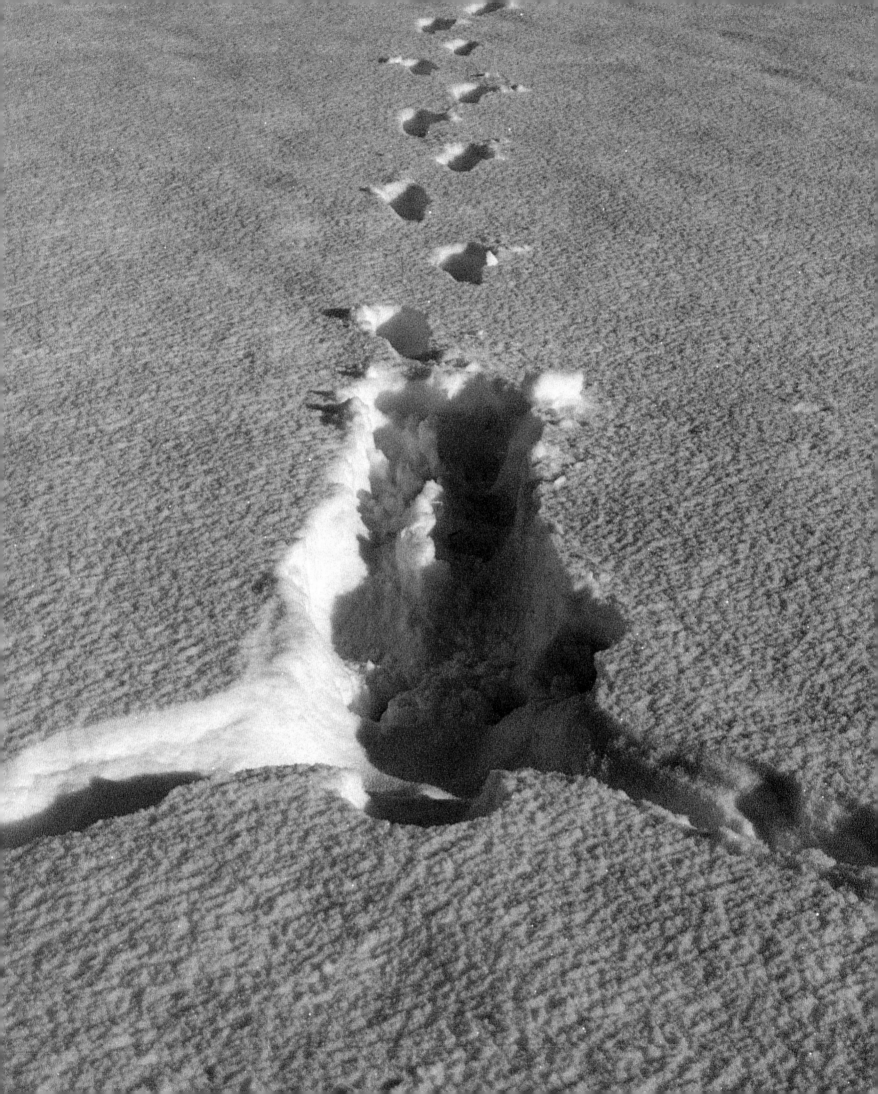

Contents

VIII

And so I come to the fields and vast palaces of memory, where are stored the innumerable images of material things brought to it by the senses. Further there is stored in the memory the thoughts we think, by adding to or taking from or otherwise modifying the things that sense has made contact with, and all other things that have been entrusted to and laid up in memory, save such as forgetfulness has swallowed in its grave. When I turn to memory, I ask it bring forth what I want: and some things are produced immediately, some take longer as if they had to be brought out from some more secret place of storage; some pour out in a heap, and while we are actually wanting and looking for something quite different, they hurl themselves upon us in masses as though to say: 'May it not be we that you want?' I brush them from the face of my memory with the hand of my heart, until at last the thing I want is brought to light as from some hidden place. Some things are produced just as they are required, easily and in right order; and things that come first give place to those that follow, and giving place are stored up again to be produced when I want them. This is what happens, when I say anything by heart.

In the memory all the various things are kept distinct and in their right categories, though each came into the memory by its own gate. For example, light and all the colours and shapes of bodies come in by the eyes, all the kinds of sound by the ears, all scents by the nostrils, all tastes by the mouth; and by a sense that belongs to the whole body that comes in what is hard and what is soft, what is hot or cold, rough or smooth, heavy or light, whether outside the body or inside. All these things the vast recesses, the hidden and unsearchable caverns, of memory receive and store up, to be available and brought to light when need arises: yet all enter by their own various gates to be stored up in memory. Nor indeed do the things themselves enter: only the images of the things perceived by the senses are there for thought to remember them.

And even though we know by which senses they were brought in and laid up in the memory, who can tell how these images were formed? Even when I am in darkness and in silence, I can if I will produce colours in my memory, and distinguish black from white and any other colours if I choose; and sounds do not break in and disturb the image I am considering that came in through the eye, since the sounds themselves were already there and lie stored up apart. For I can summon them too, if I like, and they are immediately present; and though my tongue is at rest and my throat silent I can sing as I will; nor do the images of the colours, although they are as truly present, interfere or interrupt when I call from the storehouse some other thing which came in by the ear. Similarly all other things that were brought in by the other senses and stored up in the memory can be called up at my pleasure: I distinguish the scent of lilies from the scent of violets, though at that instant I smell nothing; and I like honey better than wine, some smooth thing better than rough, though I am not tasting or handling but only remembering.

Holding onto the Future
1987-88
Cast iron, air
74 × 174 × 87 cm

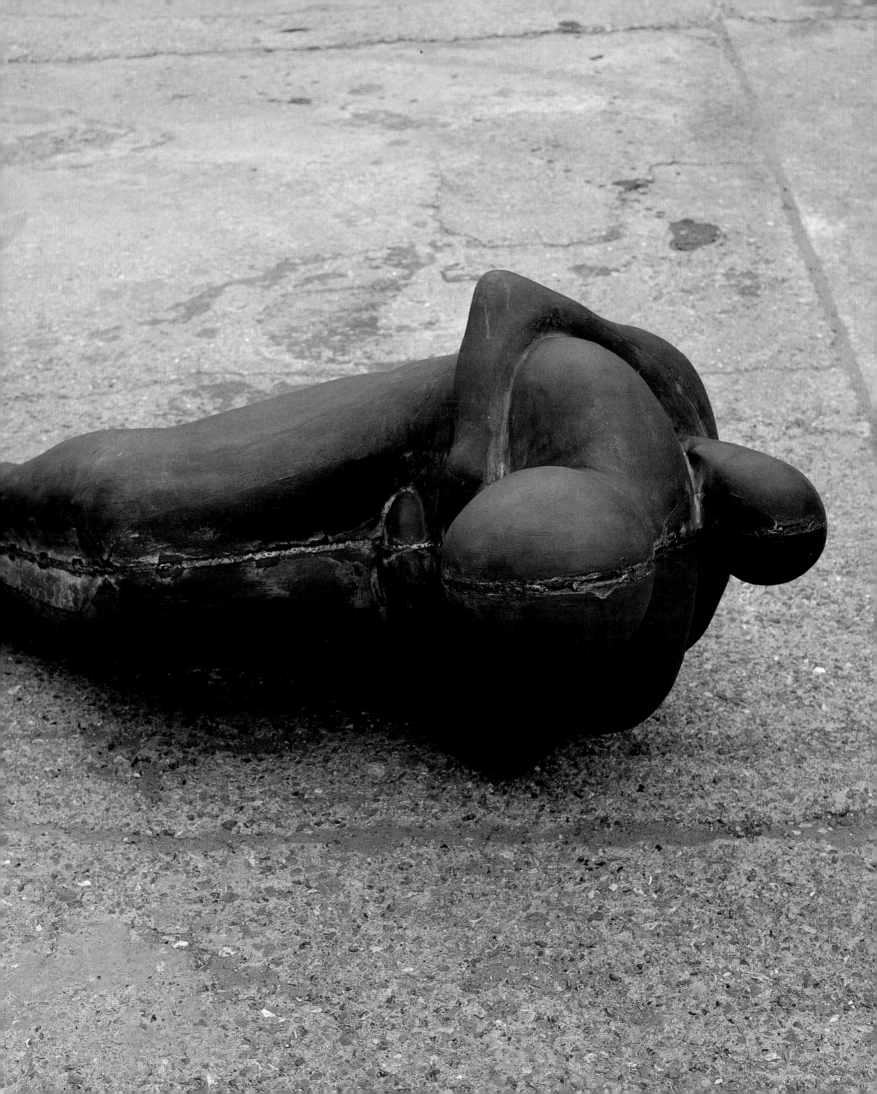

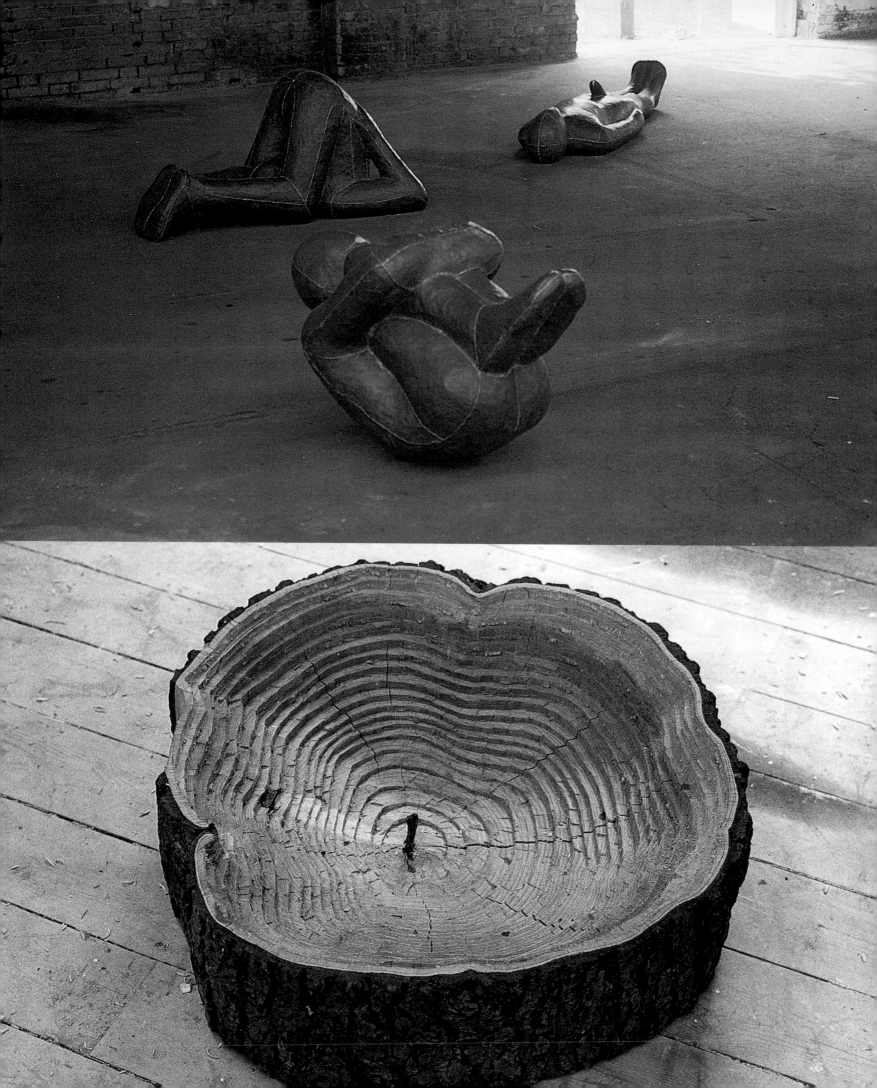

Three Ways: Mould, Hole and
Passage
1981
Lead, fibreglass, plaster
foreground,
Mould, 60 × 98 × 50 cm
middleground,
Hole, 62 × 123 × 80 cm
background,
Passage, 34 × 209 × 50 cm

All this I do inside me, in the huge court of my memory. In my memory are sky and earth and sea, ready at hand along with all the things that I have ever been able to perceive in them and have not forgotten. And in my memory too I meet myself - I recall myself, what I have done, when and where and in what state of mind I was when I did it. In my memory are all the things I remember to have experienced myself or to have been told by others. From the same store I can weave into the past endless new likenesses of things either experienced by me or believed on the strength of things experienced; and from these again I can picture actions and events and hopes for the future; and upon them all I can mediate as if they were present. 'I shall do this or that,' I say to myself in the vast recess of my mind with its immeasurable store of images of things so great: and this or that follows. 'O, if only this or that could be!' or again, 'May God prevent this or that!' Such things I say within myself, and when I speak of them the images of all the things I mention are to hand from the same storehouse of memory, and if the images were not there I could not so much as speak of the things.

Great is this power of memory, exceedingly great, O my God, a spreading limitless room within me. Who can reach its uttermost depth? Yet it is a faculty of my soul and belongs to my nature. In fact I cannot totally grasp all that I am. Thus the mind is not large enough to contain itself: but where can that part of it be which it does not contain? [How can there be any of itself that is not in itself?] As this question struck me, I was overcome with wonder and almost stupor. Here are men going afar to marvel at the heights of mountains, the mighty waves of the sea, the long courses of great rivers, the vastness of the ocean, the movements of the stars, yet leaving themselves unnoticed and not seeing it as marvellous that when I spoke of all these things, I did not see them with my eyes, yet I could not have spoken of them unless these mountains and waves and rivers and stars which I have seen, and the ocean of which I have heard, had been inwardly present to my sight: in my memory, yet with the same vast spaces between them as if I saw them outside me. When I saw them with my eyes, I did not by seeing them swallow them into me; nor are they themselves present in me, but only their images; and I know by what sense of my body each one of them was impressed upon my mind.

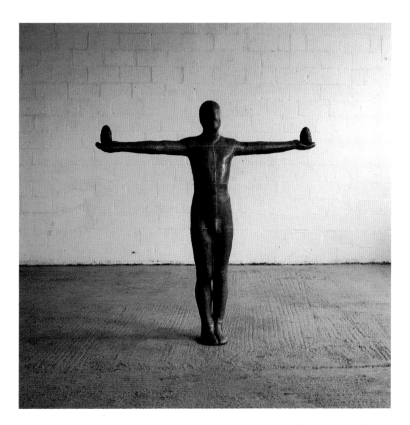

Last Tree (detail)
1979
Cedar wood
100 cm diam.

Work
1984
Lead, terracotta, fibreglass, air
195 × 192 × 30 cm

Baring Light III
1990
Plaster, fibreglass, lead,
rubber, air
16 × 41 × 27 cm

XVI

I can also name forgetfulness and know what I mean by the word; but how should I recognize the thing itself unless I remembered it? I am not speaking of the sound of the word, but of the thing the sound signifies; for if I had forgotten the thing, I should be unable to remember what the sound stood for. When I remember memory my memory itself is present to itself by itself; but when I remember forgetfulness, then memory and forgetfulness are present together - forgetfulness which I remember, memory by which I remember. But what is forgetfulness except absence of memory? How then can that be present for me to remember, which when it is present means that I cannot remember? If what we remember we hold in our memory, and if, unless we remembered forgetfulness, we should not on hearing the word recognize what is meant by it, then forgetfulness is contained in the memory. Therefore that is present, to keep us from forgetting it, which when it is present we do forget. Are we to understand from this that when we remember forgetfulness, it is not present to the memory in itself but by its image: because if it were present in itself it would cause us not to remember but to forget? Who can analyze this, or understand how it can be?

Assuredly, Lord, I toil with this, toil within myself: I have become to myself a soil laborious and of heavy sweat. For I am not now considering the parts of the heavens, or measuring the distances of the stars, or seeking how the earth is held in space; it is I who remember, I, my mind. It is not remarkable if things that I am not are far from my knowledge: but what could be closer to me than myself? Yet the power of memory in me I do not understand, though without memory I could not even name myself. What am I to say, when I see so clearly that I remember forgetfulness? Am I to say that something I remember is not in my memory? Or am I to say that forgetfulness is in my memory to keep me from forgetting? Either would be absurd. Is there a third possibility? Could I say that the image of forgetfulness is retained in my memory, not forgetfulness itself, when I remember it? But how could I say this since if the image of a thing is imprinted on the memory, the thing itself must first have been present, for the image to be able to be imprinted? Thus I remember Carthage and such other places as I have been in; I remember the faces of men I have seen and things reported by the other senses; I remember the health or sickness of the body. For when these were present, the memory received their images from them, and these remained present to be gazed on and thought about by the mind when in their absence I might choose to remember them. It follows that if forgetfulness is retained in the memory by means of an image and not in itself, then itself must at some time have been present for its image to be received. But when it was present, how did it write its image in my memory since by its presence it destroys what it finds noted there? At any rate whatever the manner of it, however incomprehensible and inexplicable, I am certain that I do remember forgetfulness, although by forgetfulness what we remember is effaced.

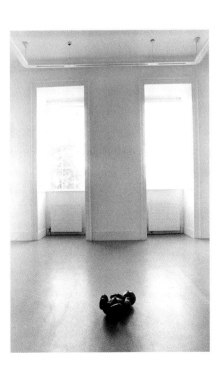

...the ethnographic
... of the
... of the ... y
... Tartars, Etc with
... sheepskin ... cloaks
... black jackets:
... ... Ukrainian
... was so many ...
... The three legged stool
... long benches — all
... Lovely

Contents

Artist's Writings Antony Gormley,

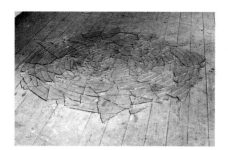

Glass Pool
1978
Glass
182 cm diam.
h. 8 mm

Skin V
1979
Sarsen stone
91 × 121 × 45cm

To act in time and be acted on by time.

On the threshold, the works are gifts of the products of nature and culture to each other.
They are an attempt to stop time and re-present the world. In revelation or insulation
there is no concern to make things stand for anything other than what they are.

Open Door
1975
Wooden door
206 × 206 x 8 cm

Floor
1981
Rubber
$122 \times 91 \times 1$ cm

Artist's Writings

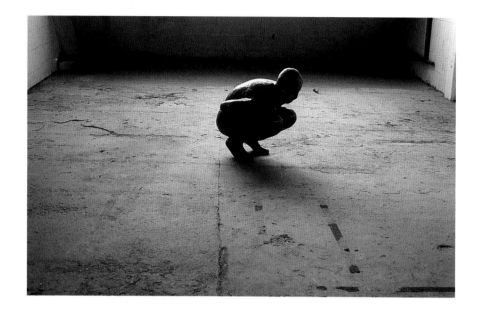

left, **Proof**
1984
Lead, fibreglass, plaster, air
80 × 56 × 80 cm

Things already exist.
Sculpture already exists.

The job is to transform what exists in the outer world
by uniting it with the world of
sensation, imagination and faith.

Action can be confused with life.
Much of human life is hidden.
Sculpture, in stillness, can transmit what may not be seen.

My work is to make bodies into vessels
that both contain and occupy space.

Space exists outside the door and inside the head.

My work is to make a human space in space.

Each work is a place between form and formlessness,
a time between origin and becoming.

A house is the form of vulnerability,
darkness is revealed by light.

My work is to make a place, free from knowledge,
free from history, free from nationality to be experienced freely.

In art there is no progress, only art.
Art is always for the future.

October, 1985, published in 'Antony Gormley: Five Works' (cat.),

1987, Serpentine Gallery, Arts Council of Great Britain, London

opposite
left, **Dark**
1986
Lead, fibreglass, plaster, air
100 × 100 × 120 cm
right, **12 Hours: The Beginning,
the Middle, the End**
1985-86
Lead, fibreglass, plaster, air
23 × 28 × 840 cm

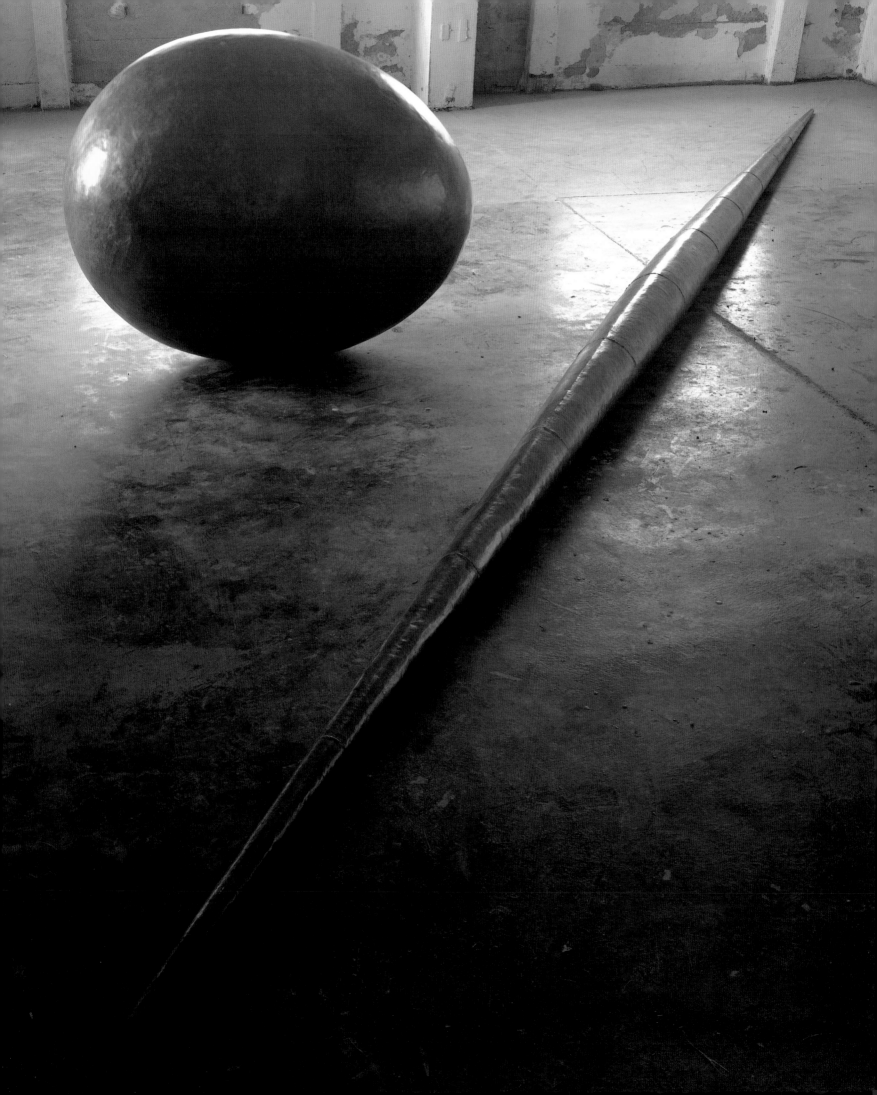

Concerning the Religious Dimension in My Art 1987

Concerning the religious dimension in my art:

The work comes from the same source as the need for religion: wanting to face existence and discover meaning. The work attempts by starting with a real body in real time to face space and eternity. The body – or rather the place that the body occupies is seen as the locus on which those forces act.

Concerning death in the work:

I see all 'things' as earth above ground. We are the most vertical animal. We have been made conscious by space and are full of space. Space exists within us as imagination, thought and sensation and outside of us in terms of distance. Death is a doorway. For me it is an affirmation of the mystery of life and connects in some way with our nature as space. I see space in light and in darkness; one has to do with the imagination and the other with thought.

Culture and our bodies:

I do believe in stressing the physical aspect of consciousness because I believe that is what connects us as human beings. For me there are two kinds of culture, one that is an expression of the connection of man with the physical world that surrounds him and the other is familiar to us all as Western rationalization that separates us from the physical world. The paradox of this is that one leads to materialism and rationalization and the other to magic and freedom. My job in a broken but self-conscious world is to reaffirm connection. The world and my body I must identify as one.

Unpublished notebook entry

Facing the World
1986
Lead, fibreglass, plaster, air
38.5 × 108 × 196 cm

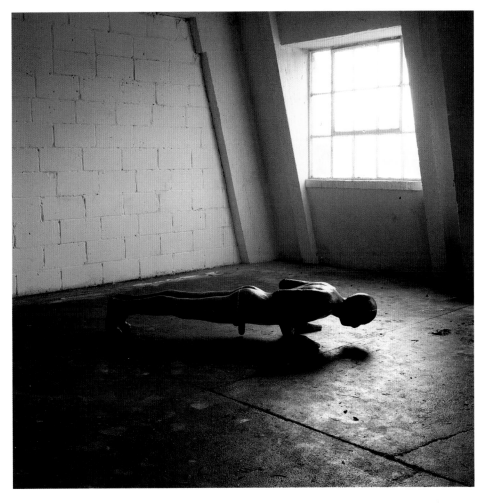

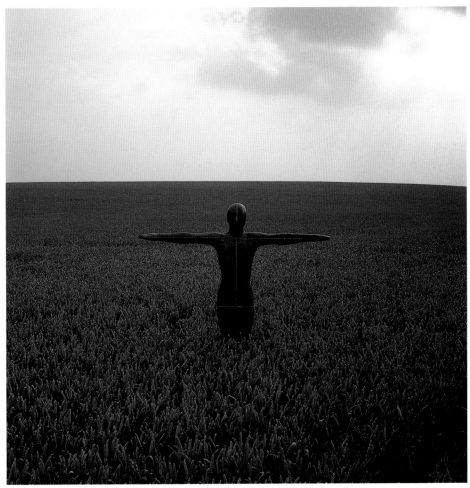

Standing Ground
1986-87
Lead, fibreglass, plaster, air
193 × 191 × 35 cm

Hold
1986
Lead, fibreglass, plaster, air
93 × 61 × 38.5 cm

Pore
1988
Lead, fibreglass, plaster, air
84 × 66 × 80 cm
Installed, Winnipeg Art Gallery,
Manitoba
Collection, Moderna Museet,
Stockholm

I think the whole history of man since the Enlightenment is one of control: of the world understood as an object out there, of vision requiring distance which promotes knowledge. My work tries to create a place of feeling, which is in contrast to objective rationalism.

I question the notion that retinal response is the only channel of communication in art, and the notion that objects are discrete entities. I want to work to activate the space around it and engender a psycho-physical response, allowing those in its field of influence to be more aware of their bodies and surroundings.

It is necessary these days to hold on to the crucial function art has in the continuance and regulation of life. It provides us with images and acts by which we identify ourselves but so often now in an unstable way. Art can be a focus for life by reasserting in times of vicissitude the central beliefs of a people. In tribal cultures it is a collective act whether in dance, carving, self-decoration that reasserts the body of the people and it is from this that the individual draws his or her power. Art and the practice of nonutilitarian skills is an act of will for the future and is as critical an aspect of survival as hunting or gathering food. What has happened to this urgency expressed in a collective creativity that projects into the future and ensures the belief necessary for life? It is not that we have lost it, but the repositories of dance, dream and art are dispersed into the hands of individuals who have responsibility not simply to a single family or tribe but as points of consciousness of the whole world.

'The Impossible Self', (cat.), 1988, Winnipeg Art Gallery, Manitoba

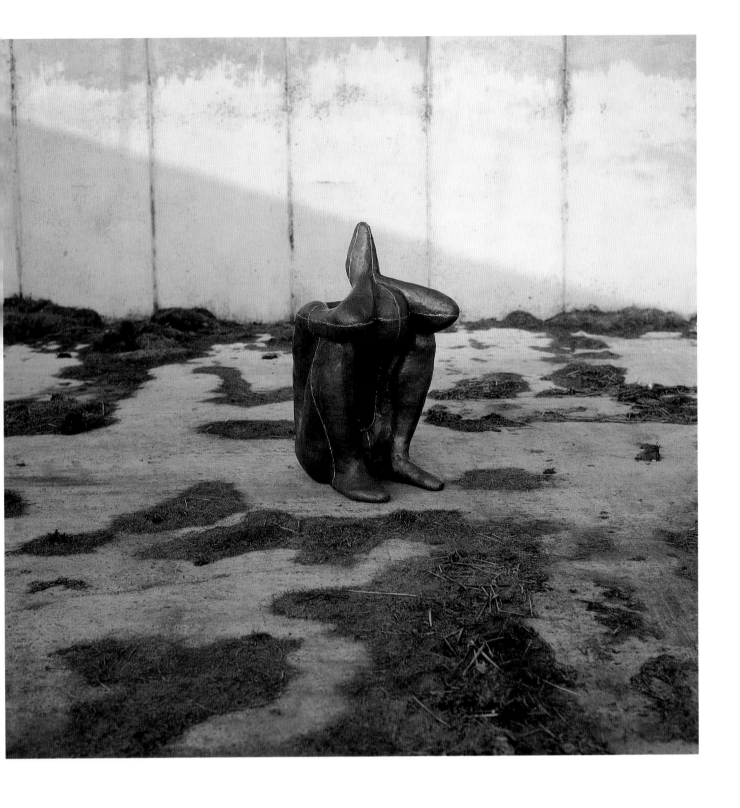

Being the World 1989

opposite, **Immersion**
1991
Concrete
181 × 50.5 × 36.5 cm

overleaf, **Natural Selection**
(details)
1981
Collection, Tate Gallery, London

Nature is within us. We are sick when we do not feel it. The sickness of feeling separate from the world is what is killing it. We are earth above ground, clothed by space, seen by light. The distance inherent in sight has made us treat the 'outside' as different. The dominance of reason depends on the continued externalisation of the world. The light of reason is balanced by the darkness of the body. The unknownness of the mind and the unknownness of the universe are the same. If we are to survive, we must balance outer action with an inner experience of matter. This is the great subjectivity and the great unity. This unity is expressed by those who live close to the earth in living ways. We must integrate our perceptions of the dynamic interpenetration of the elements with the workings of the mind and realise them in the workings of the body. We must become consciously unconscious and unconciously conscious. We are the world, we are the poisoners of the world, we are the consciousness of the world.

Artist in Residence catalogue, Art Gallery of New South Wales, 1989

Refuge
1985
Lead, fibreglass, air
172 × 46 × 46 cm

Seeds IV
1993
Lead
Unit size: 3.5 × 1.1 cm diam

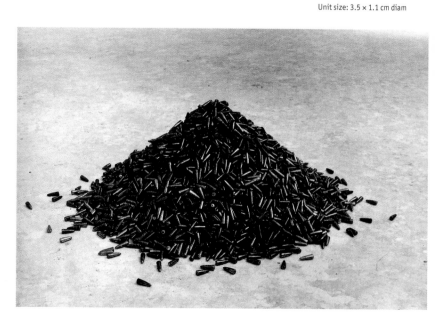

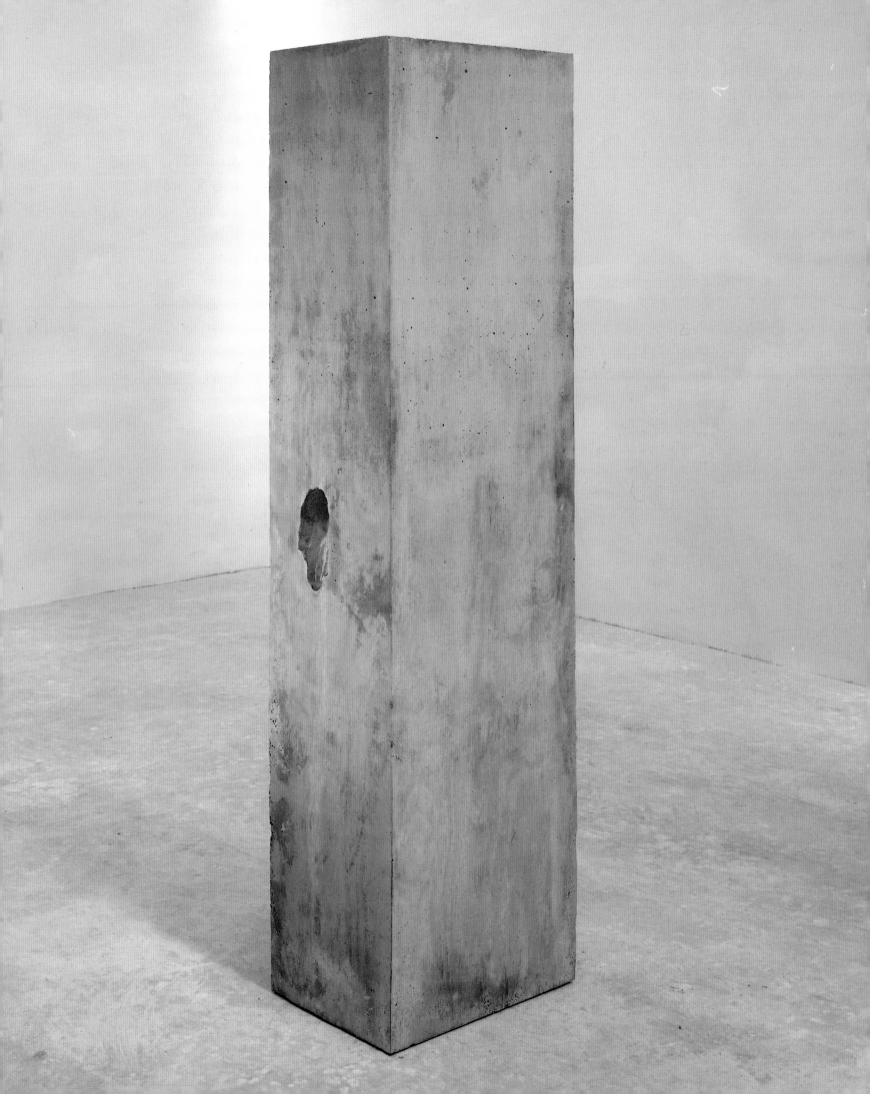

Learning to See: Body and Soul 1992

If late modernist painting conflated the figure and the ground in the interests of a single unequivocal surface, I propose that the body is the ground and that at the other side of appearance is a space far greater than the space against which, traditionally, the body is figured. If Caspar David Friedrich's *Monk and the Sea* is a Rothko with a man in it, I am trying to make a case for a man containing the boundless space of consciousness.

I know all of this is in profound opposition to the post-modern sign-reading, language-orientated currencies, but I hope neither in any nostalgic nor negative way. Perhaps I feel that the world out there is getting pretty good at interpreting itself as we are sold images of ourselves from soaps on television to knitwear ads on the street and I want to explore something else – it's as if the sophistication of culture feeding on culture has left Being out.

Being is rather a vague term. What I am asking is rather than Being engaged with acting in the world, is it possible to express consciousness with no object but itself? Being contained in the body and its feelings, Being conveyed as immersion, where questions of culture become irrelevant.

We have long considered art objects as things in the world. Minimal self-referentiality has been replaced by an enjoyment of judging an object's relation to other objects. In a deconstructive world, art objects have become part of the deconstructing process and a reflection of the plurality of languages and the relativism of value.

I still like the essentializing tendency of modernism because it is a way of feeling more alive. The problem with it was that it all got channelled into finding an objective formal language. I propose an absolute subjectivity allowing existence to become the material, subject and generating principle of art. This is an essentializing process but turned towards internal balance and survival; towards intrinsic value.

This exhibition brings together two works, *Body and Soul*: a series of nine etchings which I made between February and September 1990, and the sculpture *Learning to See* made in 1991. They are both works that evoke the deep space of the interior of the body. In the sculpture for the first time I have kept the lead-covered mould very close to my body and indicated the eyes looking within. I hope its held breath conveys a feeling of the infinity that consciousness inhabits and that you feel included in it. The etchings (my first) try to express touch as gravity made conscious and gravity as the attraction that binds us to the earth. The five dark plates are impressions of the five main orifices: a vision of the inner realm of the body irradiated by the light and energy of what Blake called 'the windows of the soul'.

'Learning to See: Body and Soul' (cat.), 1992, Contemporary Sculpture Centre, Tokyo

Declan McGonagle You have used lead, concrete, iron and in *Host* in Charleston, river mud, to make sculpture. Where does material and its manipulation sit in your preoccupations as an artist?

Antony Gormley **At a certain stage I accepted the Buddhist position; I wanted to deny desire. I saw desire in some way as a false economy of art. The desire to aesthetically possess or be possessed. Hence for the last ten years the preoccupation with enclosing things in an aesthetically neutral material. I chose lead for the same reason as Maillol did for his nudes; he wanted to have a tension between the sensuality of the form and the distancing effect of the material. In about 1984 I realized that clay was an important material. There was a time just after I moved into the new studio when it was just full of clay and I was trying to find a way of making that wasn't imposing an image on the material but allowing a one-to-one relationship between my body and the body of the clay. The forms arose naturally from the space between my hands; clay was another way of dealing with the flesh. Out of this the very first ideas of the *Field* work came. I must have made several hundred before they had eyes and I then realized that eyes were life! Somehow that was a return to desire. With *Field*, joy in material contact is there: it is about touch and touch expressed for its own sake. Touch not just of my hands but of many people's hands. Gone was the feeling that in order to be serious there had to be extreme distance between the personal engendering of the work and its public showing.**

McGonagle It seems you did not allow yourself to enjoy the material, to be seduced or to exhibit that seduction in the final work, until recently. Did you find yourself getting to a point with the material and then deliberately distancing yourself?

Gormley **In the early 1980s I wanted my body to be the prime material. I didn't want the viewer to be seduced by the work for the wrong reasons, I wanted it to be a kind of objective appraisal of my relationship to the world. I am very aware that all dialectical thinking has limited use. We are setting up oppositions between unconditioned and conditioned attitudes but taking on the body was a desire to touch things deeper than at a dialectic level, which was different from a lot of my generation's attitudes to material and how material and meaning coalesce.**

McGonagle That sounds as if the distancing is possibly more than just material.

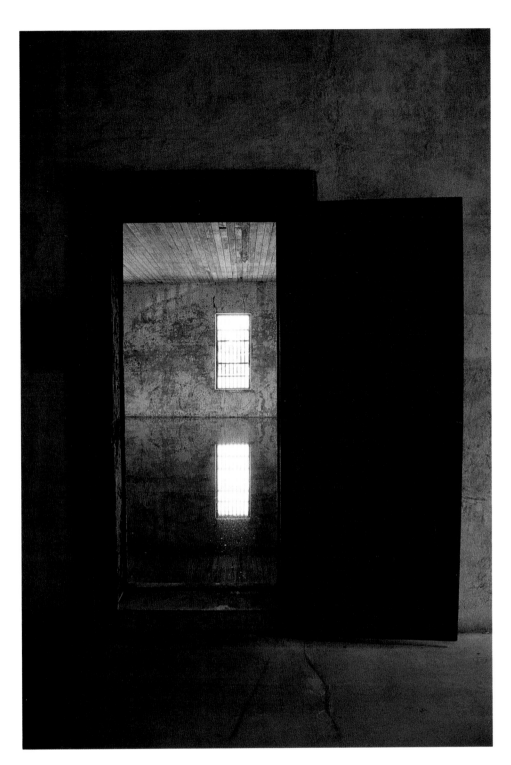

Host
1991
Mud, seawater
Depth 13 cm

Gormley I can well remember, at five or six, the first feeling of not belonging, and wondering whether I was really the son of my mother or father or whether I was some kind of implant. I think I had this sense from very early on (that I got from my father because he was always coming back from India, Malaya or Australia or somewhere) of there being another place where things were different, and that was the place for me.

From the moment I escaped from monastic education I was looking for another world view. I left the sacraments, and yet up to that point, Catholicism had been the central moral and life-supporting structure and remains a vital witness, because it is something that needs replacing. I need to build something as strong as that.

McGonagle Having had a religious, Catholic upbringing I recognize that impulse. Is your practice then built on the expression of anxiety rather than its resolution?

Gormley What you recognize in the pieces in Derry and I recognize in *Field* (page 98-99) is a witnessing of our life but is in some sense also a judgement of it. A lot of the anxiety that I feel comes from the tensions between the chaos of daily life and the sense of judgement in the Catholic moral values with which I was indoctrinated at an early age. I was told as a child that I had the devil in me. Anxiety comes from feeling judged, from not being accepted. I want to start with things that just are, that cannot be judged because judgement does not alter them.

McGonagle Do the works themselves enter the world as witnesses to this process, like *Close* as an idea but also in its siting?

Gormley What I hope *Close* (page 61) does is test the notion of site as a fixed place with the idea that nothing is fixed. My work has been characterized as trying to carry on traditions of the transcendent or the utopian, but I'm not sure about that. I think what it tries to do is talk about some base in a very confusing world by confronting the earth. Because *Close* makes a relationship between itself and the earth, I think by implication the things that are on top of the earth in its vicinity are also implicated, and that includes the viewer.

McGonagle So transcendental or utopian readings of your work are too easy?

Gormley Yes I think it is an easy reading because it suggests that through the work there is an image of release and I think it's more like … the opposite.

McGonagle Is it a doorway towards anxiety?

Gormley I don't think it is that, either. There is a kind of collective madness that is taking us towards a terminal point, but there is also a feeling that this bodily existence of ours is only one level of existence. But I don't know what the next thing is, and the work doesn't pretend to know what the next thing is, either. All I'm trying to do is materialise the uncertainty, and to isolate some point of contact between consciousness and matter.

McGonagle So all you can do is be here? Our human condition is about unknowing and uncertainty rather than knowing?

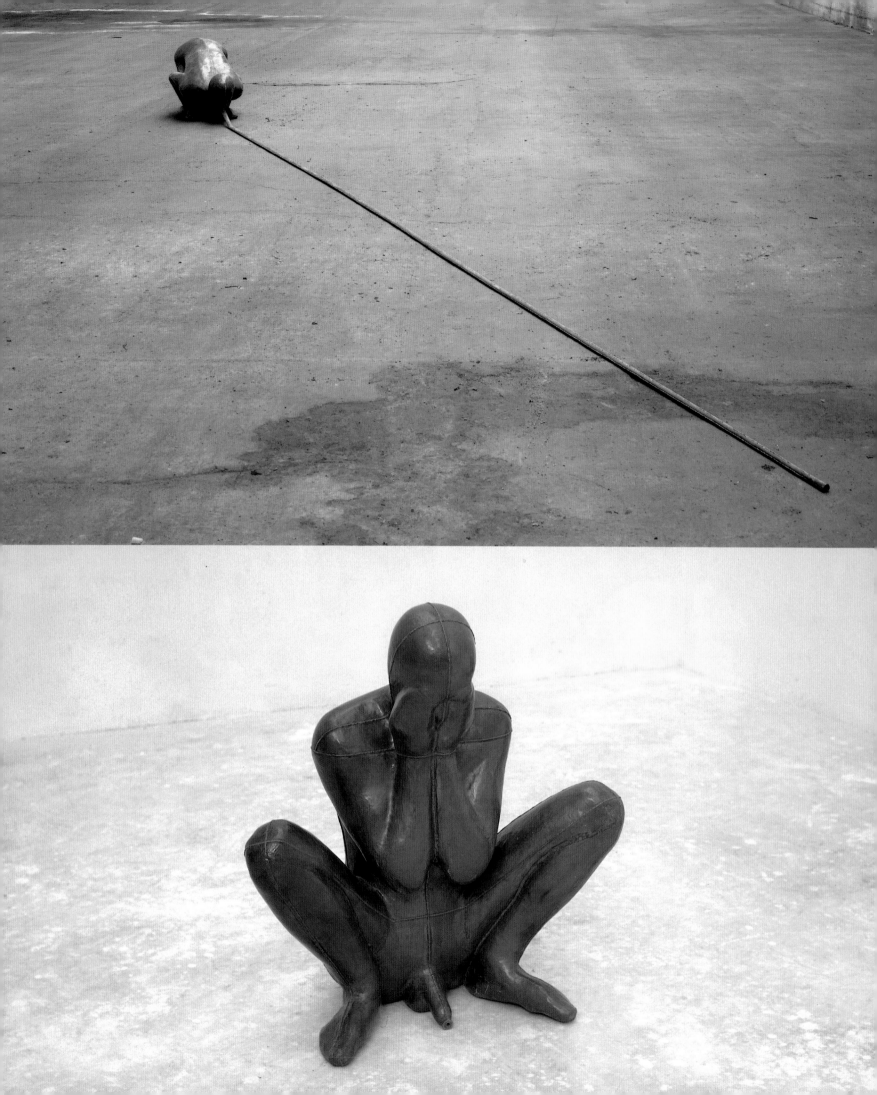

Home and the World
1985-86
Lead, fibreglass, wood,
plaster, air
57 × 405 × 55 cm

Gormley **Yes. I believe that whatever there is beyond is connected with what is here, and you can have a sense of dispersion of self when you sit for a while doing nothing but just being conscious of the body and feeling that attachment to body and self, me and mine disintegrate and you are able to experience energy rather than objects: that is freedom. Maybe people would call that death.**

McGonagle Have you described *Field* in the last few sentences?

Gormley **That's a very nice idea. The idea of being a place is rather like one consciousness being subsumed within a wider consciousness.**

McGonagle Would you make a distinction, then, between your use of the body and other current preoccupations with the body in the work of an artist like Kiki Smith, for instance, whom you feel sees the body as text?

Kiki Smith
Virgin Mary
1992
Wax and pigment
Life-size

Gormley **Yes, I think her interest in the body is, in a way, analytical, but I think what's great about the way that she uses that analysis is that she recognizes that the alimentary or neurological systems have a strong metaphoric meaning in terms of human society generally. But I still find the work plays on a peculiarly American phobia about the breakdown of the body or fear of disease – playing almost a doctoring role to that culture. I am not so concerned with recognition of the functions of the body. I am much more interested in the space that the body is. What is that space that you inhabit when you close your eyes?**

McGonagle It's interesting – this idea of work doctoring to a particular culture. Does your work doctor to any particular culture?

Gormley **'Doctor Heal Thyself', is more my line, and that means finding the other half of life that my upbringing excluded me from – which is an encounter with the earth, the body and the unconscious. You know my parents give me the initials AMDG (Ad Maiorem Dei Gloriam): For the Greater Glory of God. I can remember, when I was about six, my father taking me to one of the factories in his charge, when he had a foundation stone laid with AMDG on it, and a cross, and the date, and saying 'This is yours'.**

McGonagle It must have looked like a tombstone.

135 **Artist's Writings**

Gormley **It did look like a tombstone. But the sense that the shape of my life was known somewhere else was something that I grew up with, and is both a limitation and a kind of enabler, because I don't think I would have set off at eighteen into the unknown without a guardian angel.**

McGonagle So is *A Case for an Angel* a declaration of faith?

Gormley **A *Case for an Angel* is a declaration of inspiration and imagination. It is an image of a being that might be more at home in the air, brought down to the earth. On the other hand it is also an image of somebody who is fatally handicapped, who cannot pass through any door and is desperately burdened. When installed it is a barrier across the space, blocking out the light and blocking the passage of the viewer. The top of the wings are actually at eye level and describe a kind of horizon beyond which you can't see very much, and so you feel trapped and there is a sense of an invitation to assert yourself in the space against it. It is an attempt to re-invent an idea of the object against which you can pit yourself, as in a Serra or a Judd, but differently.**

McGonagle Are you trying to draw upon a tradition or continuum which predates the Renaissance, which is pre-modern and still viable?

Gormley **Do you mean magic – how is that different from Modernism?**

McGonagle Well, the large scale exhibition at the Museum of Modern Art in 1984, '"Primitivism" and Twentieth Century Art', far from re-affirming the principles of Modernism, demonstrated its redundancy! To disconnect art from its social meaning, and value it only in terms of its formal properties, does a disservice to both the so-called 'primitive' practice and Modernist practice. Modernism (the idea that events result from human action) and magic (the pre-modern) may come in and out of focus in human history, but possibilities for both exist now. It's what makes this period particularly interesting, as we come to an end of particular values which ran from the Renaissance through the Reformation, the Enlightenment and nineteenth century Capitalism.

Gormley **There is a recuperation of both modernism and magic. This goes back to finding the other within. It's interesting in relation to the question: 'Is the work transcendent?'. *A Case for an Angel* is not ironic. I do believe that we can be transported or be the agent of**

our own transcendence. Maybe transcendence is the wrong word – but the idea that flight, in gliding, depends on weight and its correct position, is fantastic. I like the marriage of anatomy and technology. It isn't a kind of Icarus – you know, little bird feathers. I want something that is very concrete. In terms of the idiom, you can see the technology and we know that it works. The expansion pieces are the opposite. They go the other way, and try to talk about the human extension into the organic world of cells and vegetables.

McGonagle You have said that the body is a collection of systems, that these systems can connect with other elemental systems.

Gormley **There are two ways of connecting with the elemental and one is technological and the other biological, and I think they are both valid, and both necessary. They both have to be made conscious – not extraction-orientated, integrational rather than exploitative and divisive.**

McGonagle But the body itself is quite muddled, isn't it?

Gormley **No, the body is the way it is. The mind is muddled. One's first relationship is with one's body. Then through one's body one begins to build up another kind of constellation of affection and, hopefully, an emerging sense of some kind of purpose. The sense of emerging purpose that a family describes has to be re-possessed as one of the points of resistance against the dispersal of self in consumer values.**

McGonagle You constantly use an image of dispersal in your discussion of the work, from individual pieces using lead, to the collective in *Field*, and now to the new iron work which is made up of several pieces.

Gormley **I'm thinking of calling the work *Testing a World View*. The work is a kind of psychological Cubism. An identical body cast made from the interior of a body case five times, which I then try to test against architecture. The piece expresses the polymorphousness of the self; that in different places we become different and I think this is physical. If Cubism is about taking one object and making multiple views of it in one place, this is a dispersion of one object into several cases for itself.**

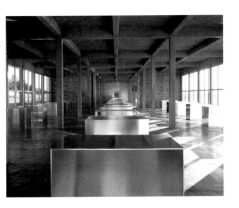

left, **Richard Serra**
Olson
1985-86
Steel
Two plates,
288 × 1036.8 × 4.8 cm each

Donald Judd
Installation, Artillery sheds,
Chinati Foundation, Marfa, Texas
1993

overleaf, **Testing a World View**
1993
Cast iron
5 body cases,
each 1120 × 470 × 1180 cm

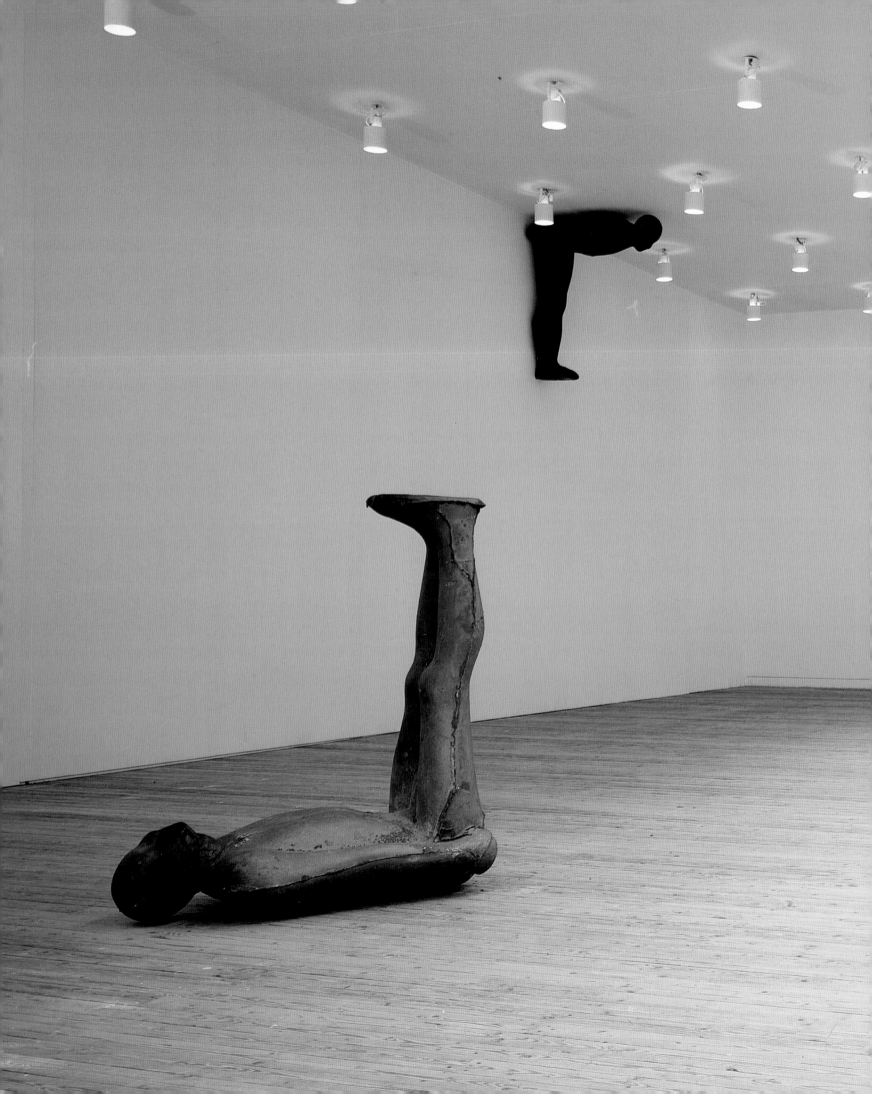

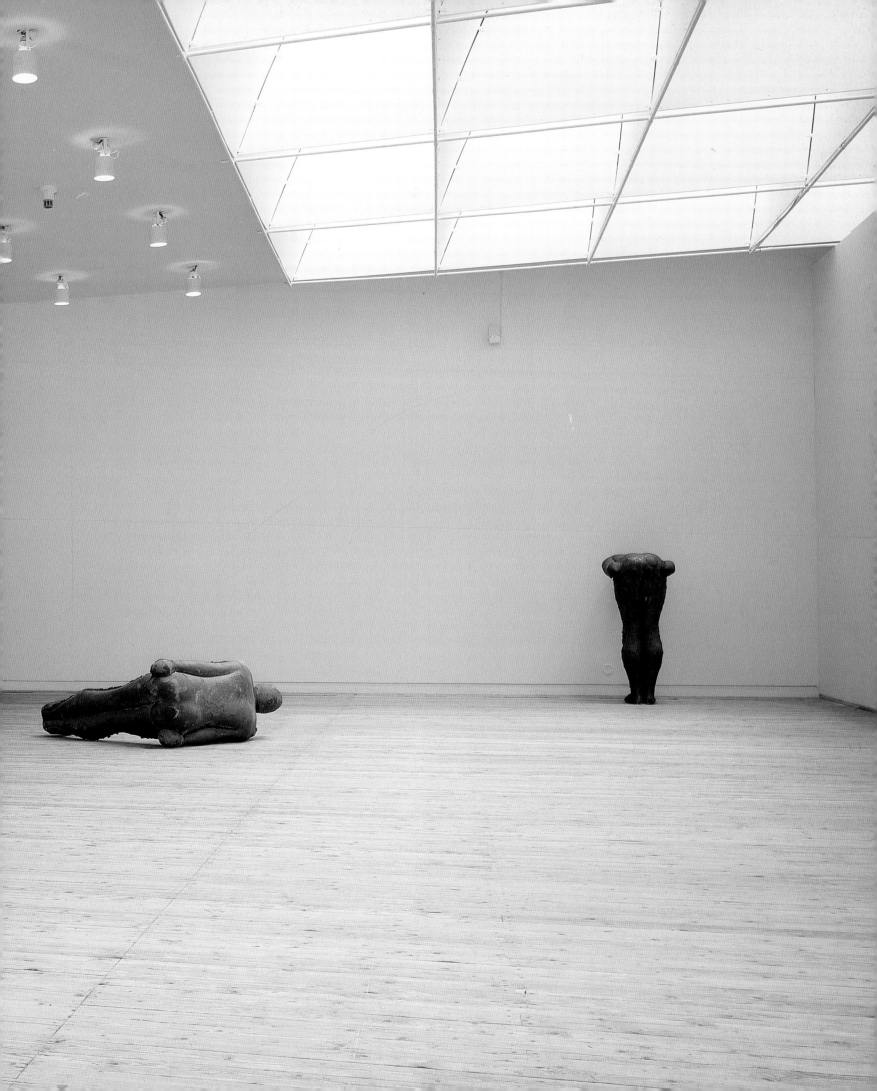

McGonagle Does it always have to be your own body?

Gormley I want to confront existence. It is obviously going to mean more if I use my own body. The optical and the conceptual have dominated in the art of the twentieth century and I turn to the body in an attempt to find a language that will transcend the limitations of race, creed and language, but which will still be about the rootedness of identity. It isn't just an idea about finding an idiom that could be universal, in a way that Modernism failed to do, it is an invitation to recognize a place and a base of consciousness. The body – I keep coming to this idea – is a moving sensor. I want the body to be a sensing mechanism, so your response to the work does not have to be pre-informed and does not necessarily encourage discourse. We are taught to use vision as an identifying force, which allied to discriminating intelligence fixes a thing. So that the strategy, for example, of Richard Deacon, deconstructing the physical world by suggesting multiple readings and denying any one in particular, is one possible strategy. But if you believe in subjects, which I do, you have to find another way. If my subject is being, somehow I have to manage to engage the whole being of the viewer.

I have always been bothered with the idea that the most visible bits of the Western figurative tradition of sculpture are dramatic muscular actions made in marble or bronze like the Discobolus, the Laocoön, or that fantastic Bernini work, *David*. What it suggests is that human potential can only be expressed sculpturally through the depiction of action. That moment of placing one foot in front of the other which began with the archaic Kouroi and continues with Michelangelo's *Slaves*, suggests that muscular action expresses the metaphysical tension between spirit and body, but I'm not so sure. Rodin momentarily recovered from that trap with his *Age of Bronze*; presenting a moment of becoming. What started as a heroic image of the soldier ends up being internalized and becomes a moment of self-consciousness within the body. For me this reconnects with the timelessness of pre-archaic Cycladic Greek sculpture which obviously uses the body in a completely different way as presence rather than actor. The head always addresses itself to the sky. There is something very powerful about the way that both Rodin's *Age of Bronze*, and the Cycladic heads connect being with the infinity of the sky, suggesting human potential, but not in terms of movement. I want to recapture that sense of imaginative space inside the body. I want there to be an internal pressure in the work, that has a relationship with the atmosphere which we sense with our bodies through the skin of the work.

Richard Deacon
If the Shoe Fits
1981
Galvanized corrugated steel, screws
331 × 152 × 152 cm

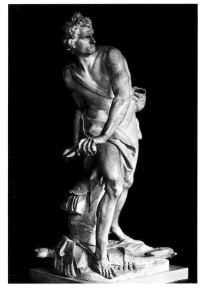

Idol from Amorgos
2500-1100 BC

Laocoon and His Two Sons
1st century AD
Marble
h. 230 cm

Gian Lorenzo Bernini
David
1623
Marble
Life-size

Michelangelo
Boboli Captive
1518-26
Marble
h. 277 cm

The Anavyssos Kouros
c. 530 BC
h. 194 cm

Auguste Rodin
The Age of Bronze
1876
Bronze
175 × 60 × 60 cm

McGonagle How else do you engage the viewer?

Gormley **Through scale, *Field* makes the viewer feel big, and the expansion pieces make one feel rather small. Playing on scale (which is not the same as size) makes us feel our bodies-in-the-world.**

McGonagle How does that work with the concrete pieces?

Gormley **The block describes the space between the body and a compressed notion of architecture, and what I find makes them quite tender is that the principle gesture of all those works is touch. Materiality in sculpture invites touch. They don't. The body that touches is not there and what is touched is space, engaging the air. The concrete has become, as it were, a necessary conditionality. The work has always identified the minimum space necessary for a man to occupy but I think the concrete pieces do it in a more intimate, open and direct way. There is a real point of contact with the particularity of my body – slipped from life into art, with every wrinkle of the knuckles embedded in the concrete. Maybe the concrete works have found a new way of engaging with the central premises of Western sculpture: the relationship of idea to raw materials, image to block.**

McGonagle Are you trying to articulate the silence of the Minimal cube?

Gormley **I think there are other kinds of silence, which are different from the silence of formal certainty, and which can encourage subjective response.**

McGonagle Judd has very powerfully mapped out an absolute in the physical and theoretical territory of his work. It's interesting that Jefferson mapped the Western states of the United States as a grid, as absolutes, and then sent the explorers Lewis and Clark to confirm them. Conception came before perception and demanded a complete invalidation of what and who was there originally and their relationship with the territory. Dominant forces simply do not recognize the 'other' and in that sense neither does puritanical Modernism.

Gormley **In *Field*, the earth is being allowed to carry the voice of the other to re-affirm the spirit of the land that lives through the people. *The American Field* has a strong presence of the original inhabitants of that continent. This is distinct from the pioneers' dreams of possession of the land, where a map is conceptualized ground. I want to make the ground fruitful for the mind. The grid you have drawn – that imposes on the**

Body and Light
1988/93
Lead, fibreglass, air, rosin
38 × 30.5 × 30.5 cm
Brain: 9 × 13 × 16 cm

Meaning
1988/93
Lead, fibreglass
30.5 × 30.5 × 30.5 cm

land – is distinct from the aboriginal intuition which is one of human consciousness being a continuation of the land, the feeling that they are embedded in the land, which is to do with the continuum between human and mineral life.

McGonagle There is a distinction here between the idea of living and the idea of being lived. Aboriginal cultures across the world have different concepts of possession of the land. Since there now seems to be a terminal sense to nineteenth century expansive Capitalism – of which Modernism is a product – different possibilities must exist for collaborative relationships, such as those involved in making a work like *Field*, in Mexico, and then the making and showing of it elsewhere, as you have done in Malmö, and will do in St. Helens.

Gormley **There are lots of things to talk about here, but for me, one of the most important things is that through sharing the engendering of the work, the makers are also the work's first audience and it is not like the audience of a spectacle. It's more like a collective experience of active imaginative involvement. I am inviting a group of people to spend some time with the earth in a way that they wouldn't normally do, to touch it again and again. There is a ritual which is important. We work on the floor at the level of the work.**

McGonagle Could you call it harvesting?

Gormley **It is a kind of harvesting – it's about tilling the earth with your hands but instead of making something grow, it is the earth you are forming directly. The harvest comes from within the people, or the thing that is growing comes out of the people. Everyone has their own row and throughout the project they continue to do row after row on the same strip like the old medieval strip field and they build up a very strong relationship with that patch of earth. Those gazes that they are seeding in the clay look back at them as they are working, suggesting that consciousness is not only inside. I see it as a kind of soul garden. It is a fragile thing but it is a link – both personal to the person who is making them and also common to all of us – something to do with the way in which the figures house the memory. That memory is transpersonal and yet we all have a personal relationship with the future. For me, *Field* is the consummation of being the other, a kind of liberation in many ways – of many ways.**

'Antony Gormley' (cat.), 1993, Malmö Konsthall; Tate Gallery Liverpool; Irish Museum of Modern Art, Dublin

Contents

Chronology Antony Gormley Born 1950 in London, where he lives and works

Selected exhibitions and projects
1968-82

1968 - 71
Studies archaeology, anthropology and art history at
Trinity College, Cambridge

1971-74
Travels through Turkey, Syria, Afghanistan, Pakistan,
India, Iraq, Iran and Sri Lanka. Studies Buddhist
meditation at monastries in India and Sri Lanka

1974 - 75
Central School of Art

1975-77
Goldsmiths School of Art

1977-79
Slade School of Fine Art

1979
'Slade Post Graduate Exhibition',
Slade School of Fine Art (group)

1980
'Nuova Immagine',
XVI Triennale, Palazzo della Triennale, Galleria del
disegno, Milan, Italy (group)
Cat., *Nuova Immagine*, Mazzotta, Milan, text Flavio
Caroli

1981
Serpentine Gallery, London (solo)

Whitechapel Art Gallery, London (solo)
Bulletin sheet, *Antony Gormley*, Whitechapel Art
Gallery, London, text Jenni Lomax

'Objects and Sculpture',
(Allington, Deacon, Gormley, Kapoor, Organ, Randall-
Page, Vilmouth, Woodrow)
Institute of Contemporary Arts, London; **Arnolfini
Gallery**, Bristol (group)
Cat., *Objects and Sculpture*, ICA, London and Arnolfini
Gallery, Bristol, texts Lewis Biggs, Sandy Nairne,
Iwona Blazwick, interviews with the artists

'British Sculpture in the 20th Century',
Whitechapel Art Gallery, London (group)
Cat., *British Sculpture in the 20th Century*, Whitechapel
Art Gallery, London, texts Nicholas Serota and Sandy
Nairne

'Two Stones',
Commission installed 1981, Ashford, Kent

1982
'Aperto '82',
Venice Biennale, (group)
Cat., *Aperto '82*, texts Guiseppe Galasso and Tommaso
Trini

'Hayward Annual: British Drawing'
Hayward Gallery, London (group)
Cat., *Hayward Annual: British Drawing*, Hayward

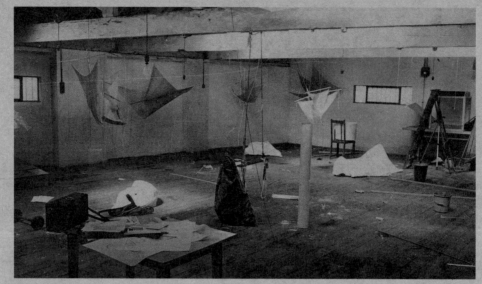
Sleeping Places, in progress, studio in Kings Cross Road 1974

Selected articles and interviews
1968-82

1980
Nuove Immagine, *Flash Art*, Milan, Summer Issue

1981

Cooke, Lynne, 'Antony Gormley at the Whitechapel',
Artscribe, London, No 29
Morgan, Stuart, 'Antony Gormley, Whitechapel
Gallery', *Artforum*, New York, Summer

Russell Taylor, John, 'Objects and Sculpture', *The
Times*, London, June 26
Feaver, William, 'An Air of Light Relief', *The Observer*,
London, 26 June
McNay, Michael, 'ICA', *The Guardian*, London, 17 July
Biggs, Lewis, 'Objects and Sculpture', *Arnolfini Review*,
Bristol, July
Roberts, John, 'Objects and Sculpture', *Artscribe*,
London, No 30
Francis, Mark, 'Objects and Sculpture', *Art Monthly*,
London, July/August

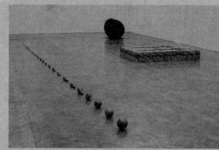
Installation, Whitechapel Art Gallery, London, 1981

'Singleton Sculpture Installation', *S.E. Art News*,
August

1982
Feaver, William, 'Bellyfull of Ballast', *The Observer*,
London

Exhibitions and projects
1982-84

Gallery, London, texts John Elderfield and Mark Francis
'Objects and Figures: New Sculpture in Britain',
Fruitmarket Gallery, Edinburgh, organized by the
Scottish Arts Council touring to **John Hansard Gallery**,
Southampton (group)
Cat., *Objects and Figures: New Sculpture in Britain*, The
Scottish Arts Council, Edinburgh, text Michael Newman

1983
'The Sculpture Show',
Hayward and Serpentine Galleries, London (group)
Cat., *The Sculpture Show*, Hayward and Serpentine
Galleries, London, texts Kate Blacker, Fenella Crichton,
Paul De Monchaux, Nena Dimitrijevic, Stuart Morgan,
Deanna Petherbridge, Bryan Robertson and Nicholas
Wadley

'New Art',
Tate Gallery, London (group)
Cat., *New Art*, Tate Gallery, London, text Michael
Compton

Coracle Press, London (solo)

'Transformations: New Sculpture from Britain',
XVII Bienal de Sao Paulo, Brazil, organized by the
British Council toured to **Museu de Arte Moderna**, Rio
de Janiero; **Museo de Arte Moderno**, Mexico;
Fundacao Calouste Gulbenkian, Lisbon (group)
Cat., *Transformations: New Sculpture from Britain*, The
British Council, London, texts Lynne Cooke, John
Roberts, Nicholas Serota, Lewis Biggs, Stuart Morgan,
Mark Francis and John McEwan

1984
'1984',
Camden Arts Centre, London (group)
Cat., *1984*, Camden Arts Centre, London, text Zuleika
Dobson and artists' statements

Salvatore Ala Gallery, New York (solo)
Cat., *Antony Gormley*, Salvatore Ala Gallery, Milan; New
York, English and Italian editions, text Lynne Cooke

'An International Survey of Recent Painting and
Sculpture',
The Museum of Modern Art, New York (group)
Cat., *An International Survey of Recent Painting and
Sculpture*, **Museum of Modern Art**, New York, text
Kynaston McShine

Riverside Studios, London; **Chapter**, Cardiff (solo)
Cat., *Antony Gormley, Drawings From the Mind's Eye*,
Riverside Studios, London; Chapter, Cardiff, no text

Selected articles and interviews
1982-84

Januszczak, Waldemar, 'The Pop, Skip and Junk
Merchants of Sculpture', *The Guardian*, London, 15
December
Vaisey, Marina, 'The Art of Any Old Iron', *The Sunday
Times*, London, 19 December

Cork, Richard, 'Back to Nature', *London Evening
Standard*, 23 December

1983

Archer, Michael, 'Antony Gormley', *Flash Art*, Milan,
December

Serota, Nicholas, 'Transformations: New Sculpture
from Britain', *Artefactum*, Belgium, February/March

Tio Bellido, Ramon, 'Antony Gormley', *Axe-Sud*, Winter
Newman, Michael, 'Man's Place: Four Works', *Art &
Artists*, New York

1984

Levin, Kim, 'The Clone Zone', *The Village Voice*, New
York, 15 May
Biegler, Beth, 'Antony Gormley at Salvatore Ala', *The
East Village Eye*, New York, June
Moorman, Margaret, 'Antony Gormley; Salvatore Ala',
ARTnews, New York, September
Linker, Kate, 'Antony Gormley', *Artforum*, New York,
October

Packer, William, 'Body Building Exercises the
Sculptor's Mind', *The Financial Times*, London, 25
September

Drawings, in progress, Frederick Street studio, 1982

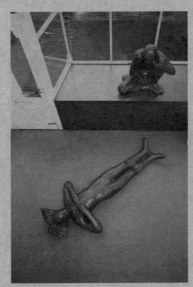

Installation, Coracle Press, London, 1983

CAMDEN ARTS CENTRE

NINETEEN EIGHTY-FOUR

AN EXHIBITION

'The British Art Show',
City of Birmingham Museum; **Ikon Gallery**,
Birmingham; **Royal Scottish Academy**, Edinburgh;
Mappin Art Gallery, Sheffield; **Southampton Art
Gallery** (group)
Cat., *The British Art Show*, texts Jon Thomson and
Marjorie Allthorpe-Guyton

'Metaphor and/or Symbol',
National Gallery of Modern Art, Tokyo; **National
Museum of Art**, Osaka (group)
Cat., *Metaphor and/or Symbol*, National Gallery of
Modern Art, Tokyo, texts Kenji Adachi, Michiaki
Kawakita and Tadao Osura

1985
'The British Show',
organized by Art Gallery of New South Wales, Sydney
and The British Council, toured to **Art Gallery of
Western Australia**, Perth; **Art Gallery of New South
Wales**, Sydney; **Queensland Art Gallery**, Brisbane; **The
Exhibition Hall**, Melbourne; **National Art Gallery**,
Wellington, New Zealand (group)
Cat., *The British Show*, Art Gallery of New South Wales,
texts various authors, Antony Gormley essay by Sandy
Nairne

Galerie Wittenbrink, Munich, Germany (solo)

Galleria Salvatore Ala, Milan, Italy (solo)

Stadtisches Galerie, Regensburg, and **Frankfurter
Kunstverein**, Frankfurt (solo)
Cat., *Antony Gormley*, Stadtische Galerie Regensburg,
Frankfurter Kunstverein, texts Veit Loers and Sandy
Nairne

Feaver, William, 'Variations on a Body', *The Observer*,
London, September
Vaisey, Marina, 'Art & Counterpart', *The Sunday Times*,
London, 16 September
Miller, Sanda, 'Antony Gormley at Riverside', *Artscribe*,
London, No 49
Januszczak, Waldemar, 'Going up Like a Lead Balloon',
The Guardian, London, 2 October
Berman, Arthur, 'Antony Gormley', *TNT*, London, 2
October
Kopecek, Paul, 'Antony Gormley', *Art Monthly*, London,
October
Rowat, Ken, 'Chapter Shows', *The Guardian*, London, 19
December

Ducann, Charlotte, 'Interview with Antony Gormley',
World of Interiors, London, November

Installation, Riverside Studios, London, 1984

Archer, Michael, 'Antony Gormley', *Flash Art*, Milan,
December

Newman, Michael, 'Discourse and Desire in British
Sculpture', *Flash Art*, Milan, January
'Antony Gormley Talking to Paul Kopecek', *Aspects*,
London, No 25, January
Dimitrijevic, Nena, 'Antony Gormley', *Flash Art*, Milan,
January

1985

Bluemler, Detelf, 'Munchen', *Kunstzeitschrift*, May
Muller, Dorothee, ' Schwebende Giftige Maner: Antony
Gormley in der Muncher Galerie Wittenbrink',
Suddeutsche Zeitung, June

Conti, Vianna, 'Antony Gormley', *Artefactum*, Belgium,
September/ October

'Weit Ausgeholt', *Suddeutsche Zeitung*, No 168, July
'Figuren in Fadenkreuz', *ART das Kunstmagazine*,
September
'Bleierner Gast im Steinernen Haus', *Frankfurter
NeuePresse*, 13 August
'Stille Skulpturen und skelettierter Kreisel', *Frankfurter
Allegmeine Zeitung*, 14 August
'Antony Gormley', *Frankfurter Allegmeine Zeitung*, 17
August
Pokorny, Rita, 'Using the Body As If It Was a Face',

Exhibitions and projects
1985-86

'Anniottanta',
Galleria Communale d'Arte Moderna, Bologna (group)
Cat., *Anniottanta*, Galleria Communale d'Arte Moderna,
text Lynne Cooke

'Drawings 1981-1985',
Salvatore Ala Gallery, New York (solo)
Cat., *Antony Gormley Drawings*, Salvatore Ala Gallery,
Milan/New York, no text

ANTONY GORMLEY
DRAWINGS

11 October to 9 November 1985

SALVATORE ALA GALLERY
52 WEST 20TH NEW YORK 10011
212 741 5544

'Nuove trame dell'arte',
Castello Colonna di Genazzano, Italy (group)
Cat., *Nuove trame dell'arte*, Castello Colonna di
Genazzano, Italy, text Achille Bonito Oliva

'Three British Sculptors',
Neuburger Museum, State University of New York,
Purchase (group)

1986
'Between Object and Image',
organized by Ministerio de Cultura and The British
Council, toured to **Palacio de Velasquez**, Parque del
Retiro, Madrid; **Centre Cultural de la Caixa de
Pensions**, Barcelona; Centro de Arte Moderna de
Fundacao Gulbenkian, Lisbon (group)
Cat., *Between Object and Image*, Ministerio de Cultura
and The British Council, texts Lewis Biggs, Juan Muñoz
and Julian Andrews

'Drawings',
Victoria Miro Gallery, London (solo)

'The Generic Figure',
The Corcoran Gallery of Art, Washington, D.C. (group)
Cat., *The Generic Figure*, The Corcoran Gallery of Art,
Washington, text Ned Rifkin

Salvatore Ala Gallery, New York (solo)

ANTONY GORMLEY

21ST FEBRUARY - 14TH MARCH 1986

VICTORIA MIRO · LONDON
21 CORK STREET LONDON WIX IHB
TELEPHONE 01 734 5082

PRIVATE VIEW THURSDAY 20TH FEBRUARY 6 - 8

'Art and Alchemy',
Venice Biennale, Italy (group)

'Prospect '86',
Frankfurt Kunstverein, Frankfurt (group)
Cat., *Prospect '86*, Frankfurt Kunstverein, texts Peter
Weiermair et al.

Selected articles and interviews
1985-86

Neue Kunst in Europe, No 9, July/August/September

Somaini, Luisa, 'Antony Gormley', *La Republica*,
10 May
Somaini, Luisa, 'I dieci corpi dello scultore buddhista',
La Republica, 5 June

'Antony Gormley', *Flash Art*, March
Weskott, Hanne, 'Antony Gormley', *Kunstforum*
Antolini, Adriano, 'La Scultura? Ha Corpo', *Il Giornale*,
26 May
Nerozzi, Barbara, 'L'esperienza dell'orizzonte', *Gran
Bazaar*, No 8/9 Milano, August/September
Comi, Enrico R., 'La quotidianita cosmica del lavoro di
Gormley, *Spazio Umano*, No 3, July/September
Weinstein, Matthew, 'Antony Gormley', *Westuff*, No 2,
September
Conti, Vianni, 'Antony Gormley', *Artefactum*, Belgium,
September/October

Bickers, Patricia, 'When is Sculpture not a Sculpture?',
Aspects, London, No 29
'Monumentale Body-Art', *Passauer Neue Presse*, July
Higgins, Judith, 'Antony Gormley', *ARTnews*, New York,
December

1986
Zaya, 'Antony Gormley: El Otro de uno Mismo', *Culturas
Diaro 16*, 26 October

Studio, 1986

Richard, Paul, 'Upbeat Creature Feature at the
Corcoran', *The Washington Post*, 15 March

Fisher, Jean, 'Antony Gormley', *Artforum*, January
Levin, Kim, 'Chernobyl, Mon Amour', *The Village Voice*,
New York, 24 June
Saunders, Wade, and Rochette, Anne, 'Antony Gormley
at Salvatore Ala', *Art in America*, New York, November

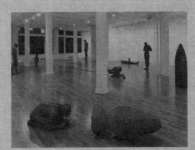

Installation, Salvatore Ala Gallery, New York, 1986

Badoni, Rudolph Kramer, 'Ein Arm Spielt auf
gespaltenei', *Die Welt*, 10 September
Merkle, Harry, 'Lau, Laut und Laokoom', *Taz Berlin*, 20
September

'Vom Zeichnen: Aspekte der Zeichnung',
Frankfurter Kunstverein; Kasseler Kunstverein;
Museum Moderner Kunst, Vienna (group)
Cat., *Vom Zeichnen: Aspekte der Zeichnung*, Frankfurter
Kunstverein, Kasseler Kunstverein, Museum Moderner
Kunst, Vienna, text Peter Weiermair

1987
'State of the Art',
Institute of Contemporary Art, London (touring
exhibition) (group)
Cat., *State of the Art*, Channel 4, London, texts Sandy
Nairne, Geoff Dunlop and John Wyver

'Five Works',
Serpentine Gallery, London (solo)
Cat., *Antony Gormley Five Works*, Serpentine Gallery,
Arts Council of Great Britain, London, text Antony
Gormley

'Vehicle',
Salvatore Ala Gallery, New York (solo)

Galerie Hufkens de Lathuy, Brussels (solo)

'Chaos and Order in the Soul',
University Psychiatric Clinic, Mainz, Germany (group)
Cat., *Chaos and Order in the Soul*, University Psychiatric
Clinic, Mainz, Germany, text Peter Weiermair

'Avant-Garde in the Eighties',
Los Angeles County Museum of Art, Los Angeles
(group)
Cat., *Avant-Garde in the Eighties*, Los Angeles County
Museum of Art, Los Angeles, text Howard N. Fox

'TSWA 3D',
City Walls, Derry, Ireland (group)
Cat., *TSWA 3D*, texts Jonathan Harvey, Tony Foster and
James Lingwood

'The Reemergent Figure',
Seven Sculptors at **Storm King Art Center**,
Mountainville, New York (group)
Cat., *The Reemergent Figure*, Storm King Art Center,
Mountainville, New York, texts Peter Stern and Suzi
Gablik

'Documenta 8',
Kassel, Germany (group)
Cat., *Documenta 8*, text Manfred Snackenburger

'Mitographie: Luoghi Visibili/Invisibile dell'Arte',
Pinacoteca Comunale, Ravenna (group)
Cat., *Mitographie: Luoghi Visibili/Invisibile dell'Arte*,
Pinacoteca Comunale, Ravenna, texts Cerritale,
Battisti, Dorfles, Bondini

'Man Made Man',
La Criée Halle d'Art Contemporain, Rennes, France
(solo)

ANTONY GORMLEY
"VEHICLE"

30 April– 26 May 1987
Opening reception: 30 April, 6–8 pm

salvatore ala
52 west 20th new york 10011 tel 741.5544

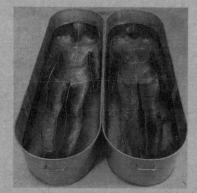

Chromosome, in progress, 1987

Dorfles, Gillo, 'Antony Gormley', *Italian Vogue*,
February/March
Cork, Richard, 'In Situ', *The Listener*, London, 5 June

1987
Archer, Michael, 'State of the Art', *Artforum*, New York,
Summer

Kent, Sarah, 'In the Lead', *Time Out*, 11 March
Cork, Richard, 'Figures of Everyman', *The Listener*,
London, 19 March
Morley, Simon, 'Serpentine Gallery: Antony Gormley',
Artline, London, April

'Les Hommes et les Objets de Antony Gormley', *Libre
Belgique*, May

Volp, Rainer, 'Geheimnisse sind immer sperrig', *Kunst
und Kirche*, Darmstadt, February

Vehicle, in progress, Dunstable, England, 1987

Gooding, Mel, 'Seeing the Sites', *Art Monthly*,
July/August
'Man of Iron', *Stroll* No . 4/5

Brenson, Michael, 'Images that Express Essential
Human Emotions', *The New York Times*, July
Zimmer, William, 'Figurative Sculpture Makes Impact at
Storm King Art Center', *The New York Times*, August

Bode, Peter M., 'Kraft Nach Kassel', *Vogue*, Munich,
June

THE REEMERGENT FIGURE
SEVEN SCULPTORS AT STORM KING ART CENTER

Lemee, Jean-Philippe, 'Antony Gormley Man Made
Man', *Art Presse*, Paris, 119

Exhibitions and projects

1987-88

'Viewpoint',
Musees Royaux des Beaux-Arts de Belgique,
Bruxelles (group)
Cat., *Viewpoint*, Musees Royaux des Beaux-Arts de
Belgique, Bruxelles, texts various authors, essay on
Antony Gormley by Marjorie Allthorpe-Guyton

'Out of the Dark',
Commission installed 1987-88, Martinsplatz, Kassel,
Germany

'Drawings',
Seibu Contemporary Art Gallery, Tokyo (solo)
Cat., *Gormley*, The Seibu Department Stores, Tokyo,
text Michael Newman

1988
Burnett Miller Gallery, Los Angeles (solo)

'The Impossible Self',
Winnipeg Art Gallery and **Vancouver Art Gallery**
(group)
Cat., *The Impossible Self*, Winnipeg Art Gallery and
Vancouver Art Gallery, texts Sandy Nairne and Bruce
Ferguson

'Starlit Waters: British Sculpture An International Art
1968-1988',
Tate Gallery Liverpool (group)
Cat., *Starlit Waters: British Sculpture An International
Art 1968-1988*, Tate Gallery Liverpool, texts Lewis
Biggs, Lynne Cooke, Richard Francis, Martin Kunz,
Charles Harrison and Iain Chambers

'Rosc '88',
Guinness Hop Store, Dublin, Ireland (group)
Cat., *Rosc '88*, Guinness Hop Store, Dublin, texts
Patrick Murphy, Aidan Dunne and Olle Granath

'British Now: Sculpture et Autres Dessins',
Musee D'Art Contemporain de Montreal, Montreal
(group)
Cat., *British Now: Sculpture et Autres Dessins*, Musee
D'Art Contemporain de Montreal, Montreal, texts
Sandra Grant Marchand and Michel Brisebois

Contemporary Sculpture Center, Tokyo (solo)
Cat., *Antony Gormley*, Contemporary Sculpture Center,
Tokyo, text Tadayasu Sakai

'Made to Measure',
Kettles Yard, Cambridge (group)
Cat., *Made to Measure*, Kettles Yard, Cambridge, text
Hilary Gresty

'The Holbeck Sculpture',
Leeds City Art Gallery (solo)

Selected articles and interviews

1987-88

De Ruyck, Jo, 'Verrassende verscheidenheid van de
hedendaagse Britse kunst', *Het Volk*, Brussels, 17
December
Meuris, Jacques, 'Une saison britannique à points de
vue multiples', *Libre Belgique*, Brussels, 26 December

Schwarze, Dirk, 'Kunst in der Stadt', *Stadt Kassel*, 6 May
'Kunst soll anstoben, nicht beruhigen', *Stadt Kassel*, 6
May
'Kunst in der Stadt', *Kassel Kulturell*, September
'Der Eiserne Gormley', *Frankfurter Rundschau*,
Frankfurt, 29 January 1992

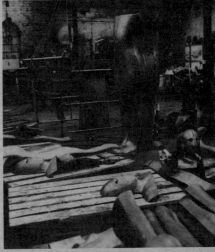

Sculpture for Derry Walls, in progress, Tay-Forth Foundry, 1987

Roustayi, Mina, 'An Interview with Antony Gormley',
Arts Magazine, New York, September
Levin, Kim, *The Village Voice*, New York, 20-26 May
Graham-Dixon, Andrew, 'Antony Gormley's Bizarre
Sculptural Techniques', *Harpers and Queen*, London,
February

1988

Enright, Robert, 'Inverse Aesthetics', *Border Crossings*,
Summer

Pulson, Diana, 'Here's a toast to two gents and, er,
sliced bread?' *The Echo*, Liverpool, 24 May

Mays, John Bentley, 'British Sculpture Show Positive
Step for MAC', *The Globe and Mail*, Montreal, Canada,
24 September

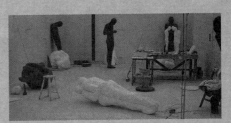

Studio, 1988

Warner, Marina, 'Statue of Liberty', *The Independent*,
London, 4 May 1987

Exhibitions and projects
1988-89

'Brick man' commission for Leeds City Council, not
realized

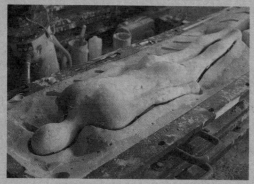

Work in progress, Lennox Foundry, Kent, 1989

1989
Museum of Modern Art, Louisiana, Humlebaek,
Denmark (solo)
Cat., *Antony Gormley*, Museum of Modern Art,
Louisiana, Humlebaek, Denmark, texts by Richard
Calvocoressi and Oystein Hjort

'It's a Still Life',
Arts Council Collection, **The South Bank Centre**,
London (group)
Cat., *It's a Still Life*, The South Bank Centre, London,
text Roger Malbert

Salvatore Ala Gallery, New York (solo)

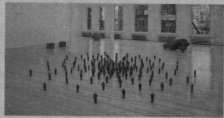

Installation, Salvatore Ala Gallery, New York, 1989

Scottish National Gallery of Modern Art,
Edinburgh (solo)

'A Field for the Art Gallery of New South Wales, A Room
for the Great Australian Desert',
Art Gallery of New South Wales, Sydney, Australia
(solo)
Cat., *A Field for the Art Gallery of New South Wales, A
Room for the Great Australian Desert*, Art Gallery of New
South Wales, Sydney, texts by Antony Gormley and
Anthony Bond

'Drawings',
McQuarrie Gallery, Sydney, Australia (solo)

Selected articles and interviews
1988-89

'Dropping a Brick', *Yorkshire Evening Post*, October
Williams, Alan, 'Permission to Stand', *The
Independent*, 4 July
Topp, Amanda, 'Brickman a Landmark', *Yorkshire
Evening Post*, 18 August
Bailey, Martin, 'Monumental Man Set to Tower Over
City', *The Sunday Observer*, London, 16 October
Bakewell, Joan, 'Vote to Cement History', *The Sunday
Times*, London, 30 October
'BrickMan', *The Sunday Telegraph*, London, 13
November
Januszczak, Waldemar, 'The Might Have Been Man', *The
Weekend Guardian*, London, 17 December
Waterhouse, Keith, 'The Brick Colossus', *Daily Mail*,
London, 1 September
Auberon Waugh's Column, *The Sunday Telegraph*,
London, 4 September

1989
Wachtmeister, Marika, *Sysvenenska Dagbladet*, Malmo,
Sweden, 30 January
Christiansen, Flemming, 'Kroppe af bly', *Politiken*,
Copenhagen, 20 January
Meyer, Peter S., 'Suveraen iscenesaettelse', *Kristeligt
Dagsblad*, 25 January
Kobke Sutton, Gertrud, 'Kroppens tyste tale',
Information, 14 February

Brenson, Michael, 'A Sculptor Who Really Gets Into His
Work', *The New York Times*, 17 May
Kaufman, Jason Edward, 'Antony Gormley's Human
Cyphers', *The New York Tribune*, 10 May
Reeves, Jennifer W., 'Cast in the Sculptor's Own
Mould', *The Christian Science Monitor*, New York, 14
August
Faust, Gretchen, New York in Review, *Arts Magazine*,
New York, September

Prince, Geraldine, 'A Plastered Sculptor', *The
Independent*, London 2 May
MacDonald, Murdo, 'Body Language That Reflects the
Universal Condition', *The Scotsman*, Edinburgh, 11 May
Graham-Dixon, Andrew, 'Life Set Upon a Cast', *The
Independent*, London, 9 May
Prince, Geraldine, 'A Cast of One', *The List*, 18 May
Henry, Clare, 'Figured Out: a Way of Lifting Base Metal
to Artistic Heights', *Glasgow Herald*, 26 May

MacDonald, John, 'Sumptuous Commodities', *The
Sydney Morning Herald*, Sydney, 18 November
Lynn, Elwyn, 'The Ambiguity of Intimacy', *The Weekend
Australian*, Sydney, 18–19 November

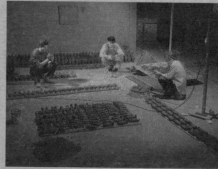

Lynn, Elwyn, 'Subtly Reduced, with Abandon', *Weekend
Australian*, Sydney, 4–5 November

Field for the Art Gallery of New South Wales, in progress, 1989

Exhibitions and projects
1989-91

'Objects of Thought',
Tornberg Gallery, Malmo, Sweden
'Visualization on Paper: Drawing as a Primary Medium',
Germans van Eck, New York (group)

1990
'Baring Light',
Burnett Miller Gallery, Los Angeles (solo)

'Drawing',
Burnett Miller Gallery, Los Angeles (solo)

'Great Britain - USSR',
The House of the Artist, Kiev; **The Central House of the Artist**, Moscow (group)
Cat., *Great Britain - USSR*, The House of the Artist, Kiev; The Central House of the Artist, Moscow, texts David Thorp and Jonathan Watkins

'British Art Now: A Subjective View',
organized by the British Council, toured to **Setagaya Museum**, Tokyo; **Fukuoka Art Museum; Nagoya City Museum; Tochigi Prefectural Museum of Fine Arts; Hyogo Prefectural Museum; Hiroshima City Museum** (group)
Cat., *British Art Now: A Subjective View*, The British Council, texts Junichi Shioda, Andrew Graham-Dixon and Akio Obigane

1991
'Drawings and Etchings',
Frith Street Gallery, London (solo)

Galerie Isy et Christine Brachot, Brussels (solo)

'Field',
Salvatore Ala Gallery, New York (solo)

'Places with a Past', Sculpture for the Old Jail,
Spoleto Festival U.S.A., Charleston, South Carolina (group)
Cat., *Places with a Past*, Spoleto Festival, texts Mary Jane Jacob, Theodore Rosengarten, Nigel Redden and John McWilliams

'Inheritance and Transformation',
The Irish Museum of Modern Art, Dublin (group)
Cat., *Inheritance and Transformation*, The Irish Museum of Modern Art, Dublin, texts John Hutchinson and Declan McGonagle

Selected articles and interviews
1989-91

Wachtmeister, Marika, *Sysvenenska Dagbladet*, Malmo, Sweden, 30 January

Morley, Simon, 'Antony Gormley', *Tema Celeste*, Siracusa, April/June
'Antony Gormley', *Art and Design*, Academy Editions, vol 5, No 3/4, London
Turnbull, Clive, 'Antony Gormley: The Impossible Self', *The Green Book*, vol III, No 1, Bristol
Lynn, Victoria, 'Earth Above Ground', *Art & Text*, Paddington, Australia, Summer

1990
Pagel, David, 'Antony Gormley', *Arts Magazine*, New York, April
Curtis, Cathy, Gormley's Vision, *Los Angeles Times*, 24 April

1991
Graham-Dixon, Andrew, *The Independent*, London, 22 January

Taplin, Robert, 'Antony Gormley at Salvatore Ala', *Art in America*, New York, November
Brenson, Michael, 'Antony Gormley: Salvatore Ala Gallery', *The New York Times*, 29 March
Schwabsky, Barry, 'Antony Gormley', *Arts Magazine*, New York, Summer
Padon, Thomas, 'Antony Gormley: Salvatore Ala, New York', *Sculpture Magazine*, New York, September/October

Danto, Arthur C., 'Spoleto Festival USA', *The Nation*, New York, 29 July
Brenson, Michael, 'Visual Arts Join Spoleto Festival USA', *The New York Times*, 27 May

Learning to Think, in progress, workshop, Peckham, London, 1990

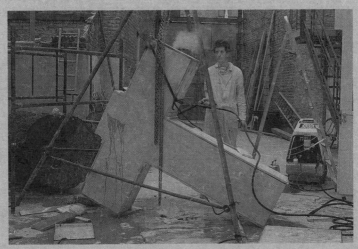

Flesh, in progress, studio, Peckham, London, 1990

GALERIE CHRISTINE ET ISY BRACHOT • RUE VILLA HERMOSA, 8 • 1000 BRUXELLES
TEL. (32.2) 512.14.16 • FAX (32.2) 514.59.35

ANTONY GORMLEY

16.1 - 2.3.1991

Vernissage le mercredi 16 janvier de 19 à 21h
Opening woensdag 16 januari vanaf 19 tot 21 u

GALERIE CHRISTINE EN ISY BRACHOT • VILLA HERMOSASTRAAT, 8 • 1000 BRUSSEL
TEL. (32.2) 512.14.16 • FAX (32.2) 514.59.35

Exhibitions and projects
1991-92

'Sculpture',
Galerie Nordenhake, Stockholm (solo)

'Field and Other Figures',
Modern Art Museum of Fort Worth, Texas ; **Centro Cultural/ Arte Contemporaneo**, Mexico City; **San Diego Museum of Contemporary Art**, La Jolla, California; **The Corcoran Gallery of Art**, Washington DC; **The Montreal Museum of Fine Arts**, Montreal (solo)
Cat., *Antony Gormley: Field and Other Figures*, Modern Art Museum of Fort Worth, Fort Worth, Texas, texts Thomas McEvilly and Richard Calvocoressi; Montreal catalogue texts Pierre Theberge, Antony Gormley, Gabriel Orozco and Thomas McEvilley

Field, San Diego Museum of Contemporary Art, in progress, 1992

'Colours of the Earth',
organized by the British Council, touring India and Malaysia (group)
Cat., *Colours of the Earth*, The British Council, texts Oliver Watson, Michael Casson and Alison Britton

'Sculpture',
Miller Nordenhake, Cologne (solo)

'Baring Light',
Gallery Shirakawa, Kyoto (solo)

1992
'Arte Amazonas',
Museu de Arte Moderna, Rio de Janiero, Brazil (group)
Cat., *Arte Amazonas*, Museu de Arte Moderna, Rio de Janiero and Goethe Institute, texts various authors

'Natural Order',
Tate Gallery, Liverpool (group)
Cat., *Natural Order*, Tate Gallery, Liverpool, text Penelope Curtis

'Recent Iron Works',
Burnett Miller Gallery, Los Angeles, California (solo)

'Body and Soul: Learning to See',
Contemporary Sculpture Centre, Tokyo (solo)
Cat., *Antony Gormley: Learning to See: Body and Soul*, Contemporary Sculpture Centre, Tokyo, text Masahiro Ushiroshoji

'C'est pas la fin du monde',
La Criée Halle d'Art Contemporain, Rennes; Faux

Selected articles and interviews
1991-92

Sandquist, Gertrud, 'Manniskan som blykista', *Svenska dagbladet*, Stockholm, 14 September
Ericsson, Lars O, 'Klafsigt Malade traramar och blykroppar', *Dagens Nyheter*, Stockholm, 17 September
Harleman, Carl-Fredrick, and van der Heeg, Erik, 'Concentrated Spaces', *Material Konst-Fanzine*, No 2, Stockholm

Hart, Jane, 'Interview with Antony Gormley', *Journal of Contemporary Art*, vol 4, No 3, New York, Fall
Campo, Carlos, 'Un Cuerpo Colectivo Denominado Campo', *Activa*, Mexico, February 1992
'Las Cosas ya Existen. La Escrultura ya Existe', *Poliester*, Mexico, March 1992
Tibol, Raquel, 'Edgar Negret y Antony Gormley en Mexico', *Proceso 801*, Mexico, 9 March 1992
L. Pincus, Robert, 'Sculptor with Earthy World View', *San Diego Union Tribune*, 8 October 1992
Freudenheim, Susan, 'Contemplative Spectacle', *Los Angeles Times*, 17 October 1992
L. Pincus, Robert, 'Gormley's Engaging Vision of Humanity Takes Many Forms', *San Diego Union-Tribune*, 12 November 1992
Burchard, Hank, 'Outstanding in his Field', *The Washington Post*, Washington DC, 12 February 1993
Richard, Paul, 'The Field: It Figures', *The Washington Post*, Washington DC, 8 March 1993
McPherson, Anne, 'Reviews-Antony Gormley-Field', *Canadian Art*, Canada, Winter 1993
Grande, John K., 'Reviews: Montreal: Antony Gormley', *Artforum*, New York, October 1993

1992
Metken, Gunter, 'Traver und Risse im Atelier der Tropen', *Frankfurter Algemeiner Zeitung*, Frankfurt, 10 March

Pagel, David, 'Gormley's Sculptures Get Physical', *Los Angeles Times*, 8 October

Exhibitions and projects
1992-93

Mouvement, Metz; **FRAC** Basse Normandie, Caen; **FRAC** Poitou Charentes, Angouleme (group)
Cat., *C'est pas la fin du monde*, La Criée Halle d'Art Contemporain, Rennes

1993
'Iron: Man',
Commission installed, Victoria Square, Birmingham

'The Human Factor: Figurative Sculpture Reconsidered',
The Albuquerque Museum, Albuquerque, New Mexico (group)
Cat., *The Human Factor*, Albuquerque Museum, Albuquerque, text Christopher French

Galerie Thaddaeus Ropac, Paris (solo)
Cat., *Learning to See*, Thaddaeus Ropac, Paris; Salzburg, texts by Yehuda Safran, Antony Gormley interviewed by Roger Bevan

'HA HA: Contemporary British Art in an 18th Century Garden',
Killerton Park, Exeter (group)
Cat., *HA HA: Contemporary British Art in an 18th Century Garden*, Plymouth Polytechnic, texts Iwona Blazwick and Peter Pay

'The Raw and the Cooked',
Barbican Art Gallery, London; **Museum of Modern Art**, Oxford; **Glynn Vivian Art Gallery**, Swansea; **The Shigaraki Ceramic Cultural Park**, Japan (group)
Cat., *The Raw and the Cooked*, Museum of Modern Art, Oxford, texts Alison Britton and Martina Margetts

'The Body of Drawing',
Graves Art Gallery, Sheffield; **The Mead Gallery**, University of Warwick; **Aberdeen Art Gallery**, Aberdeen; **Victoria Art Gallery**, Bath; **Oriel Mostyn**, Llandudno (group)
Cat., *The Body of Drawing*, Graves Art Gallery, texts Gerlinde Gabriel and Tony Godfrey

Konsthall Malmö, Sweden (solo)
Cat., *Antony Gormley*, Konsthall Malmo, Sweden; Tate Gallery, Liverpool; Irish Museum of Modern Art, Dublin, texts Lewis Biggs, Stephen Bann, text for Konsthall Malmö Karsten Thjurfell

'European Field',
Centrum Sztuki Wspolczesnej, Warsaw; **Museum of Modern Art**, Ljubljana; **Muzej Suvremena Umjetnosti**, Zagreb; **Ludwig Museum**, Budapest; Prague Castle, Prague (solo)
Cat., *European Field*, Centrum Sztuki Wspolczesnej, Warsaw, text Stephen Bann; Museum of Modern Art, Ljubljana, Antony Gormley interviewed by Marjetica Potrc; Muzej Suvremena Umjetnosti, Zagreb, texts Stephen Bann and Marijon Susovski; Ludwig Museum Budapest, text Stephen Bann

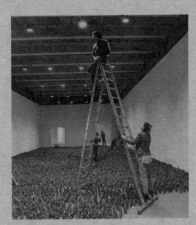

European Field, in progress, Centrum Sztuki, Wspolczesnej, Warsaw , 1993

Selected articles and interviews
1992-93

1993
Grimley, Terry, 'Vision of Latest City Sculpture', *The Birmingham Post*, 14 September 1991
Grimley, Terry, 'Don't Knock This Bold Tribute to Our City's Past', *The Birmingham Post and Mail*, Birmingham, March

Iron: Man, in progress, Victoria Square, Birmingham, 1993

Delincee, Susanne, 'Koerper Formt Koerper', *Observer*, Vienna, 21 June

Lubbock, Tom, 'An Unnatural Device', *The Independent*, London, 13 July

Post, in progress, HA HA, Killerton Park, Exeter, 1993

Wachtmeister, Marika, 'Kropper och dess holje', *Kristianstads-Bladet; Solvesborgs-Tidningen; Karlshamns Allehanda*, Sweden, 29 September
Lind, Maria, 'Fornimmandet finns i enfalden', *Material no. 1*, No 17, Stockholm
Zeylan, Hakan, 'Konsten angar oss alla', *Skanska Dagbladet*, Malmo, 8 October
Ericsson, Lars O, 'Kroppen som fodral for manniskans ide', *Dagens Nyheter*, Stockholm, 15 October

Muzurovic, Lamija, 'Antony Gormley: Polja olovnih figura', *Kontura*, No 16, Zagreb, Croatia, April
Glavan, Darko, 'M Mazemo biti biljka ili oblak', *Nedjeljna Dalmacija*, Croatia, 11 May 1994
Blazevic, Dalibor, 'Ozivljavavje otudenih bica', *Gradski Vodic*, Croatia, June 1994
Ayton, Ewa, 'Antony Gormley – Pole i inne rzezby', *Plastyka i Wychowanie*, Warsaw, July 1994
Vidovic, D., 'Krik za savjest covjecalistva', *Oslobocyeiye*, Sarajevo, Bosnia, 27 September 1994

Field for the British Isles',
Tate Gallery, Liverpool; **Irish Museum of Modern Art**,
Dublin; **Oriel Mostyn**, Llandudno; **Scottish National
Gallery of Modern Art**, Edinburgh; Orchard Gallery,
Derry; Ikon Gallery, Birmingham; National Museum of
Wales, Cardiff (solo)
Cat., *Field for the British Isles*, Tate Gallery, Liverpool;
Irish Museum of Modern Art, Dublin; Oriel Mostyn,
Llandudno; Scottish National Gallery of Modern Art,
Edinburgh, text Adrian Plant

Galerie Nordenhake, Stockholm, Sweden (solo)

'Sound II',
Commission installed at Winchester Cathedral

1994
'Lost Subject',
White Cube, London (solo)

'Air and Angels',
ITN Building, London with Alison Wilding

'Open Space',
Commission for City of Rennes at La Place Jean-Monnet

'Sculptors' Drawings from the Weltkunst Collection',
Tate Gallery, London (group)

'From Beyond the Pale (Part 1)',
Irish Museum of Modern Art, Dublin (group)
Cat., *From Beyond the Pale*, Irish Museum of Modern
Art, Dublin, texts Thomas McEvilley, Nuala Ni
Dhomhnail, Brian Doherty, Pat Steir, Edward Kelly,
David Frankel, Michael Tarantino

'The Essential Gesture',
Newport Harbor Art Museum, Newport Beach,
California (group)
Cat., *The Essential Gesture*, Newport Harbor Art
Museum, texts Michael Botwinick and Bruce Guenther

Lecture, Moderna Galerija, Ljubljana, Slovenia,
published in *M'ARS*, vol. 3-4

'Turner Prize Shortlist',
Tate Gallery, London (group)

Awarded Turner Prize

Buck, Louisa, 'Feats of Clay', *GQ*, London, December
Lubbock, Tom, 'Fine Figures of a Man', *The
Independent*, London, 7 December
Feaver, William, 'Field Full of Folk and Banana Skins',
The Observer, London, 12 December
Side, Jeffrey, 'The Field as Metaphor', *Off the Cuff*,
University of Liverpool English Society, Lent, 1994
Farrell, John, 'Gormley Show Has to Be Seen', *The
Sunday Press*, Dublin, 24 April
Clancy, Luke, 'Power of a Lapsed Optimist', *The Irish
Times*, Dublin, 30 April
Clancy, Luke, 'Avoiding the Post-modern Trap', *The
Irish Times*, Dublin, 9 Jun

Van der Heeg, Erik, 'Reviews: Antony Gormley:
Nordenhake, Stockholm', *Flash Art*, Milan, May/June
1994

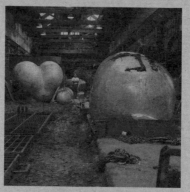

l. to r., **Earth, End Product, Still Running, Body,**
in progress, Hargreaves Foundry, Halifax, 1993

Pietch, Hans, 'Er nimnt Mass on eigenen korper', *ART*,
Hamburg, March

1994
Norman, Geraldine, 'Sculptor Casts Himself in Star
Role', *The Independent*, London, 18 April
Dorment, Richard, 'Appearances can be Deceptive',
Daily Telegraph, 6 April

Rankin-Reid, Jane, *Art and Text*, No 49, September

Jiry, Louise, and Hall, James, 'Bodymoulder Builds Big
Lead in Turner Prize Line-up', *The Guardian*, London, 20
July
Searle, Adrian, 'We Know You're in There', *The
Independent*, London, 4 November
Hall, James, 'Frame Game', *The Guardian*, London, 7
November

Herbert, Susannah, 'Turner Prize for Sculptor Whose
Body Is His Art', *The Daily Telegraph*, London, 23
November

**The
Turner Prize
1994**

Exhibitions and projects
1994-95

'Testing a World View',
Tate Gallery, Liverpool (solo)

Noulso Galeria Pedro Oliviera, Oporto, Portugal
(solo)
Cat., *Antony Gormley*, Noulso Galeria Pedro Oliviera,
Oporto, text Andrew Renton

'Artists' Impressions',
Kettles' Yard, Cambridge; **Castle Museum**,
Nottingham (group)
Cat., *Artists Impressions*, Kettles' Yard, Cambridge,
texts Sarah Glennie and Michael Harrison

1995

'Iron Angel of the North',
commission for Gateshead Metropolitan Borough

'Ars '95',
Museum of Contemporary Art, Helsinki (group)

'Broken Glass, Open Sky',
commission for the Ville de Rouen, France

'Havmann',
Public commission for Artskap Nordland, Norway

Koji Ogura,
Nagoya, Japan (solo)

'Fredsskulptur 95',
Denmark (group)

'Intimacy and Distance',
Remise, Vienna (solo)

'Drawings',
Pace Foundation, San Antonio, Texas (solo)

Selected articles and interviews
1994-95

Cerveira Pinto, Antonio, 'O corpo pela Alma',
Independente, Lisbon, 9 December
Melo, Alexandre, 'O espaco do corpo', *Expresso*, Lisbon,
Portugal, 24 December

Wachtmeister, Marika, 'Mannen bakon blyholjina',
Femina, Stockholm, January
Ayton, Ena, 'I Am Fighting a Deconstructive World
View', *Art and Business*, Warsaw, March/April
Ball, Keith, 'Intimate Architecture – Antony Gormley',
Everything, No 13, London, April/May
Liiv, Toomas H, 'Antony Gormley teab vastust',
Puhapaevaleht, Tallinn, Estonia, 25 June

1995

Pedersen, Geir, 'Havmannen setters på plass', *Rana
Blad*, Norway, 22 September

Havmann, in progress, 1994

Bibliography

Allthorpe-Guyton, Marjorie, *Viewpoint*, Musees Royaux des Beaux-Arts de Belgique, Bruxelles, 1987

'Antony Gormley', *Art and Design*, Academy Editions, vol 5, no 3/4, London, 1989

Bakewell, Joan, 'Vote to Cement History', *The Sunday Times*, London, 30 October, 1988

Ball, Keith, 'Intimate Architecture – Antony Gormley', *Everything*, no 13, London, April/May 1994

Bann, Stephen, *Antony Gormley*, Konsthall Malmo, Sweden; Tate Gallery, Liverpool; Irish Museum of Modern Art, Dublin, 1993

Bann, Stephen, *European Field*, Centrum Sztuki Wspolczesnej, Warsaw, Muzej Suvremena Umjetnosti, Zagreb, 1993

Bevan, Roger, Interview, *Learning to See*, Thaddaeus Ropac, Paris/Salzburg, 1993

Bickers, Patricia, 'When is Sculpture not a Sculpture?', *Aspects*, London, No. 29, 1985

Biggs, Lewis, 'Objects and Sculpture', *Arnolfini Review*, Bristol, July, 1981

Biggs, Lewis, *Objects and Sculpture*, ICA, London and Arnolfini Gallery, Bristol, 1981

Biggs, Lewis, *Antony Gormley*, Konsthall Malmo, Sweden; Tate Gallery, Liverpool; Irish Museum of Modern Art, Dublin, 1993

Blazwick, Iwona, *Objects and Sculpture*, ICA, London and Arnolfini Gallery, Bristol, 1981

Bluemler, Detelf, 'Munchen' *Kunstzeitschrift*, Munich, May, 1985

Bond, Anthony, *A Field for the Art Gallery of New South Wales, A Room for the Great Australian Desert*, Art Gallery of New South Wales, Sydney, 1989

Brenson, Michael, 'Images that Express Essential Human Emotions', *The New York Times*, July, 1987

Brenson, Michael, 'Antony Gormley: Salvatore Ala Gallery', *Weekend, The New York Times*, 29 March, 1991

Brenson, Michael, 'Visual Arts join Spoleto Festival USA', *New York Times*, 27 May, 1991

Calvocoressi, Richard, *Antony Gormley*, Museum of Modern Art, Louisiana, Humlebaek, Denmark, 1989

Calvocoressi, Richard, *Antony Gormley: Field and Other Figures*, Modern Art Museum of Fort Worth, Fort Worth, Texas, 1991

Campo, Carlos, 'Un Cuerpo Colectivo Denominado Campo', *Activa*, Mexico, February 1992

Cerveira Pinto, Antonio, 'O corpo pela Alma', *Independente*, Lisbon, 9 December 1994

Clancy, Luke, 'Power of a Lapsed Optimist', *The Irish Times*, Dublin, 30 April 1993

Clancy, Luke, 'Avoiding the Postmodern Trap', *The Irish Times*, Dublin, 9 June 1993

Comi, Enrico R., 'La quotidianità cosmica del lavoro di Gormley', *Spazio Umano*, Italy, No 3, July-September, 1985

Conti, Vianna, 'Antony Gormley', *Artefactum*, Belgium, September/October, 1985

Cooke, Lynne, 'Antony Gormley at the Whitechapel', *Artscribe*, London, No 29, 1981

Cooke, Lynne, *Antony Gormley*, Salvatore Ala Gallery, Milan, 1984

Cork, Richard, 'In Situ', *The Listener*, London, 5 June, 1986

Cork, Richard, 'Figures of Everyman', *The Listener*, London, 19 March, 1987

Danto, Arthur C., 'Spoleto Festival USA', *The Nation*, New York, 29 July, 1991

De Ruyck, Jo, 'Verrassende verscheidenheid van de hedendaagse Britse kunst', *Het Volk*, Brussels, 17 December, 1987

Dimitrijevic, Nena, 'Antony Gormley', *Flash Art*, Milan, January, 1984

Dorment, Richard, 'Appearances can be Deceptive', *Daily Telegraph*, 6 April, 1994

Erricsson, Lars O, 'Klafsigt Malade traramar och blykroppar', *Dagens Nyheter*, Stockholm, 17 September, 1991

Erricsson, Lars O, 'Kroppen som fodral for mannkans ide', *Dagens Nyheter*, Stockholm, 15 October 1993

Ferguson, Bruce, 'The Impossible Self, Winnipeg Art Gallery and Vancouver Art Gallery, 1988

Fisher, Jean, 'Antony Gormley', *Artforum*, New York, January, 1986

Foster, Tony, 'TSWA 3D', Plymouth, 1987

Francis, Mark, 'Objects and Sculpture', *Art Monthly*, London, July/August, 1981

Gablik, Suzi, *The Reemergent Figure*, Storm King Art Center, Mountainville, New York, 1987

Gooding, Mel, 'Seeing the Sites', *Art Monthly*, London, July/August, 1987

Gormley, Antony, *The British Show*, Art Gallery of New South Wales, 1985

Gormley, Antony, *A Field for the Art Gallery of New South Wales, A Room for the Great Australian Desert*, Art Gallery of New South Wales, Sydney, 1989

Gormley, Antony, *Learning to See*, Thaddaeus Ropac, Paris/Salzburg, 1993

Graham-Dixon, Andrew, 'Antony Gormley's Bizarre Sculptural Techniques', *Harpers and Queen*, London, February, 1987

Graham-Dixon, Andrew, 'Life Set Upon a Cast', *The Independent*, London, 9 May, 1989

Grimley, Terry, 'Don't Knock this Bold Tribute to our City's Past', *The Birmingham Post and Mail*, Birmingham, March 1993

Hall, James, 'Frame Game', *The Guardian*, London, 7 November 1994

Hart, Jane, 'Interview with Antony Gormley', *Journal of Contemporary Art*, New York, Vol 4, No 3, Fall, 1991

Harvey, Jonathan, 'TSWA 3D', Plymouth, 1987

Higgins, Judith, 'Antony Gormley', *ARTnews*, New York, December, 1985

Hjort, Oystein, *Antony Gormley*, Museum of Modern Art, Louisiana, Humlebaek, Denmark, 1989

Jacob, Mary Jane, *Places with a Past*, Spoleto Festival, Charleston, 1991

Jiry, Louise, and Hall, James, 'Bodymoulder Builds Big Lead in Turner Prize Line-up', *The Guardian*, London, 20 July 1994

Kaufman, Jason Edward, 'Antony Gormley's Human Cyphers', *The New York Tribune*, 10 May, 1989

Kent, Sarah, 'In the Lead', *Time Out*, London, 11 March, 1987

Kobke Sutton, Gertrud, 'Kroppens tyste tale', *Information*, 14 February, 1989

Kopecek, Paul, 'Antony Gormley', *Art Monthly*, London, October, 1984

Lemee, Jean-Philippe, 'Antony Gormley Man Made Man', *Art Presse*, Paris, 119, 1987

Levin, Kim, 'The Clone Zone', *The Village Voice*, New York, 15 May, 1984

Levin, Kim, 'Chernobyl, Mon Amour', *The Village Voice*, New York, 24 June, 1986

Lind, Maria, 'Fornimmandet finns i enfalden', *Material no. 1*, no 17, Stockholm 1993

Liiv, Toomas H, 'Antony Gormley teab vastust', *Puhapaevaleht*, Tallinn, Estonia, 25 June 1994

Lingwood, James, 'TSWA 3D', Plymouth, 1987

Linker, Kate, 'Antony Gormley', *Artforum*, New York, October, 1984

Loers, Veit, 'Antony Gormley', Stadtische Galerie Regensburg, Frankfurter Kunstverein, 1985

Lubbock, Tom, 'An Unnatural Device', *The Independent*, London, 13 July 1993

Lubbock, Tom, 'Fine Figures of a Man', *The Independent*, London, 7 December 1993

Lynn, Victoria, 'Earth Above Ground', *Art & Text*, Sydney, Summer, 1989

McEvilly, Thomas, *Antony Gormley: Field and Other Figures*, Modern Art Museum of Fort Worth, Fort Worth, Texas, 1991

McPherson, Anne, 'Reviews-Antony Gormley-Field', *Canadian Art*, Canada, Winter 1993

McWilliams, John, *Places with a Past*, Spoleto Festival, Charleston, 1991

Melo, Alexandre, 'O espaco do corpo', *Expresso*, Lisbon, Portugal, 24 December

Miller, Sanda, 'Antony Gormley at Riverside', *Artscribe*, London, No 49, 1984

Moorman, Margaret, 'Antony Gormley; Salvatore Ala', *ARTnews*, New York, September, 1984

Morgan, Stuart, 'Antony Gormley, Whitechapel Gallery', *Artforum*, New York, Summer, 1981

Morley, Simon, 'Serpentine Gallery: Antony Gormley', *Artline*, London, April, 1987

Morley, Simon, 'Antony Gormley', *Tema Celeste*, Siracusa, April/June, 1989

Muzurovic, Lamija, 'Antony Gormley: Polja olovnih figura', *Kontura*, No 16, Zagreb, Croatia, April 1993

Nairne, Sandy, *Objects and Sculpture*, ICA, London and Arnolfini Gallery, Bristol, 1981

Nairne, Sandy, *British Sculpture in the 20th Century*, Whitechapel Art Gallery, London, 1981

Nairne, Sandy, *Antony Gormley*, Stadtische Galerie Regensburg, Frankfurter Kunstverein, 1985

Nairne, Sandy, *State of the Art*, Channel 4, London, 1987

Nairne, Sandy, *The British Show*, Art Gallery of New South Wales, 1985

Nairne, Sandy, *The Impossible Self*, Winnipeg Art Gallery and Vancouver Art Gallery, 1988

Newman, Michael, *Objects and Figures: New Sculpture in Britain*, The Scottish Arts Council, Edinburgh, 1982

Newman, Michael, 'Discourse and Desire in British Sculpture', *Flash Art*, Milan, January, 1984

Newman, Michael, *Gormley*, The Seibu Department Stores, Tokyo, 1987

Orozco, Gabriel, *Antony Gormley: Field and Other Figures*, Modern Art Museum of Fort Worth, Fort Worth, Texas, 1989

Padon, Thomas, 'Antony Gormley: Salvatore Ala, New York', *Sculpture Magazine*, New York, September/October, 1991

Pagel, David, 'Antony Gormley', *Arts Magazine*, New York, April, 1990

Pietch, Hans, 'Er nimmt Mass on eigenen korper', *ART*, Hamburg, March 1993

Plant, Adrian, *Field for the British Isles*, Tate Gallery, Liverpool; Irish Museum of Modern Art, Dublin; Oriel Mostyn, Llandudno; Scottish National Gallery of Modern Art, Edinburgh, 1993

Pokorny, Rita, 'Using the Body As If It Was a Face', *Neue Kunst in Europe*, No 9, July/August/September, 1985

Potrc, Marjetica, *European Field*, Museum of Modern Art, interview, Ljubljana, 1993

Rankin-Reid, Jane, *Art and Text*, Sydney, No. 49, September, 1994

Redden, Nigel, *Places with a Past*, Spoleto Festival, Charleston, 1991

Roberts, John, 'Objects and Sculpture', *Artscribe*, London, No 30, 1981

Rosengarten, Theodore, *Places with a Past*, Spoleto Festival, Charleson, 1991

Roustayi, Mina, 'An Interview with Antony Gormley', *Arts Magazine*, New York, September, 1987

Safran, Yehuda, *Learning to See*, Thaddaeus Ropac, Paris/Salzburg, 1993

Sakai, Tadayasu, *Antony Gormley*, Contemporary Sculpture Center, Tokyo, 1988

Sandquist, Gertrud, 'Manniskan som blykista', *Svenska dagbladet*, Stockholm, 14 September, 1991

Saunders, Wade, and Rochette, Anne, 'Antony Gormley at Salvatore Ala', *Art in America*, New York, November, 1986

Schwabsky, Barry, 'Antony Gormley', *Arts Magazine*, New York, Summer, 1991

Serota, Nicholas, *British Sculpture in the 20th Century*, Whitechapel Art Gallery, London, 1981

Serota, Nicholas, 'Transformations: New Sculpture from Britain', *Artefactum*, Belgium, February/March, 1983

Side, Jeffrey, 'The Field as Metaphor', *Off the Cuff*, University of Liverpool English Society, Lent, 1994

Snackenburger, Manfred, *Documenta 8*, Kassel, 1987

Stern, Peter, *The Reemergent Figure*, Storm King Art Center, Mountainville, New York, 1987

Susovski, Marijon, *European Field*, Muzej Suvremena Umjetnosti, Zagreb, 1993

Taplin, Robert, 'Antony Gormley at Salvatore Ala', *Art in America*, New York, November, 1991

Theberge, Pierre, *Antony Gormley: Field and Other Figures*, Modern Art Museum of Fort Worth, Fort Worth, Texas, 1989

Tibol, Raquel, 'Edgar Negret y Antony Gormley en Mexico', *Proceso 801*, Mexico, 9 March 1992

Turnbull, Clive, 'Antony Gormley: The Impossible Self', *The Green Book*, vol III, no 1, Bristol, 1989

Ushiroshoji, Masahiro, *Antony Gormley: Learning to See: Body and Soul*, Contemporary Sculpture Centre, Tokyo, 1992

Van der Heeg, Erik, 'Reviews: Antony Gormley: Nordenhake, Stockholm', *Flash Art*, Milan, May/June 1994

Weiermair, Peter, *Vom Zeichnen: Aspekte der Zeichnung*, Frankfurter Kunstverein, Kasseler Kunstverein, Museum Moderner Kunst, Vienna, 1986

Weiermair, Peter, *Chaos and Order in the Soul*, University Psychiatric Clinic, Mainz, Germany, 1987

Weinstein, Matthew, 'Antony Gormley', *Westuff*, No 2, September, 1985

Weskott, Hanne, 'Antony Gormley', *Kunstforum*, Cologne, 1985

Wyver, John, *State of the Art*, Channel 4, London, 1987

Public Collections

Art Gallery of New South Wales, Sydney
Lhoist Collection, Brussels
Jesus College, Cambridge, UK
Irish Museum of Modern Art, Dublin
Scottish National Gallery of Modern Art, Edinburgh
Marquiles Foundation, Florida
Museum of Modern Art, Fort Worth, Texas
Iwaki Municipal Museum, Fukushima, Japan
Caldic Collection, the Hague
Hakone Open-air Museum, Japan
Sapporo Sculpture Park, Hokkaido, Japan
Louisiana Museum, Humblebaek, Denmark
Israel Museum, Jerusalem
Neue Museum, Kassel, Germany
Southampton City Art Gallery
Stadt Kassel, Germany
Henry Moore Foundation for the Study of Sculpture, Leeds, UK
Leeds City Art Gallery, UK
Arts Council of Great Britain, London
British Council, London
British Museum, London
Contemporary Arts Society, London
Tate Gallery, London
Victoria and Albert Museum, London
Museum of Contemporary Art, Los Angeles
Malmö Konsthall, Sweden
Walker Arts Centre, Minneapolis
Museet for Samtidskunst, Oslo
Ashmolean Museum, Oxford, UK
Ville de Rennes, France
Moderna Museet, Stockholm
Umedalen Sculpture Foundation, Umea, Sweden
Winchester Cathedral, UK
Weltkunst Foundation, Zurich